Feminine Look .

SUNY series in Psychoanalysis and Culture
Henry Sussman, editor

SUNY series, Insinuations: Philosophy, Psychoanalysis, Literature
Charles Shepherdson, editor

FEMININE LOOK

Sexuation, Spectatorship, Subversion

Jennifer Friedlander

STATE UNIVERSITY OF NEW YORK PRESS

Cover image: André Kertész, "Elizabeth and I," Paris, 1931 © 2007 Estate of André Kertész Higher Pictures.

An earlier version of chapter 4 appeared in *Journal for Psychoanalysis of Culture and Society* (Spring 2003, vol. 8.1), and preliminary research on the images addressed in chapters 6 and 7 appeared in *Moving Pictures: Where the Police, the Press, and the Art Image Meet* (Sheffield: Sheffield Hallam University Press, 1998).

Published by
State University of New York Press, Albany

© 2008 State University of New York

For information, contact State University of New York Press, Albany, NY
www.sunypress.edu

Production by Judith Block and Eileen Meehan
Marketing by Anne M. Valentine

Library of Congress Cataloging-in-Publication Data

Friedlander, Jennifer
 Feminine Look : sexuation, spectatorship, subversion / Jennifer Friedlander.
 p. cm. — (SUNY series in psychoanalysis and culture) (SUNY series, insinuations: philosophy, psychoanalysis, literature)
 Includes bibliographical references (p.) and index.
 ISBN 978-0-7914-7295-8 (hardcover : alk. paper)
 ISBN 978-0-7914-7296-5 (pbk. : alk. paper)
 1. Photography—Philosophy. I. Title.

TR183.F755 2008
770.1—dc22

 2007007702

10 9 8 7 6 5 4 3 2 1

Contents

Illustrations

Acknowledgments

This book has benefited greatly from the support of scholars, mentors, friends, and family. I regret that the depth of my appreciation exceeds my ability to pay proper tribute to their profound influences. I am exceptionally fortunate to have inspiring colleagues and friends throughout Pomona College. My colleagues in the Art and Art History Department, Mark Allen, Jud Emerick, George Gorse, Kathleen Howe, Phyllis Jackson, Sandeep Mukherjee, Michael O'Malley, Sheila Pinkel, Frances Pohl, and Mercedes Teixido, have been unfailingly supportive and intellectually invigorating. I can only mention a few of the other many friends at Pomona College who not only have provided much-needed support of intellectual and emotional (and sometimes culinary) kinds throughout this process but also have made my life immeasurably richer: Vin De Silva, Bob Gaines, Kathleen Fitzpatrick, Stephanie Harves, Yvonne Houy, Susan Larsen, Ian Moyer, Mary Paster, Peggy Waller, Gary Wilder, and Meg Worley. My early mentors, Constance Coiner and Bish Sen, sparked my initial excitement for cultural theory and have been enduring role models for me as a professor. I would also like to express deep gratitude to my dissertation chair at the University of Pittsburgh, John Lyne, for supporting this project in its early stages and to Larry Prelli for his wise and kind mentorship while I was a faculty-in-residence at the University of New Hampshire.

This work has been enormously improved by the perspicacious insights of scholars in many different places. I am particularly thankful for the generous feedback I received following presentations of portions of this book to the Department of Psychoanalysis, University of Ghent, Belgium; the Pychoanalytic Studies Program, Deakin University, Australia; The Power Institute Foundation for Art and Visual Culture and the Department of Art History and Theory at the University of Sydney, Australia; the Ljubljana Graduate School of the Humanities, Slovenia; as well to annual meetings of the Association for Psychoanalysis of Culture and Society and to my students at

Pomona College, who ask frightfully smart questions. Robert Gurbo generously provided me with unpublished information about André Kertész's life. I am grateful for the careful and caring help that Caitlin Myers provided with the formatting of text and image. I thank the University of Pittsburgh for awarding me the Austrian Nationality Room Scholarship, which enabled me to spend a summer in Linz, where conversations with philosopher Robert Pfaller stretched my thinking in exciting directions. Charles Shepherdson's astute suggestions regarding additions and revisions enhanced this book beyond measure. I would also like to express my appreciation to the Pankey family for their generosity to the Pomona College Media Studies Program in establishing the Edgar E. and Elizabeth S. Pankey Professorship.

My parents' unwavering support and unconditional love have nourished me in inestimable ways. Mama Roz, who read every word of the dissertation from which this book developed, has been wonderfully encouraging throughout this long process. The kindness and love of Mama Jessie and Papa Larry continue to influence my life profoundly. I am grateful for Karen Iorio's enthusiasm for what I do and for my Aunt Vic's support and good humor (not to mention funny stories—see chapter 4!). Genna Miller's marvelous friendship has been a constant source of strength and inspiration. Finally, my deep love and gratitude go to Henry Krips, who has made invaluable contributions to this book as well as making my life full of undreamt joy.

Introduction

Throughout my first undergraduate media studies course, I was continually exhilarated by the explanatory power and interventionist potential of cultural studies. However, the most memorable moment occurred on the last day. In my memory, the scene plays as follows. The professor, speaking rather informally to the few remaining die hards, offered an analysis of the way the only male detective of color on a prime-time series was disempowered. In the course of discussing the subtle mechanisms by which texts carry traces of oppression and prejudice, Professor X pointed out that the detective of color wore formal, professional suits, while the white detectives wore casual clothes. This incongruity, he claimed, revealed the way minorities have to work harder to be regarded equally as capable as their colleagues. One observant student challenged the significance of this textual evidence by pointing out that the professor would have reached the same conclusion had the clothing styles been reversed. If the detective of color had been worse dressed than his colleagues, she argued, the professor would have just as easily used *this* to demonstrate that the character was an outsider: either ignorant of/ resistant to/ or too lazy to care about "appropriate" (i.e., white) professional behaviors. Professor X, a sharply dressed man from Southasia among a largely blue-jeaned white faculty, was famous for inviting students to challenge him to intellectual spars (in which he exhibited incisive wit), and I eagerly awaited his riposte.

Professor X could have quite justifiably reinforced his point by calling upon the structural significance of the opposing dress of the minority character to his white counterparts, regardless of the specific content of this difference. Similarly, an appeal to the polysemic nature of the text would have enabled him to explain how texts implicitly contain a variety of signs that work to reinforce a dominant reading, to sustain negotiated readings, and to act as resources from which to construct oppositional readings. Nor would it have been unprecedented for Professor X to make the reflexive move and candidly discuss how the complexities of his own subject position influenced

1

his critical judgments. But Professor X did none of these. In fact, he did nothing at all. A quick collection of our essays and some abbreviated farewells were all that ensued.

Riveted by the professor's silence, I lingered in my seat, sensing the dire inadequacy of language to grasp what had happened, an inadequacy that seemed to match the professor's own silence. I sat and wondered how the symbolic could so profoundly elude Professor X, a scholar of representation, widely admired for his deft use of language, and how it also eluded the moment in which I confronted that elusiveness. In that moment I groped for what I have since come to encounter in the work of Jacques Lacan: a notion of psychoanalytic "truth," which exists precisely where knowledge fails. As Paul Verhaeghe describes, there is a "difference between knowledge and something beyond knowledge, something that belongs to another register, other than the symbolic order.... [T]here is something that cannot be put into words, something for which words are lacking" (Verhaeghe 38). For Lacan, such "truth" differs from "mere knowledge" in that "the essential characteristic of truth is that it confronts us with the ultimate point where knowledge about desire...can no longer be put into words.... This dimension beyond the signifier is the Lacanian real" (39).

Although we may traditionally associate such points of failure in the symbolic with trauma, more often than not (and this will be important to the ensuing arguments) seemingly trivial or insignificant events and objects inexplicably trigger these flashes of the Real. We are often struck, not so much by events or objects themselves, but rather by a palpable sense of their hauntingly indistinct threat. As Verhaeghe describes, the Real can be thought of as what is "just waiting around the corner, unseen, unnamed, but very present. Lacan calls this the imminence of the object (just think of the nightmare: we are awakened a split second before we would see or experience 'it')" (12).

My interest here lies not in trying to understand why the interchange with Professor X triggered the responses that it did. Rather, this book takes as its task the exploration of how what I will call these psychic "accidents" or "surprises" may be compatible with the critical, politically interventionist goals of cultural studies. In particular, I consider ways in which they might contribute to new understandings regarding relationships among subjects, cultural products, and ideology.

The book will take visuality (both practice and object) as the primary field through which to explore such relationships. In particular, I will be concerned with "moving images" in at least three senses: First, the way in which images move in the sense of circulating physically among geographical loca-

tions, time periods, genre, and medium. The often unpredictable effects of these movements on reception, I will argue, provide possibilities for rich insights into relationships among an image's formal characteristics, its contexts of production, and its contexts of reception. These relationships also offer us a sense of how images "move" in a second way—namely, how they emotionally resonate with certain viewers at particular times or places, and for seemingly unanticipated reasons. In order to investigate these first two issues, I shall draw upon the historical and cultural contexts, as well as theories of compositional form of the images and psychic mechanisms that accompany the act of looking.

Last, behind all of the images I explore lurks the question of how images may "move" viewers in a third, political sense. In answering this question, I will not only examine ways in which images respond to or mobilize social action but also discuss a possible political strategy for spectatorship that enables viewers to view images subversively. The strategy that I offer will involve being moved by images, while resisting the comfortable options of explaining their significance, ignoring their effects, or refusing their pleasures. This, in the words of Samuel Weber, "means relearning how to be *struck* by the signifier.... In the theatre of the unconscious, one never gets over being stage-struck" (Weber 151).

Through a focus upon such a "politics of the image," this book engages one of the most enduring debates in the area of cultural studies, concerning the nature of ideology and in particular the struggle to articulate the connections between the ideological sphere of cultural production and the material/social relations of a society. Theorists such as Raymond Williams and Stuart Hall have focused on the relationship of popular culture to politics and economics. They have argued that culture and ideology are neither directly emergent from material relations, nor independent from them but instead are capable of producing their own material effects. In contemporary media and cultural studies, these arguments have been further elaborated in the light of Louis Althusser's insight that ideology itself is material, existing as a "lived representation" structuring everyday practices. It follows that not only do cultural practices such as art constitute sites of ideological struggle, but also art today constitutes its own mode of production, the "culture industry." As Hal Foster emphasizes, "culture is not merely superstructural...it is now an industry of its own, one that is crucial to our consumerist economy as a whole" (Foster 24). It is at this juncture that I situate this book's intervention. But my concern will be not only to explore ways in which cultural productions create and embody social and economic practices, but also, through investigations of controversial art images, to show

how culture may precipitate viewer anxieties and pleasures. In so doing, I bring together the basic premises of cultural studies with Lacanian psychoanalysis in order to bridge the traditional divide between the cultural and the psychic. Specifically, this book aims to construct a psychoanalytically based feminist theory of spectatorship, which brings together key insights from the postrstructuralist work of Roland Barthes and the psychoanalytic work of Lacan.

The first half of the book explicates foundational concepts, beginning with Lacan's notion of the Real and Barthes' concept of the '*punctum*' (chapter 1). For Lacan, the Real, elaborated most originally and extensively in *Seminar XI*, refers to "that which lies beyond the automaton [of the symbolic order]" (Lacan *Sem XI* 54). Like the elusive "it" that escapes the dreamer, the Real can never be symbolically represented or directly encountered, but only felt or sensed through its anxiety-provoking effects. The "real," Lacan explains, "has to be sought beyond the dream: . . . hidden from us behind the lack of representation" (60). It can only appear as a "missed encounter [which] present[s] itself in the . . . form of a trauma" (55).

Barthes' *punctum* similarly refers to a photographic "element," which for reasons that appear inaccessible to the viewer, unexpectedly "rises from the scene, shoots out of it like an arrow and pierces" the viewer (Barthes *CL* 26). It, too, takes the form of trauma, by evoking a "sense of ineffable loss [through] the missed encounter" (Lury 103). The *punctum*, Barthes describes, gestures toward a "subtle *beyond*—as if the image launched desire beyond what it permits us to see" (Barthes *CL* 59). I contend that reading these concepts together suggests a new understanding of Barthes' influential work on photography, *Camera Lucida*, which opposes most critical interpretations. *Camera Lucida*, I argue, has been largely misread as Barthes' recantation of the poststructuralist project in favor of realism, a misreading that has foreclosed alternate approaches to understanding the relationships among visual texts, viewers, and ideology. In particular I argue that, rather than espousing a realist view of the photograph, Barthes offers a compelling and poignant account of the photograph's uncanny power to evoke the Lacanian Real. In my account, Barthes' highly contested concept of the *punctum* finds a place within the Lacanian architectionic, as a scopic manifestation of what Lacan describes as the signifier of lack in the Other, the sexuated pole of Woman.

Then I explore further the question of the photograph's relationship to realism and the Real by looking at a set of "photographic accidents" in the work of Hungarian expatriot photographer André Kertész (chapter 2). Here I

provide an in-depth account of the way in which the *punctum* may operate in relation to the Lacanian Real. In exploring issues of photographic realism, I focus particularly on intersections between ways photographs function as apparently transparent representations of realities and as formal aesthetic productions. This chapter explicates what it means to identify, not with a photograph's points of meaning, but rather with its points of symbolic failure. In so doing, it sets the scene for understanding a key point of the book: a shift away from the focus of most feminist film theory upon what it means to look *at* Woman, to a focus upon what it means to look *as* Woman. The ambiguity in the title of chapter four, "How Should a Woman Look?" is intended to signal this same shift away from discussions of how a woman is looked at (how she is seen) to how a woman looks (how she sees as woman). In particular, in viewing Kertész's photograph, "New York City," I am interested in thinking about what it means to identify with the image's point of symbolic failure (in the case of this image, the vase) rather than with how the image of Woman (in this case, the glass bust) might appear. In this sense, my project elucidates Jacqueline Rose's suggestion that film theory must seek to elaborate "not just what we see, but how we see" (Rose 231).

From these insights follows the crux of the book's theoretical contribution to theories of spectatorship and a politics of the image (chapters 3 and 4). I propose a psychoanalytically inflected approach to theorizing feminist spectatorship that differs from traditional media studies work in this area. Traditionally, film and art theorists (such as Laura Mulvey, Mary Ann Doane, and Griselda Pollock) have predicated their approaches to feminist spectatorship on the rejection of pleasure and surprise. Consequently, much earlier work remained pessimistic about the possibilities for a subversive feminist spectatorship in the face of the multiple and complex mechanisms of oppression associated with mainstream films and images. In fact, so theoretically daunting was the task of strategizing a subversive feminist viewing practice that Mulvey and many of her colleagues and followers turned their attention away from questions of media consumption and instead situated their interventions in the field of media production, in particular the creation of avant-garde film. By producing self-reflexive films that foregrounded rather than erased their techniques of production, Mulvey and other avant-garde filmmakers tried to loosen films' ideological grip on spectators. In particular, they attempted to produce films that avoided both the objectification of women and a masochistic position for the female spectator. In line with these suggestions, filmmaker and theorist Peter Gidal proposed that films "should exclude all images of woman on the grounds that they could only partake of the dominant system of meanings" (Lapsley and Westlake 100). The ludicrousness of

this proposal, Lapsley and Westlake comment, "makes all the more evident the impasse film theory had reached" (100). Rather than follow these earlier approaches, I elaborate a subversive strategy that makes space for the pleasures of viewing mainstream films and images. In particular, I develop a politics/theory of the feminist spectator that depends precisely on moments of surprise and the potential for pleasure.

In elucidating the ideological function performed by cinema, early feminist film theory scholarship tended to concentrate on the role of genre, particularly, melodrama, film noir,[1] and horror films.[2] Elizabeth Cowie's influential analysis of the 1978 film *Coma*[3] demonstrates the fertility of genre theory in accounting for the complexities of filmic interpretation. The leading character in *Coma*, Susan Wheeler, has been celebrated as a feminist heroine—an ideal response to the frequent demand for "positive" images of women in film, "both to challenge existing, negative definitions and as progressive figures for identification" (Cowie 12). Wheeler is an intelligent and independent woman—depicted as a dedicated surgeon and a caring friend—whose suspicions about the disappearance of patients at the hospital in which she works propel large portions of the narrative action. Cowie argues, however, that this traditional "progressive" reading of Wheeler is sustained only by ignoring the generic conventions that frame the viewers' filmic expectations and interpretations. By drawing upon the cinematic codes of both detective films and suspense films, Cowie undermines this feminist reading of Susan Wheeler. In commenting upon Cowie's analysis, Lapsley and Westlake point out, "...unlike the male heroes of classic Hollywood [detective films], Susan as detective is not always the bearer of knowledge. Susan's position is better understood within the conventions of the suspense film, where the protagonist is perceived as a victim, beset by dangers of which she remains unaware and of which the audience has knowledge" (Lapsley and Westlake 27). Cowie's attention to genre, thus, moves us away from an analysis of representation based upon the presence of textual elements (whether texts contain, for example, "positive" or "negative" images of women) and toward an understanding of how representation, as a discursive practice, does "not simply reproduce given definitions" but rather operates as a site for "a (re)constitution of definitions" (Cowie 39).

Other feminist scholarship at the time demonstrated how genres such as melodrama, which are usually derided for perpetuating degrading portrayals of women, could actually function subversively.[4] In particular, this scholarship focused upon how melodrama's "inability to contain the various contradictions it sought to manage resulted in incoherent and fissured texts, thereby exposing rather than concealing the oppression of patriarchy"

(Lapsley and Westlake 28). Within the project to reveal the feminist potential of melodrama, two key approaches became dominant. The first, espoused by Teresa deLauretis[5] involves reading a text "against the grain," in order to discover its internal inconsistencies, excesses, and fissures, in particular, looking for places where patriarchal discourse breaks down. This approach has yielded significant contributions to scholarship in the area of female spectatorship, but as Judith Mayne points out, there are "the obvious limitations" to restricting the investigation of feminist spectatorship to "what falls through the cracks of patriarchal discourse" (Mayne 71).

The second approach involves "theorizing the complex range of desires inspired by the cinema" (71). It recognizes that viewers' cinematic identifications are often unstable. In particular, viewers' identifications may not line up with their gender or sexuality. Linda Williams' work on the 1937 melodrama *Stella Dallas* demonstrates this approach. Williams contends that "in the 'woman's film'—addressed to a female audience and taken up with traditionally female concerns—a multiplicity of subject-positions are produced... [leading] the female spectator...to identify with contradiction itself" (72). This in turn, it is contended, interrupts "the single narrative perspective of the classic Hollywood cinema" (72).

By removing the stigma of "collusion and complicity...[with] the interests of patriarchy" that the term "identification" came to imply, Jackie Stacey's groundbreaking work on female spectatorship[6] provides a point of departure from these two approaches (Storey 72). Through an analysis of two melodramas (*All About Eve* [1950] and *Desperately Seeking Susan* [1984]) that deal with "one woman's obsession with another woman," Stacey examines the unexplored significance of "a woman's look at another woman" both within the diegesis and between spectator and character (Stacey 249). The pleasures these films offer female spectators, Stacey argues, cannot be contained within the prevalent paradigm that reduces spectatorial pleasure to either a modality of desire or of identification.

This book expands upon these insights gleaned from genre analysis in considering how viewers position themselves in relation to what they see. In particular, it seeks to account for Parveen Adams' charge that "it is not the image of woman as such that is crucial, but how the image organizes the way in which the [it] is looked at" (Adams *EI* 2). In addition, it aims to revisit earlier work on genre analysis in the light of a Lacanian distinction between the "look" and the "gaze," a distinction that, with the notable exception of Cowie's contributions, this work tends to confuse.

In *Seminar XI* Lacan illustrates the difference between the look and the gaze through an interpretation of a passage from Jean-Paul Sartre's *Being and*

Nothingness. Sartre describes a voyeur looking through a keyhole who is star-
tled by the sound of footsteps in the corridor. For Lacan, "the look" refers to
the voyeur's act of staring through the keyhole, while "the gaze" refers to that
which "surprises him in the function of voyeur, disturbs him, overwhelms him
and reduces him to a feeling of shame" (Lacan *Sem XI* 84). The gaze, for
Lacan, occurs when we "sense ourselves as beings who are looked at" (75).
The gaze, thus, is not "a seen gaze, but a gaze imagined by me in the field of
the Other" (84).

In most feminist film theory scholarship, the phrase *the male gaze* is used
to refer to the position of mastery from which the spectator is encouraged to
view classic Hollywood films. From the position of "the male gaze," viewers
identify with the male protagonist and see the on-screen women as an erotic
object that possesses what Mulvey calls a "to-be-looked-at-ness." But for
Lacan, the gaze has nothing to do with mastery. Indeed, as Cowie empha-
sizes, "the gaze is the inverse of the omnipotent look.... [It is what] surprises
the subject in its desiring" (Cowie 288). Thus, in Lacanian parlance, what is
usually called the "male gaze" more precisely describes his notion of "the
look." The gaze, for Lacan, resides not on the side of the subject but rather
emanates from the object.

Joan Copjec argues that film theory has confused Lacan's notion of an
'indeterminate gaze' with Michel Foucault's concept of a 'panoptic gaze.'
Rather than understand the gaze in Foucauldian terms, as a mechanism of
surveillance, under whose watch the subject is totally visible, the Lacanian
gaze "does not see you" (Copjec 36). Copjec traces this misunderstanding to
film theory's reliance on Lacan's formulation of the "mirror-stage" in *Ecrits*
(1966) as the paradigm for understanding how a subject comes to "misrecog-
nize" her/himself within the cinematic screen. In *Seminar XI* (1973), how-
ever, Lacan revises this earlier account of the mirror phase and provides his
most detailed account of the gaze as a site for a process of misrecognition
(*méconnaissance*) which, as Silverman puts it, "may induce a very different
affective response than the jubilation attributed to the child in 'The Mirror
Stage'—in other words, it does not invariably involve an identification with
ideality" (Silverman *TVW* 19). In particular, rather than a simple specular
identification with what one sees, Lacanian misrecognition occurs at the
point *beyond* what is visible to the subject. Copjec takes Lacan's rejection of
ideality even further, arguing the radical point that

> For beyond everything that is displayed to the subject, the question is
> asked, "What is being concealed from me?"...This point at which
> something appears to be *invisible*, this point at which something
> appears to be missing from representation...is the point of the

Lacanian gaze.... [I]t is an *unoccupiable* point, not, as film theory claims, because it figures an unrealizable ideal but because it indicates an impossible real. (35)

Misrecognition, in this formulation, occurs as a result of the subject's inability to identify with the place—this *beyond* representation—from which it senses it is being watched. The subject is thus constituted less by what it sees than it is by what it cannot see.

The second half of the book brings these theoretical developments to bear on an analysis of a series of controversial art images. The challenge we encounter in such images resembles the difficulty posed by mainstream film: how can one construct a subversive viewing strategy for deeply hegemonic cultural productions? Hal Foster points to this difficulty when he argues that the pluralism of contemporary art enables it to cooperate too conveniently with the hegemony of multinational capitalism. In particular, Foster argues that through its pluralism,

> art becomes one more curiosity, souvenir, commodity among others. Pluralism is precisely this state of others among others, and it leads not to a sharpened awareness of difference (social, sexual, artistic, etc.) but to a stagnant condition of indiscrimination—not to resistance but to retrenchment.... [Pluralism carries] an indifference...of its own, one that absorbs radical art no less than it entertains regressive art. (31–32)

We are faced with the pessimistic conclusion that art that tries to subvert cannot help but participate in the conventional. Transgressive art, it seems, becomes merely one more site for turning a profit. In that respect, indeed, the situation facing contemporary art may prove to be even more desperate than the corresponding problem of mainstream film. Avant-garde cinema at least shows a glimmer of subversive potential. But, Foster laments, in contemporary art, by contrast, "we have nearly come to the point where transgression is a given.... [S]hock, scandal, estrangement: these are no longer tactics against conventional thought—they *are* conventional thought" (25–26).

In reply to Foster, I shall suggest a strategy for spectatorship based upon what Roland Barthes calls the *"punctum"* which, I argue, corresponds to what Lacan calls the "signifier of lack in the Other," that he associates with the feminine pole of sexuation. This strategy, I argue, is particularly well suited as a feminist strategy of subversion, because, by confronting the viewer with an encounter that cuts across cultural convention, it avoids the

possibility of cooptation to which Foster alerts us. I critically explore the results of viewing for the *punctum* in a series of key images taken from contemporary art.

The images selected include: (1) Jamie Wagg's computer-generated ink-jet painting *History Painting: Shopping Mall*, which derives from the mass-mediated surveillance footage of a small boy's abduction from an English shopping center by two other children (chapter 5); (2) Marcus Harvey's *Myra*, a painting of Britain's infamous serial killer of children, Myra Hindley, which appeared in the *Sensation* exhibit. (Harvey's image adds a twist to Hindley's widely circulated mug shot; when viewed close up, it becomes apparent that her face is comprised of numerous infant handprints, in the style of a Chuck Close portrait, thus producing an effect of *trompe l'oeil*) (chapter 6); (3) The controversies surrounding American photographer, Sally Mann's images of children, which engage the complex figure of the modern child as it is situated at the intersection of cultural representation and lived experience (chapter 7). My analyses of these images, I suggest, offer a vital shift in focus from most scholarship in this area: whereas previous studies have tended to ask how spectatorship may be influenced by sexual difference, this book asks how particular spectatorial encounters may precipitate sexuated responses.

The conclusion of the book reconsiders my claims in the light of recent attacks on psychoanalytic film theory posed by "posttheory" advocates David Bordwell and Noel Carroll. In particular, I show how my strategy for a subversive spectatorship not only suggests a new politics of the image but also offers a novel theoretical approach for film scholarship that corrects some of the mistakes of earlier psychoanalytically informed approaches.

Chapter One

Overlooking the Real in *Camera Lucida*

Critics of *Camera Lucida* persistently overlook the role of the Lacanian Real in Barthes' account, claiming that toward the end of his life, Barthes betrayed the poststructuralist project by embracing an unreconstructed realism.[7] John Tagg, for example, asserts that Barthes' work terminates with a "demand for [photographic] realism" (Tagg 1). Similarly, Peter Geimer regards *Camera Lucida* as "an almost canonical text" for espousing the view of "photographic transparency" (Geimer 122). In Geimer's characterization, "Barthes treats photographs as almost magic self-recordings of nature, representations without any technical interference, pure reference, all message, no medium" (122). By contextualizing Barthes' work with contemporaneous texts by Lacan, I argue, contra Tagg and Geimer, that *Camera Lucida* engages, not with photographic realism, but rather with the Lacanian Real. At the risk of imprudence, I venture an even stronger claim: that *Camera Lucida* constitutes Barthes' most properly "poststructuralist" text and that his engagement with the Real exceeds even that of Lacan's.

At first sight, Barthes does indeed seem to espouse a realist position in *Camera Lucida*. For example, Barthes' move away from the overtly poststructuralist discourse of the "duplicity of the signifier" toward a preoccupation with what he calls the "stubbornness of the referent" appears to signal a "realist" concern with the possibility of a direct, unmediated relationship with things in the world. This reading seems especially apt in the case of passages such as the following: "I perceive the referent (here, the photograph really transcends itself; is this not the sole proof of its art? To annihilate itself as a medium, to be no longer a sign but the thing itself?)" (Barthes CL 45). Here Barthes appears to be invoking the realist notion of the transparency of the signifier. Upon deeper scrutiny, however, this appearance dissolves. Rather

11

than regressing toward realism, I suggest, Barthes ends his career by engaging with what Lacan calls the "Real," points of limitation of the symbolic order.

I will argue for this reading by examining two other places within *Camera Lucida*, which lend the impression that Barthes returns to realism, but on closer inspection turn out to signal a move toward the Real. At first sight, the nostalgic tenor of the book, in which Barthes mourns the death of his mother and laments the photograph's inability to provide a "just image," appears to express nostalgia for a lost reality.[8] John Tagg, for example, suggests that: "the trauma of Barthes' mother's death throws Barthes back on a sense of loss which produces in him a longing for a pre-linguistic certainty and unity—a nostalgic and regressive phantasy, transcending loss, on which he founds his idea of photographic realism" (Tagg 4).[9] But, if one follows Slavoj Žižek's view of nostalgia, Barthes' fascination here is not for some real "lost object" but rather for the "gaze." The gaze, according to Lacan, is the unsettling, but enthralling, object around which the scopic drive revolves, alternately positioning the subject as viewer and viewed, creating both "unrealistic anxiety" and a sense of self-scrutiny. Nostalgia, Žižek argues, involves fascination with the "gaze of the naive 'other' absorbed, enchanted by [an object]" (Žižek LA 114).[10]

An instance of nostalgia in exactly this sense is referred to in the opening sentence of *Camera Lucida*, where Barthes describes the initial "amazement" that provided the impetus for his contemplation of the photograph. As he explains, "one day, quite some time ago, I happened on a photograph of Napoleon's youngest brother Jerome, taken in 1852. And I realized then, with an amazement I have not been able to lessen since: 'I am looking at the eyes that looked at the Emperor'" (Barthes CL 3). Barthes' fascination is not with the lost object itself (Napoleon), nor a response to being looked at by the eyes of another, but rather with identifying with the gaze of another for whom the object was present. Similarly, in the Winter Garden photograph, the unpublished photograph in which he "finds" his mother, she is present as a child, as a figure he never knew. What he has "found," therefore, is not simply the lost object but instead an identification with the point from which one could look at this child and see her "gentleness," her "kindness" [which] having "proceeded from the imperfect parents who loved her so badly...was specifically out-of-play" (69).

The longing in question is not for the presumed gaze of her actual parents, however, since, as Barthes contends, they "loved her so badly," but rather, as he makes clear, for the continuation of his own relationship to her. Barthes explains, "During her illness, I nursed her...; she had become my little girl, uniting for me with that essential child she was in her first photo-

graph" (72). This, I argue, suggests that the nostalgia evoked by Barthes has little to do with a real "lost object" but instead centers on a notion of the gaze as a "stain of the Real" that violates the image's symbolic consistency. For Barthes, the photograph of his mother as a small child posing for the photograph can never evoke a "reality" for him, but it nevertheless materializes what Freud calls "psychical reality," moments which, whether or not they correspond to actual experience, yield unconscious effects. The gaze functions, then, as a remnant of this psychical reality, an embodiment of the partial object around which the scopic drive revolves. Thus, rather than experience an imaginary unity with the (M)Other, through the Winter Garden photograph Barthes encounters the gaze. In particular, the photograph allows him to identify with the place (that of an affectionate viewer who recognizes the child's gentleness) at which the object itself appears to the gaze. It follows that, despite its rhetoric, Barthes' account of the photograph aims not to rescue realism, but rather to show how the photograph may engage with a "body of experience [which] is excluded from reality," or what Lacan calls "the Real" (Quinet 145).

Thus, rather than a realism that accomplishes a "unity" between what is present and what is absent, that in Tagg's terms, aims to "transcend loss," the photograph, for Barthes, performs a loss of its own (Tagg 4).[11] That is, moving beyond the mimetic, the photograph incites the consciousness of loss by triggering an awareness *not* of the "*being-there* of the thing... but an awareness of its *having-been-there*"[12]—in other words, an experience of the Lacanian Real (Barthes "RI" 44).

Camera Lucida also invokes what we may take as the Lacanian Real in its formulation of the *punctum*. The photograph's *punctum*, Barthes explains, is the seemingly ordinary detail, which, due to structural contingency, violates the culturally expected reading—the *studium*. This concept of the *punctum* seems to presuppose a traditional approach to images, in which the I/eye that sees gives the image its meaning in terms of culturally encoded expectations. Such a Cartesian conceptualization of the relationship of viewing subject to image also undergirds realist accounts of language and the world. *Camera Lucida* thus seems to involve a turning back toward realist ways of thinking. But against this view, I point out that according to Barthes, the *punctum* is *not* a point of some deeply hidden meaning but instead is a point of nonmeaning, "never coded," and thus operates at the level of the Real.

Consideration of the historical context of Barthes' work provides yet further support for the idea that, rather than a realist engagement with reality, throughout *Camera Lucida* Barthes seeks to engage with what amounts to the Lacanian Real. Not only has Barthes consistently opposed realist accounts of

representation, but also his later writings move increasingly toward more radical ways of conceptualizing the limits of representation.[13] For example, Barthes' 1972 essay, "Change the Object Itself," written contemporaneously with Lacan's delivery of *Seminar XX, Encore: On Feminine Sexuality: The Limits of Love and Knowledge*[14] (in which Lacan focuses prominently on the notion of the "object") strikes a Lacanian theme in calling for a theoretical practice that "fissure[s] the very representation of meaning...[and] challenge[es] the symbolic itself" (Barthes "COI" 167). In this essay Barthes also reworks the notion of the "object," providing it with a Lacanian cadence. For Barthes, as for Lacan, the object is to be understood neither in the realist sense as an actual thing in the world that language transparently represents nor in the Saussurian sense in which the object is the site of signification. Instead, according to Lacan, the object takes the form of the "Freudian Thing" (*das Ding*)—the "nonsignified and unsignifiable object" (Fink 95). And Barthes explicitly invokes this Lacanian principle in explaining that what he is searching for in the photograph is what "Lacan calls the Tuché, the Occasion, the Encounter, the Real, in its indefatigable expression" (Barthes 4). The *punctum*, as Hal Foster puts it, is the "visual equivalent...of our missed encounter with the real" (Foster 134).

With this in mind, I return to the following passage: "I perceive the referent (here, the photograph really transcends itself; is this not the sole proof of its art? To annihilate itself as a medium, to be no longer a sign but the thing itself?)" (Barthes *CL* 45). Barthes makes clear that this description of a denotation that resists mediation applies not to ordinary realist reproductions but rather to the rare photographs that he distinguishes as traumatic. For example, in "The Photographic Message" Barthes contends:

> If such a denotation exists, it is perhaps not at the level of what ordinary language calls the insignificant, the neutral, the objective, but, on the contrary, at the level of absolutely traumatic images. The trauma is a suspension of language, a blocking of meaning....[T]he traumatic photograph...is the photograph about which there is nothing to say....One could imagine a kind of law: the more direct the trauma, the more difficult is connotation. ("PM" 30–31)

For Barthes, this distinction between a coded or connotative realism and an "intractable" or denotative realism lies at the heart of what he refers to as the "two ways of the Photograph" (Barthes *CL* 119). In the final page of *Camera Lucida*, Barthes distinguishes these "two ways" as "mad or tame." Photography, he declares, "can be one or the other: tame if its realism remains relative, tempered by aesthetic...habits...; mad if this realism is

absolute and...original" (119). Thus, for Barthes, the "intractable" realism of the photograph, leads not to the comforting "confirmation of an existence," as Tagg claims on his behalf, but rather to the madness of "photographic ecstacy" that derives from confronting in the photograph "the wakening of intractable reality" (119).

In this light, we may understand Barthes' allusion to the "stubbornness of the referent," not as an allusion to conventional realism, but rather as coming close to describing a violent encounter with the Real. In Lacanian terms, such a relationship with "the thing itself" (as the alluring, but terrifying *das Ding*) moves beyond the claims of realism and lands us instead in the abyss of the Real. Here, then, the physical imprint of the photographic referent, as a materialization of the thing that is lacking, takes on the qualities of the Lacanian object.[15] The stubborn "trace" of the photographic referent, present as a stain on a—to use Tagg's description—"paltry piece of chemically discoloured paper," asseverates beyond its materiality. It persists, refuses to go away, overpowering the medium's ability to contain it within its symbolic net.[16]

Celia Lury perceptively describes Barthes' formulation of the relationship between photograph and referent as a "sticky realism": "as with glue, 'the referent adheres'" (Lury 91). In other words, the referent, for Barthes, "sticks" like the Real, "which always comes back to the same place"; "'it carries it glued to its heel'" (Lacan *Sem XI* 49; Evans 159). Further echoes of the Lacanian Real in Barthes' account of the photographic referent are clear in Alan Sheridan's writing. Sheridan, translator of several Lacanian works, explicates the Lacanian Real as "the ineliminable residue of all articulation, the foreclosed element, which may be approached, but never grasped: the umbilical cord of the symbolic" (Sheridan *Sem XI* 280). And Barthes too speaks of a "tenuous umbilical cord" as the "luminous shadow which accompanies the body" through which the "photographer gives life." The failure of the photographer to "supply" this "shadow" prevents the referent from persisting; without this "shadow," "the subject dies forever" (Barthes *CL* 110).

In what follows, I suggest that this articulation between Barthes' concept of the *punctum* and the Lacanian Real provides a theoretical basis for a subversive feminist spectatorship, which avoids some of the difficulties encountered by traditional feminist film theory. It is to an account of the workings of the *punctum* in André Kertész's photographs that we now turn.

Chapter Two

The Accident That Will Have Happened
Barthes, Kertész, and the *Punctum*

THE PHOTOGRAPHIC ACCIDENT:
BETWEEN EPISTEMOLOGY AND AESTHETICS

Precariously poised at the unstable nexus of epistemology and aesthetics, the photographic image provokes enduring critical debate. For some critics, such as Rudolf Arnheim, Anne Beattie, Janet Malcolm, and Andy Grundberg, the photograph's "accidental" features constitute its distinctive link to reality. For Arnheim, for example, the photograph "embraces accident, since not everything in the lens' view can be controlled....Its imperfection is a sign of the victory of reality over the artist's efforts" (Steiner 40). In this view the accidental elements testify to the photograph's indexical relationship to reality, nudging it toward the side of epistemology with its claims to nature, objectivity, documentation, and transparency.

Other critics have explored ways in which the presence of an unintended or accidental detail prods the photograph in the opposite direction, away from epistemology and in the direction of the aesthetic—the domain of culture, subjective experience, fiction, and representational codes. For example, historians of science Lorraine Daston and Peter Galison recall that in early scientific uses of photography, the inclusion of uncontrollable or accidental details marked a limitation to photography's claim to accuracy. Intrusions of quirky and unexpected imperfections into the photographic image, although objectively "true," inaccurately represented the characteristics of the subject matter. Daston and Galison explain, "The sacrifice of resemblance was more than justified by the immediacy of the machine-made images of nature that eliminated the meddlesome intervention of humans"

(Daston and Galison 117). Furthermore, rather than evacuate the influence of the photographer, these inclusions were taken as testaments to the photographer's character; they functioned culturally as signifiers of his "disciplined self-denial of the temptation to perfect" (115). In this case, the artists' aspirations to ethical and even aesthetic distinction overwhelm the randomness of nature.

Paradoxically, this refusal in the name of truth to "correct" accidental features arising from limitations of the mechanical apparatus to produce appropriate contours, colors, and textures further impelled the photograph toward the aesthetic and the cultural. The very fact that early photographs, riddled with profound imperfections, could function as the prime symbol of truth underscores the photograph's status as a heavily negotiated cultural form. Photographs do not simply bear a greater resemblance to their subject matter than other forms of representation. Rather, as John Tagg contends, the "photograph's status as evidence and record (like its status as Art) had to be produced and negotiated to be established" (Tagg 6). Knowledge of photographic representational codes is necessary in order for photographs to achieve their ideological function as transparent "messages without a code" precisely *because of* their limitations and not in spite of them. Photographs, as Daston and Galison tell us, "carry the stamp of the real only to eyes that have been taught the conventions...of that brand of realism" (Daston and Galison 93).

Roland Barthes' posthumously published meditation on the photograph, *Camera Lucida*, enters this debate at a critical juncture. Barthes contemplates a type of photographic accident, the *punctum*, which complicates the traditional accounts of the photograph's engagement with both epistemology (nature) and aesthetics (culture). For Barthes, the *punctum* is a concrete, seemingly ordinary detail within the photograph, which due to contingent metonymic associations takes on unexplained resonances. The presence of this accidental detail gestures toward an aleatory meaning that overreaches the image. As Barthes recounts, "the photograph's *punctum* is that accident which pricks me (but also bruises me, is poignant to me)" (Barthes CL 27).

The *punctum*, although unintentional, unplanned, unpredictable, and uncoded, does not exist exclusively on the side of nature, however. Rather the *punctum* "*de*-naturalizes," the image, making what seemed ordinary appear suddenly strange or uncanny, *unheimlich* in the Freudian sense. But the *punctum* does not link the photograph to culture in any straightforward way. Rather the *punctum* disrupts, indeed *violates* the culturally coded and expected reading, the *studium*. Thus, I shall argue, as conceived by Barthes, the *punctum* points "beyond" *both* nature and culture, to their inevitable

impossibilty, to what Jacques Lacan calls the domain of the "Real"—anxiety provoking anomalies in the order of symbolic representations.

Rather than associate such symbolic ruptures with trauma, however, Barthes' formulation of the *punctum* foregrounds Lacan's point that often seemingly trivial or insignificant objects or events trigger these flashes of the Real. As I describe in the introduction, we are often most disturbed not so much by events or objects themselves but rather by a palpable sense of their hauntingly indistinct threat. Paul Verhaeghe, we have seen, captures this characteristic of the Real as what is "just waiting around the corner, unseen, unnamed, but very present… (just think of the nightmare: we are awakened a split second before we would see or experience 'it')" (Verhaeghe 12). I suggest that the accident of the *punctum* produces precisely such an effect.

KERTÉSZ: THE ACCIDENTAL PURIST?

Throughout *Camera Lucida* Barthes distinguishes André Kertész's photographs as exemplary of the phenomenon of the *punctum*. In this chapter I focus on three of Kertész's photographs: the first two intervene in debates regarding Barthes' forms of realism; the last, I will argue, engages Lacan's category of the Real.[17] Kertész's images embody the tension between the random event (the natural) and the carefully composed scene (the cultural), a theme explored with particular piquancy in his narration of "Landing Pigeon" (New York, 1960), which depicts, with exceptional formal acuity, the descent of a single pigeon onto a decaying tenement (fig.1). The line of the pigeon seems to complete the composition of the photograph as if choreographed, yet it appears only as a contingency. On the one hand, this coincidence, which occurs within the world pictured by the photograph, contributes to the impression of realism described by Arnheim—an occurrence in the "lens' view" that is beyond the artist's control. On the other hand, the aesthetic precision of this image complies with the conventions of modernism, contaminating nature with stains of culture.

Kertész, himself struggled with this tension throughout his career.* On the one hand, he is aware of his position as an "auteur" within an emerging modernism that privileges autonomy and interpretation. On the other hand, he is reluctant to abandon photography's epistemological claims to truth. Kertész attempts to resolve this tension by steadfastly insisting that he "cap-

*In this chapter, I largely draw upon narratives that Kertész circulated about his own life and work. In private conversation, Robert Gurbo, curator of the Kertész Estate, however, cautions that these stories often functioned strategically for Kertész, covering up or conflating events to suit his purposes at difficult periods in his life.

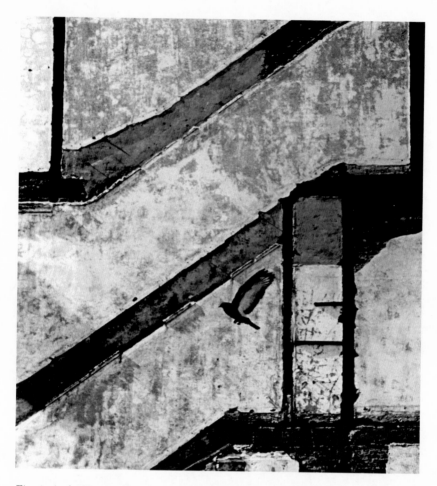

Fig. 1. André Kertész, "Landing Pigeon," 1960. Estate of André Kertész.
Courtesy of Silverstein Photography.

tures" rather than "arranges" his scenes and then struggling to explain the paradoxical juxtaposition of the chance moment with the thoughtfully planned scene. As he explains in regard to "Landing Pigeon": "The original idea for this photograph dates back to my days in Paris [1925–1936]. . . . Here in New York I sat and waited. Time and time again I went back. . . . Then one day I saw the lonely pigeon. I had waited maybe thirty years for that instant" (Kertész 100).

How can we understand Kertész's struggle here? Drawing upon Barthes' distinction between "aesthetic" realism and "referential" realism developed in "The Reality Effect," I suggest that for Kertész "aesthetic constraints are steeped—at least as an alibi—in referential constraints" (Barthes "RE" 145).

In other words, Kertész struggles to bring together the two forms of realism: on the one hand, "aesthetic realism," in which seemingly "insignificant" details become meaningful not through their conformity to a preexisting, spontaneous reality, but instead through their compliance with the "cultural rules of representation" (as in pseudodocumentaries such as the *Blair Witch Project*); and on the other hand, "referential realism," in which details matter simply because they attest to "'what really happened'" (a mode of representation that Barthes associates most closely with the medium of photography).

For Barthes, the effort to hold *together* these two modes of realism carries considerable advantage. On the one hand, by demanding conformity to cultural convention, the constraint of the "aesthetic function" works to limit the potentially endless "vertigo of notation" (145). On the other hand, "pretending to follow...in a submissive fashion" the referential logic of realism protects a representation against attacks of mere "fantasmatic activity" (145). In short, when held in tension with the appeal to the aesthetic function, the constraint of the referential function leads not to a justification for displaying an inexhaustible array of details, but rather, to the necessity of finding "a new reason to describe" (145).

Kertész may be seen as contributing to and anticipating the Barthesian quest to hold together these two forms of realism by destabilizing an implicit opposition that underlies the discourses of both aesthetic and referential realism—the assumption of the "objective" as "accurate" and of the "subjective" as "deceptive." According to Kertész, an accurate depiction of reality often involves artistic manipulation. Unlike the nineteenth-century scientific illustrators who would, in Daston and Gallison's words, "sacrifice resemblance" for the sake of objectivity, Kertész seeks to impose his artistic sensibility on the world to reveal a deeper "truth." His "reason to describe" emerges, not from an eagerness to subvert realism, but from an aspiration to convey reality more accurately.

Kertész most directly expresses this view when describing his encounter with the unionized production team of the American Ballet, for whom he had been hired to do a photographic shoot. In recalling his outrage at being prevented from hanging his own "primitive" lights, Kertész invokes a conception of both photograph and photographer that recalls the view of eighteenth-century scientific atlas makers (as well as some of their skeptical nineteenth-century counterparts) that, without the intervention of a master to prevent their deception, even the most technically perfect photographs (and before that, the images of the camera obscura) risk unreliability (Daston and Galison). Along these lines, Kertész complains that the American studio system compromises the photograph's integrity by interfering with the photographer's special skill at *creating* "honest" images. Kertész, then, twists the usual formula of equating mechanical objectivity with truth, and human intervention with deception, by adding that "of course a picture can lie, but

only if you…don't have enough control over your subject. Then it is the camera working, not you" (Kertész 80).

In the second image, "Broken Plate" (Paris 1929) Kertész presents us with a different type of photographic accident (fig. 2). Rather than a coincidence within the world that is photographed (as in "Landing Pigeon"), we see an accident that occurs within the photographic apparatus itself. In "Broken Plate," a panorama of Montmartre is shattered by the intrusion of a splintering hole just left of its center, caused by a cracked lens plate. When Kertész left Paris for America in 1936, due in part to France's changing political climate in which his work was frequently coopted in the service of France's increasing nationalism, he left behind most of his negatives. Upon his return to Paris many years later, he discovered that 60% of his glass plates were broken. Kertész disposed of the damaged negatives, with the exception of this one, which he printed, explaining that "an accident helped me to produce a beautiful effect" (72).

What role does this "accident" play in the photograph's relation to realism? On the one hand, the photograph's transparency is destroyed by an overt display of a sign of its process of production. By interrupting the autonomy of the represented scene, the conspicuousness of the photographic

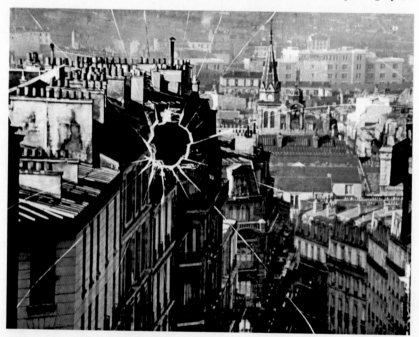

Fig. 2. André Kertész, "Broken Plate," 1929. Estate of André Kertész. Courtesy of Silverstein Photography.

mechanism undermines the image's claims to a transparent or "referential realism." On the other hand, within a modernist aesthetic, inclusions of intentional reminders of the process of photographic production will encode an image as documentary or "realist": cracked lenses, unfocused images, and irregular camera angles all lend images an impression of an "aesthetic realism." At yet another level, however, the detail of the crack attests to a referential realism; it is a sign of something that "really" happened. As such, it is at once both a stylistic indicator of the realist aesthetic and a testament of "what has been"—the "reality" of the broken lens, which carries a material reminder of the real political conditions which the image endured.

Through his narration of "New York City" (1979), Kertész presents us with yet a third distinct type of photographic accident, which I associate with the coincidence of Barthes' *punctum* (fig. 3). This type of accident, I shall argue, moves us away from questions of reality, into the realm of the Lacanian Real. At the center of this image we see, resting upon a vase, a glass bust through which a distorted view of New York City emerges. The coincidence that is at work here occurs neither in the world photographed nor in the mechanisms of the photograph's production, but rather in Kertész's attraction to the bust, which he explains moved him "because it resembled my wife—the shoulder and the neck were Elizabeth," who had recently died. After months of being haunted by the bust, Kertész purchases it and photographs it on the windowsill of the New York apartment that he and Elizabeth shared for twenty-four years, resulting in an image that one art historian distinguishes as "among the most delicately wrought images of mourning in art" (Phillips 196). The enormous, but nebulous, significance that this image carries for Kertész (who as a *viewer* of the image expressed surprise at how deeply it moved him) can be explored through a deeply pregnant chain of associations that link Kertész to this image. Before discussing these, however, I need to differentiate my own approach from more conventional psychoanalytic approaches to analyzing texts.

My analysis opposes what Howard Risatti refers to as "psychosociological" or "pyschobiographical" approaches to art, which use an artist's biography and history to arrive at insights regarding the meaning of a work of art. Such approaches employ psychoanalysis as a hermeneutic tool to uncover hidden meanings with an aim to "discover the [agency of the] Author...beneath the work" (Barthes "DA" 50). Barthes, in "The Death of the Author" explicitly warns against such approaches, which he says, "grant the greatest importance to the author's person," by privileging the author as the text's final signified. But, by involving consultation with historical and biographical material, analyses that attempt to trace the *punctum* flirt dangerously with such approaches. How, then, can a Barthesian approach protect itself against accusations of

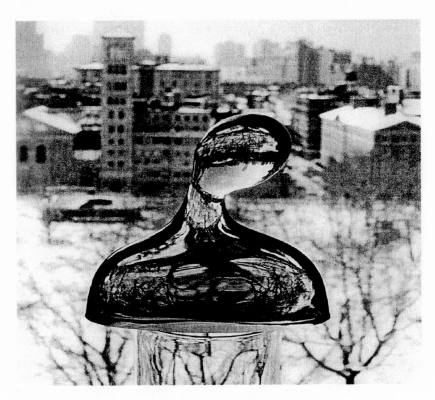

Fig. 3. André Kertész, "New York City," 1979. Estate of André Kertész. Courtesy of Silverstein Photography.

resuscitating the importance of the author? By emphasizing that the *punctum* is an irruption of "nonmeaning"—a seemingly insignificant accident— Barthes insulates the *punctum* from any question of the author's conscious intentions and meanings. As Barthes himself puts it, by highlighting the "'accidental nature of his activity,'" an emphasis upon the *punctum* "cast[s] the Author into doubt and derision" (50). By appearing to viewers as insignificant or superfluous details, the *punctum* also confronts us with the central question that occupies Barthes in "The Reality Effect" and to which I now return, namely, "[W]hat is ultimately, so to speak, the significance of insignificance[s]?" (Barthes "RE" 143).

"New York City" presents the viewer with an opportunity to explore exactly such a "significant insignificance." The exploration that I have in mind requires that we shift our attention away from the clearly significant *bust* and toward the seemingly insignificant *vase* upon which the glass bust rests. The vase seems, in Lacan's words, to be "out of place in the picture." It

serves only the banal function of raising the bust to a more prominent height. The formal "insignificance" of the vase becomes conspicuous, however, when considered in relation to the aesthetic precision that generally characterizes Kertész's work. Such "superfluous" details are often presumed to most straightforwardly denote a concrete reality. But, like the *punctum*, they may also take on an uncanny quality, in which case, rather than representing reality, they evoke what amounts to the Lacanian Real.[18] Or to put it in Barthes's terms: "[T]hese details...say nothing but this: *we are the real*; it is the category of 'the real' (and not its contingent contents) which is then signified" (148).

The vase's significance as an evocation of the Real emerges not simply through the personal "meanings" that, as we will see, it carries for Kertész, but also through its formal place within the image. If Kertész had produced an image in which the vase conformed to aesthetic conventions, although it might still carry vast personal importance for him, it would merely be an instance of what Barthes calls the "*studium*" (a purely conventional representational element). Instead, however, the vase, through its surprising, "accidental" quality, constitutes an instance of the *punctum*. But whereas in "Landing Pigeon," the "accident" remains only at the level of the *studium* (since the coincidence lies precisely in the *belongingness* of the contingent pigeon to the modernist aesthetic), in "New York City," by contrast, the vase evokes the *punctum* through its disruption of the formal composition; the *punctum* "sticks out" precisely because it does *not belong*. In short, the *punctum* exists not at the level of content, but rather at the level of form. The *punctum* thus functions similarly to the Freudian notion of a dream detail. As Slavoj Žižek describes, a dream detail, "*in itself* is usually quite insignificant...but...*with regard to its structural position* denatures the scene...renders the whole picture strange and uncanny" (Žižek LA 53). It follows that analysts of the *punctum* must follow Freud's technique of dream analysis and avoid being lured by the "fetishistic fascination of the 'content' supposedly hidden behind the form" (11). Thus the significance of dreams lies not in their ability to articulate a deep, hidden unconscious message that is too ghastly for the conscious mind to bear. On the contrary, Žižek contends, if we proceed to excavate the manifest content of dreams for their seamy latent meaning, we are "doomed to disappointment: all we find is some entirely 'normal'—albeit unpleasant—thought" (12). This thought appears in hidden form in a dream, not because it cannot be articulated consciously, but because it attaches to other unconscious, repressed fragments with which it associates on the level of the signifier. One can often speak fluently about a traumatic experience yet remain unaware of how the trauma has organized one's psychic economy. As Žižek

trenchantly makes the point, "the 'secret,' to be unveiled...is not the content hidden behind the form...but, on the contrary, *the 'secret' of this form itself*" (11).

Rather than imply that there is a "deeper meaning" *behind* the dream detail, I follow Freud in saying that it is precisely in the *meaninglessness* of these superficial details that the void at the heart of our subjectivity is articulated. Meaning does not *cause* or motivate these details, but rather meaning is the *result* of contingent psychic attachments to meaningless details.

Although such details may be the result of idiosyncratic associations, they are, nonetheless, general in their *effects*. This has been one of the lessons of art controversies such as those surrounding the work of Robert Mapplethorpe. Even though no one else may share Mapplethorpe's particular cluster of psychic and social associations, his images nonetheless strike diverse viewers similarly in provoking unrealistic anxieties. In "Man in Polyester Suit," (fig.4) for example, despite the large differences between the idiosyncratic associations that shape their various and varied reactions to the picture, a variety of viewers may be struck by the gap between the "High Art" form and "pornographic" content.

This tension between form and content deserves further comment. If, in "Man in Polyester Suit," we restrict attention to the penis as the element of disturbance, then all we find is a point of symbolic transgression—a purely conventional, explicable "shock"—characteristic of the *studium*.[19] If, by contrast, we focus on the bit of underwear fabric peaking out from the fly of the trousers, we are unlikely to be "shocked." Rather we are "surprised." We wonder what it is doing there, since it steps outside any set of symbolic codes.[20] And, I claim, a similar surprise greets the viewer who attends to the vase rather than the bust in Kertész's photograph "New York City."

Such intrusions of meaningless or insignificant fragments of the Real (now clearly in Lacan's sense of the term) shatter the possibility of *any* "complacent immersion in the socio-symbolic reality" (Žižek *FRT* 123.) Viewers are provoked to respond to these points of symbolic dissolution, through which a piece of the Real flashes before them. The point is not that all of us *will* respond uniformly, but that viewers *tend* to respond in surprisingly similar ways; the gap between form and content tends to produce similar *effects*, *despite* the absence of uniformity in the particular associations that give rise to these effects. (The different ways in which they respond to this symbolic rupture—for example, by trying to understand or cover over the gap or by exploring and inhabiting the gap—is the focus of the fourth chapter on spectatorship.) None of this, of course, is intended to invalidate questions of the

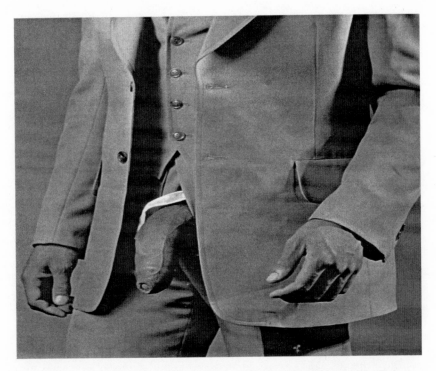

Fig. 4. Robert Mapplethorpe, "Man in Polyester Suit," 1979. Copyright The Robert
Mapplethorpe Foundation. Courtesy of Art + Commerce.

personal significance that the picture had for Kertész. On the contrary, it
provides a backdrop against which such questions can be asked.

In 1925 Kertész moved from Hungary to Paris, where he knew virtually
no one, had no job, and could barely speak French. Within a year he had
developed a group of friends who led to his introduction to the painter Piet
Mondrian in 1926 who agreed to let Kertész photograph him and his studio.
Kertész, initially struck most strongly by Mondrian's perfectly symmetrical
compositions, noticed upon studying the photographs he had taken what art
historian Sandra Phillips describes as "telling deviations from Mondrian's pre-
cise geometry" (Phillips 31). Of particular interest to Kertész was Mondrian's
"aspiration to order and the slight and human divergences from it" (31).
Particularly memorable, however, were Mondrian's moustache, which
Kertész observed had been trimmed to a slight angle in order to compensate
for an asymmetry within his physiognomy, as well as a vase housing an artifi-
cial flower which, juxtaposed with the "insistent angularities" of Mondrian's
studio, seemed "antithetical to the artist's painting" (31). The out-of-place

quality of this vase has subsequently captured the attention of many observers. Mondrian, as described by his close friend and fellow painter Michel Seuphor, "so strongly fe[lt] the lack of a woman in his daily life that he always kept a flower—an artificial flower suggesting a feminine presence—in the round vase standing on the hall table of his studio" (31).

Memories of this visit remained vivid to Kertész for the remainder of his life. Phillips credits the enormous impact of Kertész's encounter "with the most important figure in abstract painting in Paris" with setting Kertész "on a new course," leading him to what she describes as a "new formalism" evident by his increasing attention to "the detail" as "both an abstraction and a kind of document" (32).

In this light, one can reevaluate the role of the vase in "New York City." The vase, which appears, at first glance, to be nothing more than a mere pedestal for the display of the sublime object (the uncanny embodiment of the figure of Elizabeth) begins to resonate beyond its function. On the one hand, the vase *links* the grieving Kertész with the melancholic Mondrian (who misses the woman he never had), yet on the other hand, the vase's placement in the composition *undermines* the importance of Mondrian's meticulous attention to precision and the detail. Put in other terms, the vase, at the level of *content*, carries a metynomic association to the inspirational Mondrian and yet, at the level of *form*, marks a subversion of his artistic influence. In this gap between content and form, "the form articulates the 'repressed' truth of the content" (Žižek *PF* 188). One can speculate that the "repressed truth," articulated in the dissonance between the form and the content of the vase is connected with Kertész's history through the following chains of association. During his first migration from Budapest to Paris, Kertész began to experiment with avant-garde techniques, gaining particular recognition for his series of "Distortions." In these images, Kertész used a warped mirror through which he photographed nude Parisian women he had met from within his newly burgeoning circle of acquaintances, most of whom were artists and intellectuals.[21] These Distortions, constituting an anomaly in his published work, were made at the end of his only period of separation from his wife, Elizabeth, during their forty-four-year relationship. The Distortions reached their peak in 1933, the same year that witnessed both the death of his mother and (according to many biographers) his marriage to Elizabeth, as well as the publication of his first book, *Enfants*, which he dedicated to both his mother and Elizabeth.

Ambiguity surrounding his marriage to Elizabeth further enriches the complexities of this period for Kertész. His published work suggests a romantic narrative of Elizabeth and himself as passionate young lovers in Budapest,

separated for a brief but seemingly interminable period while he went to Paris, only to be reunited and married shortly after. Kertész continually confirmed this impression through interviews. Yet, as Charles Hagen points out, "fifteen years elapsed before they got back together in Paris" and during this time Kertész had married another woman, photographer Rosza Klein, (who was also known by the name Rogi André) a marriage which, according to David Travis, he publicly "pretended never happened" (Phillips 120). Kertész's inability to integrate this other marriage into his self-narrative manifests in profound silences. Travis tells us that, when asked about Klein, Kertész replied, "'I think she was a photographer in Paris'" (120).

Through the logic of what Freud calls *"Nachträglichkeit"* one can think about how the absence of Kertész's first marriage from his symbolic framework sets the scene for the loss of Elizabeth decades before her actual death. In the temporal status of the subject, the repressed, as noted by Žižek and Hal Foster, "always returns from the future." *Nachträglichkeit*, described by Foster as "deferred action," provides a way of understanding the "psychic temporailty of the subject" as "a *complex relay of anticipated futures and reconstructed pasts . . . that throws over any simple scheme of before and after, cause and effect, origin and repetition*" (Foster 28–29). The traumatic event (in this case, the death of Elizabeth) becomes uncanny, since "before it actually happened, there was already a place opened, reserved for it in fantasy-space" (in this case by the symbolic vacancy of his first wife) (Žižek *SOI* 69). Trauma, like the photograph more generally, follows the logic of the future anterior: it indicates that, as Bruce Fink tells us, "at a certain future moment, something will have already taken place" (Fink 64). In exactly this way, the historic and structuring absence of Kertész's first wife designates and holds open an empty place for the event of Elizabeth's death to inhabit. This void marks the Real—the traumatic "nothing" around which the symbolic is structured. The accident of the *punctum*, in this case embodied in the seemingly insignificant vase, materializes this constitutive lack.

Thus we see that Kertész's work, perhaps through its own structure of *Nachträglichkeit*, both advances and awaits Barthes' project. Kertész's images achieve, at a concrete level, Barthes' theoretical project to upset the traditional opposition of nature and culture. As Pierre Bost makes the point in a 1928 review, Kertész's images take on "a certain concreteness and personality, yet a strangeness despite their familiarity," a description that eerily recalls our account of the *punctum* (Phillips 36). Thus an analysis of the accident of the *punctum* leads not only to a richer account of Kertész's work but also to insights into deep theoretical connections between Barthes and Lacan, which in turn carry implications not just for questions of photographic realism but also for psychoanalytic approaches to theories of the image. Such approaches

do not violate Barthes' "death of the author" thesis. Rather they show the way in which, by exploring anomalies between form and content, psychoanalytic theories of the image can be articulated with a more detailed approach that pays due attention to the idiosyncratic associations through which individual viewers flesh out such tensions.

Through elaborating the relation of Barthes' *punctum* to the Lacanian Real, this chapter sets a conceptual foundation for the developments that follow. In particular, it provides key elements in a framework for elaborating a politics of the image that resides, not in the content of the image, but rather in a spectatorial procedure that relies upon engagement with incongruities among an image's form, content, and context. In the next chapter, I develop further elements for this project by critically examining the Freudian and Lacanian underpinnings of feminist scholarship in the area of film theory.

Chapter Three

Film Theory, Sexual In-Difference, and Lacan's Tale of Two Toilets

It has become standard protocol for film theorists[22] concerned with exam-
ining questions of sexual difference to begin their accounts by retelling
Freud's tale of children's investigations into sex and sexuality.

In its bare-boned version, Freud's famous story of the child's initiation
into sexual difference, via the course of the Oedipus complex, centers
around a boy child, who, upon seeing a naked girl (sister) or woman
(mother), discovers that females do not have a penis. In the Freudian
model, the boy assumes that the girl had once possessed a penis but that it
has been cut off as a punishment. For the boy, this belief finds support in
threats such as the one made by the mother of Little Hans, the boy about
whom Freud writes in "Analysis of a Phobia in a Five-Year-Old Boy" (1909).
When she caught Hans at the age of three and half touching his penis, his
mother threatened: "If you do that, I shall send for Dr. A. to cut off your
widdler" (Freud AP 8). The boy's visual perception of the girl's genital area
confirms his belief in the possiblity of castration and thus leads to what
Freud terms "the castration complex": the boy worries that the girl must
have suffered castration as a punishment, and therefore the same thing
could happen to him (and why not?).

Although this is frequently recounted as a tale of the child's frightful ini-
tiation into the recognition of sexual difference, other readings are suggested
by Freud's assertion that "it is self-evident to a male child that a genital like
his own is attributed to everyone he knows" (Freud TE 195). In this light,
rather than interpreting the absence of the penis in the girl as an obvious
indication of sexual difference, we may instead take it and the possibility of
castration as indications of sexual "in-difference," namely, the idea that his-
torically at least boys and girls alike possessed penises. The child then dis-

31

criminates which children are at risk for castration, not based on sexual divisions, but according to behavioral distinctions; castration is the danger facing children (boys *or* girls) who, to use the words of Hans' mother, engage in "piggish" behavior. Indeed, exactly this reading is suggested by Freud's remark: "This conviction [that everyone has a penis] is energetically maintained by boys, is obstinately defended against the contradictions which soon result from observation, and is only abandoned after severe internal struggles (the castration complex)" (195).[23] In this chapter I follow this suggestion by arguing more specifically that sexual identity arises not from biological difference but rather occurs as a result of the symbolic's indifference to the subject's need for a solid identity, an identity that may be implemented in either of two ways: the "male" or the "female."

FREUD AND FILM THEORY: ANOTHER PATH?

The "severe internal struggles" over castration, to which Freud refers, trigger an elaborate structure through which the boy disavows what he, nonetheless, "knows" he saw. In his analysis of Little Hans, the "decisive [case] in Freud's discovery of the castration complex," Freud tells us that after Hans sees his younger sister Hanna being given a bath, Hans' father tells him that "his sister has not got a widdler like him" (Laplanche and Pontalis 56; Freud 31). In these all-important words (a paternal confirmation of a child's most pressing concern), an ambiguity arises: Is Hans' father telling him that his sister's widdler is unlike Hans' own widdler, or is he making the more extreme assertion that his sister, unlike Hans, has not got a widdler at all? The following comments imply the latter interpretation: The father continues, "Little girls and women...have no widdlers" (31). Yet, even in the light of his father's verbal corroboration of Hans's visual perception (that girls do not have widdlers), Hans, it would appear, refuses to accept this knowledge. For Freud, Hans' resistance to accepting this view, in the face of what would appear to be overwhelming supporting evidence, emerges from his wishing that it were not true. In Freud's explanation, "the enlightenment [Hans] had been given to the effect that women have no widdlers was not accepted by him at first. He regretted that it should be so, and in his phantasy he stuck to his former view" (31).

While continuing to base myself upon Freud's (not unequivocal) remarks, I shall suggest a somewhat different account of Hans' rejection of his father's statement. Although, as the case study makes clear, Hans undoubtedly rejects his father's "enlightenment" that "women have no widdlers," he also appears to accept the more precise knowledge that girls do indeed have a different sort of "widdler" than boys. For example, we see that

when his father explained to Hans that "women do not have widdlers," Hans challenged this "enlightenment" by retorting, quite sensibly, "But how do little girls widdle, if they have no widdlers?" (31). At the conclusion of his discussion of the case, Freud gestures toward this ambiguity in Hans' analysis, which was conducted by Hans' father via correspondence with Freud: "If matters had lain entirely in my hands, I should have ventured to give the child the one remaining piece of enlightenment which his parents withheld from him. I should have confirmed his instinctive premonitions, by telling him of the existence of the vagina" (145).

After seeming to conclude his introductory remarks to the case of Little Hans, Freud appends, with no transitional statement or interpretive commentary of his own, "one other observation," an apparent afterthought, about Hans during the time of his analysis, which Freud had received in a letter from Hans' father:

> Hans (aged four and a half) was again watching his little sister being given a bath, when he began laughing. On being asked why he was laughing, he replied: "I'm laughing at Hanna's widdler." "Why?" "Because her widdler's so lovely." Of course his answer was a disingenuous one. In reality her widdler had seemed to him funny. Moreover, this is the first time he has recognized in this way the distinction between male and female genitals instead of denying it. (21)

Yet, as Freud also makes explicit in his concluding remarks, Hans presaged the physical distinction between the sexes throughout his earlier childhood investigations of widdlers. Hans' father's neglect to integrate this "one other observation" into the narrative of the case study constitutes a curious absence.

Furthermore, upon reflection fifteen years after he published his "Three Essays on the Theory of Sexuality" (1905), and eleven years after publishing the Little Hans case, Freud saw fit to add a footnote to his discussion of the castration complex regarding its occurrence in girl children as well as in boys. "We are justified in speaking of a castration complex in women as well," he declares, since "both male and female children form a theory that women no less than men originally had a penis, but that they have lost it by castration" (195). As we will see, this addendum, like the afterthought in the Little Hans case, carries considerable significance (albeit in quite different ways) for feminist film theorists who tend to predicate their accounts of masculine and feminine viewing structures upon the different responses of boys and girls to the sight of "castration." It also has significance for Lacan's interpretation of Freud, according to which it is the subject's response to the

phallus and castration, rather than to the penis/widdler, which determines
the categories of woman and man.

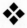

Within film theory, in particular, the representative work of Mary Ann
Doane, the differences between male and female scopic economies corre-
spond precisely with the different reactions demonstrated by boys and girls
in Freud's scenario. For example, Doane cites Freud's remark that "girls do
not resort to denial of this kind when they see that boys' genitals are
formed differently from their own. They are ready to recognize them imme-
diately" (Doane *DD* 195). Thus there is no distance between her sight of
the penis and her recognition of its "'difference and, it must be admitted, its
significance too'" (79). Doane then points out that this concurrence
between seeing and believing poses insurmountable difficulties for the
female spectator.

The boy, by contrast, experiences a "delay between seeing and under-
standing"; he disavows what he "perceives as a loss that threatens...his
integrity" (Rodowick 24). Thus, by engaging in "distanciating" viewing prac-
tices, particularly voyeurism and fetishism, the male spectator can take plea-
sure from both viewing the woman's body and identifying with the male
protagonist, all the while shielding himself from castration anxiety. As Freud
affirms, boys will construct "substitutes for this penis which they feel is miss-
ing in women" (195). These substitutes for the missing maternal phallus
often take the form of metonymies of woman. The overvaluing or "fetishiz-
ing" of another body part such as the foot, hair, or breast functions as com-
pensation for her "deficiency," and in turn, allays boys' castration anxiety.

But, Doane argues, this comforting mechanism of distanciation, belong-
ing exclusively to the province of the masculine scopic regime, is unavailable
to the female spectator, thus encumbering her with the problem of what
Doane calls her "over-proximity" to the cinematic image. Thus according to
Doane, the female viewer is left defenseless to confront "that body which is
so close [it] continually reminds her of the castration which cannot be
'fetishized away'" (Doane "FM" 80). Tania Modleski summarizes Doane's
"nihilistic position": "Because women lack a penis, they lack the possibility of
losing the 'first stake of representation,' the mother, and thus of symbolizing
their difference from her.... [W]oman's...inability to separate decisively
from the *maternal* body...is related to her...inability achieve a distance from
the *textual* body" (Modleski *WWKTM* 7).

Along similar lines, Rodowick argues that for Doane, the female specta-
tor is left "with nothing to lose and lacking the means to symbolize [the]

lack" so is often seduced into one of two equally unsavory viewing positions (Rodowick 24). On the one hand, as Modleski puts it, she can engage in self-destructive narcissism (in which she passively[24] identifies with the on-screen "female object of desire") (Modleski 6). On the other hand, she can take up the ideologically unsound position of masochism (in which she engages in "straightforward role reversal" by taking on the masculine desire for the female sexual object) (6).

The view that I put forward in this chapter joins Modleski in asserting that "there must be other options for the female spectator than these two, which have been pithily described by B. Ruby Rich in the following terms: 'to identify either with Marilyn Monroe or with the man behind me hitting the back of my seat with his knees'" (6). I share Modleski's suspicion of Doane's "'ideal[ization]' of 'distanciation'" and the "denial of pleasure to the female spectator." But I will disagree with Modleski's reproduction of a binary view of gender differences that hinges upon a dichotomous conception of "male" and "female." The view that I develop derives from the Lacanian claim that "sexual binarism itself is the greatest fiction, regardless of its theoretical derivation" (Rodowick 68). According to Lacan, sexual identity marks precisely the *failure of a binary* (and specifically complementary) relationship between two sexes. In what follows, I explain my position by unfolding its relation to Modeleski's critique of Doane.

For Doane, the female spectator suffers from "over-proximity" to the image. The remedy for this that she prescribes involves techniques by which the female spectator can distance herself from the image. Modleski's first objection to Doane's remedy uses Linda Williams' notion of woman as "exile." Williams cautions that the attempt to impose distance between woman and image suffers not only from unwarranted optimism but also from futile redundancy since woman always and already "experiences a 'distance' from the image as an inevitable result of her being an exile 'living the tension of two different cultures'" (Modleski 8). Modleski objects even more strongly to Doane's endorsement of a Brechtian concept of "distanciation," which, she claims, carries with it grave risks for a feminist viewing strategy. In particular, Modleski argues that Doane's strategy of privileging the (implicitly masculine) virtues of distanciation and "detachment...to some extent participate[s] in the repression of the feminine" (9).

My objection to Doane differs from Modleski's. Rather than following Modleski in appealing to a simple oppositional structure between "masculine" and "feminine" qualities, I will argue against Doane's politics of distanciation on the basis of Žižek's insight that ideology is not weakened by, but rather *depends upon* subjects' ability to distance themselves from it through such

mechanisms as criticism, cynicism, irreverence, mockery, irony, parody, and so on. Such apparently "healthy measures" of nonconformity end up by "mak[ing] an ideology 'workable.'" To be specific they pacify subjects by assisting them to live *as if* they are, to some extent, free from ideological constraints: "[T]he lesson is clear: an ideological identification exerts a true hold on us precisely when we maintain an awareness that we are not fully identical to it" (Žižek *PF* 21).

Modleski's second objection to Doane concerns the "denial of pleasure to the female spectator." For Doane, in order to "get the joke" female viewers must take up the position of masochist. Modleski contends that, in asserting this, Doane confuses "getting the joke" with "the idea of receiving pleasure from it" (Modleski 26.) Modleski, by contrast, maintains that a woman can "get" jokes that she does not enjoy; she can even "get" jokes she finds abhorrent. According to Modleski, Doane's conflation of "getting" with "enjoying" forecloses the oft-neglected possibility of a woman responding to the joke, not with pleasure, but with anger. Woman's anger holds particular importance for Modleski for having long been denied or repressed on the grounds that it is "the most unacceptable of all emotions" (27).

But here, perhaps, we can turn Modleski's earlier criticism of Doane against Modleski herself. By assigning value to a response such as anger on the basis of its incompatibility with conventional notions of femininity, Modleski, it seems, not only reproduces sexual binarism but also esteems attributes in virtue of their association with masculinity. My position, by contrast, inverts the question of whether woman "enjoys" the jokes that she "gets." I ask instead, whether woman can enjoy the moments or "jokes" that she does not "get." Put in other terms, rather than focus on the "*plaisir*" that comes from making sense of the text (regardless of whether the meaning leads one to laugh or scream), my vision of a feminist spectatorship elaborates the potential subversion of "*jouissance*" that arises precisely where *any* sort of "making sense" fails—where "getting it" is no longer a relevant question. (Here I am following Kate Linker in arguing that *jouissance* can "challenge signification's ideological character"—Linker in Risatti 212).

To be precise, rather than focus on the *content* or meaning of what the child sees, I prefer to explore the moments where the child's vision falters— where one's mechanisms for making meaning fail. These symbolic failures, I contend, are the ground from which our sexual identity emerges. Here I align myself with Jacqueline Rose, who, in her explication of Freud's work on the relationship between visual representation and sexuality, highlights the importance of disruptions and fissures of the visual field. Freud, Rose tells us, continually emphasized

moments in which perception *founders* (the boy child refuses to believe the anatomical difference that he sees) or in which pleasure in looking tips over into the register of *excess*....Each time the stress falls on a problem of seeing.... [S]exuality lies less in the content of what is seen than in the subjectivity of the viewer.... The relationship between viewer and scene is always one of fracture, partial identification, pleasure and distrust. (Rose 227)[25]

In the following chapter I will extend Rose's insight in order to theorize a strategy for a subversive feminist spectatorship that is based upon the view that not only the structure of the visual field as scene of the scopic drive but also the sexed subject as either feminine or masculine are products of such symbolic failure.

LACAN, THE PHALLUS, AND CASTRATION

In Lacan's reworking of the Freudian scenario, sexual difference emerges in relation to castration and the phallus. But within the Lacanian system, these terms function differently than they do for Freud. Castration, for Lacan, is the loss or lack that the subject suffers in order to gain entry into the symbolic, the realm of language. For Lacan, castration is "a lack or a loss... [that] is required to set the symbolic in motion" (103). Prior to this moment of loss, the child enjoyed an imaginary unity with the (M)other, where it not only lacked nothing, but coped with its utter dependence upon the (M)other by imagining that it is as "indispensable to the mother as she is to it" (Lapsley and Westlake 72). Yet this imaginary state cannot last, for without a disruption to this unity (inaugurated by the child's realization that its needs are not the mother's only focus), the child cannot become a full-fledged subject with a place within the symbolic order. As Bruce Fink puts it

> if nourishment is never missing, if the desired warmth is never lacking, why would the child take the trouble to speak? As Lacan says.... "[W]hat is most anxiety producing for the child is when...there is no possibility of lack, when its mother[26] is constantly on its back." Without lack, the subject can never come into being. (103)

On this Lacanian account, the phallus functions as the signifier of the lack to which the child is introduced as the price of entry to the symbolic, a lack that can be thought of as the desire of the (M)other—what the (M)other desires beyond the child. As Bruce Fink describes, according to Lacan, "a child tries to fathom its (M)other's desire... [and through which] it is forced to come to terms with the fact that it is not her sole interest..., not

her be-all and end-all...because of priorities and desires of her own that do not involve her child" (Fink 50–51). And Samuel Weber continues, saying that "the phallus must be understood as that which *marks the passage from the imaginary to the symbolic, from demand to desire,* as a discontinuous and con-flictual one.... The favored name for this discontinuity and conflict is castra-tion" (Weber 143). Or as Lacan puts it, "'the child does not find himself or herself alone in front of the mother.... [T]he phallus forbids the child the satisfaction of his or her desire, which is the desire to be the exclusive desire of the mother'" (Rose 61).

The figure of the father can come to stand for the phallus through his role as object of the mother's desire; he appears to the child as what the mother lacks and desires. Yet the father cannot be the phallus either, since the phallus turns out to be a structuring absence that sets the subject on a lifelong course of unfulfillable desire. Indeed the phallus' only guarantee is the subject's failure to satisfy its desire. Thus desire, for children of both sexes, emerges in relation to the phallus as the third term that intervenes to split the (M)other/Child dyad. This lack is central to *all* subjects (except in the case of psychosis in which such a split never occurs). As Lapsley and Westlake explain, "the subject's subsequent history consists of a series of attempts to figure and overcome this lack, a project that is doomed to failure" (Lapsley and Westlake 67).

The subject constructs a fantasy scenario to enable him/her to cope with the lack. And it is in this context that the Lacanian concept of 'sexuation' arises. The key issue, then, becomes whether a subject responds to the lack through the fantasy position of Woman, by structuring his/her libidinal econ-omy around an active questioning of sexual identity. Or, by contrast, does the subject respond through the fantasy position of Man, by looking to con-firm sexual identity through investing in the authority of the symbolic?

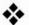

In *Ecrits*, Lacan tells a story about sexual difference that highlights the significance of language in this process through which the child emerges as a sexuated subject. Lacan's version stages two small children, a brother and a sister, sitting face to face next to the window on a train. The train comes to stop, leaving the children to look out at the platform upon which stands a set of bathrooms, side by side. As Lacan tells it:

> "Look," says the brother, "we're at Ladies!"; "Idiot!" replies his sister, "Can't you see we're at Gentlemen."...The rails in this story material-ize the bar in the Saussurian algorithm.... For these children, Ladies and Gentlemen will be henceforth two countries towards which each of

their souls will strive on divergent wings, and between which a truce will be the more impossible since they are actually the same country and neither can compromise on its own superiority without detracting from the glory of the other. (Lacan *Ecrits* 152).

When film theorists recount this story (as for example in the work of D. N. Rodowick), they often leave out the key sentence, "The rails in this story materialize the bar in the Saussurian algorithm." But in *Encore* Lacan specifically warns against any such underestimation of the role of the "bar" in Saussure's account of the sign, cautioning that "it is important not to elide the fact that between signifier and meaning effect there is something barred that must be crossed over.... The effects of the unconscious have no basis without this bar" (Lacan *Encore* 18, 34).

This bar, Lacan then remarks, "is not unrelated to the phallus," which, in turn, marks the subject's entry into language (39). As Weber puts it, "the subject here is literally *borne* by the bar separating the signifier from the signified: its place is on the rails, and yet on rails that simultaneously derail" (43). An account of this oft-overlooked way in which Lacan has extended the Saussurian framework will provide us with the basis for a deeper understanding of the connection between sexuation and signification.

SAUSSURE, SIGNIFICATION, SEXUATION

When Lacan introduces the bathroom story in 1966, it is not in the context of explicating his theories of sexuation (which are not elaborated until 1972–1973). Instead it is in order to reformulate Saussure's sketch of the linguistic sign. Lacan replaces Saussure's illustration with one of his own (figs. 5 and 6).

What is Lacan criticizing in Saussure by his modification of Saussure's diagram? According to Lacan, Saussure flirts with nominalist or representationalist approaches to language, according to which the signifier (word-sound) "t-r-e-e" is a name attributed to a preexisting signified (picture-concept) of tree.[27] Saussure's account is haunted by a representationalism in his implicit prioritization the signified as that which the signifier must convey. According to Lacan, by contrast, meanings (signifieds) only emerge from a system of signifiers. So, for example, only through the differences between their respective signifiers, "ladies" and "gentlemen," do the two apparently identical lavatory doors take on distinct meanings, in effect, become "two countries." Like subjects, the doors are not inherently differentiated; it is only the signifier that provides the illusion of identity and difference.

TREE

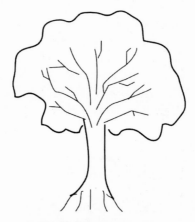

Fig. 5. Saussure's diagram.

LADIES **GENTLEMEN**

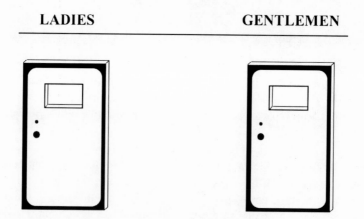

Fig. 6. Lacan's diagram.

In short, according to Lacan, Saussure's example fails to illuminate the extent to which the signifier implicates itself in the signified. Furthermore, Lacan argues, it is the bar that separates but also *joins* the signifier and signified, which embodies this interdependence of signifier and signified. As

Lacan explains, "were it not for this bar...you could not see that signifiers are injected into the signified" (Lacan *Ecrits* 34). Lacan makes two points here: (1) he opposes nominalist approaches to language, and (2) he recognizes the penetration of the signifier into the signified. These two points are related; as he explains, "it is not only with the idea of silencing the nominalist debate with a low blow that I use this example, but rather to show how in fact the signifier enters the signified" (151).

This elaboration of Lacan's notion of the signifier is crucial for an understanding of his account of the sexed subject, since for Lacan, the subject is "nothing but a signifier....Men, women, and children—means nothing qua prediscursive reality. Men, women, and children are but signifiers" (39, 33). Indeed, on the Lacanian view, human subjects, as *speaking* subjects, both occupy the signifier and are occupied by it (as well as with it). This is clear within the analytic context, where what Lacan calls the "stupid" (i.e., "meaningless") signifiers that analysts encourage their analysands to utter, allow analysts to glimpse the subject of the unconscious (22). To be specific, the analysand's signifiers "result...in a confrontation with the limits of...knowledge, and thus with the part of the truth that lies beyond verbalization" (Verhaeghe 45).

According to Verhaeghe such encounters are akin to the crisis that precipitates sexuation. To be specific, the signifiers that the subject encounters in the analytic situation confront him/her

> with the irreparable lack that lies at the heart of the symbolic. This is the same lack where the infantile search for knowledge came to a standstill for the same reasons: the symbolic sexual identity...the sexual rapport. The symbolic can never embrace these aspects of the real; as a lack in the symbolic, they open the void for the subject. (45)

And, Verhaeghe continues, this confrontation leaves the subject "with two [and only two] possibilities." As we will see in more detail in the next chapter, these two possibilities for dealing with this symbolic void are, for Lacan, the male way (what he calls "imposture" or "display") and the female way (what he calls "masquerade"). In this sense, then, sexual identity (for both men and women) emerges as a response to lack that is symbolized by the phallus and instituted by castration.

D. N. Rodowick offers an interpretation of Lacan's "joke" or "'childhood memory'" that, by emphasizing the "ontological insecurity to which the subject's recognition of place falls prey, seems to conform to Lacan's account of the subject and sexual difference" (Rodowick 64). In Rodowick's

view, the joke's humor arises from a misrecognition of "place," which under-
girds the "problem of the sexes." Roughly put, neither men nor women
locate themselves in the place where they can relate to each other as "man"
and "woman." As Rodowick puts it, "Lacan's bathroom joke is funny because
of its matter of fact inversion of place: the little passengers on Lacan's
Oedipal train each arrive at the wrong destination" (65). For Rodowick, the
"truth" at the kernel of the joke involves the recognition that sexual identity
never "arrives at its destination" (65).[28]

Rodowick then counters "Lacan's bathroom joke" with a bathroom
scene from the 1987 film *Personal Services* in which Dolly (Danny Schiller),
who passes for a woman without suspicion from other characters or the audi-
ence, is discovered in the women's bathroom by her friend, Christine, to have
a penis. Christine, Rodowick tells us, "exclaims gleefully, 'Dolly, you've got a
willy!,' [to which] Dolly responds, 'It's nothing to be proud of'" (64).
Rodowick's scene interweaves elements from both Freud's and Lacan's sto-
ries. The scene inverts the classic Freudian moment: rather than encounter
the boy's horror at not finding a penis in the place where he expected to find
it, we have the surprise of a woman catching sight of the penis where she
least expected to find it.

Rodowick applauds this cinematic moment for its celebration of the
"erosions of phallic identity" (65). But this applause involves a fundamental
misunderstanding of Lacan. Dolly's rejection of "phallic identity" does not
undermine its power. Although Dolly refuses phallic identification, she does
so as a way of distancing herself from being a man. Thus, Dolly upholds,
rather than undermines, the "phallus=penis" association, as well as the spe-
cial status it confers upon Man.

For Lacan, it is important to remember that the phallus "can play its role
only when veiled" (Lacan *Ecrits* 277). This absence of the penis, both within
cultural imagery and scholarly inquiry supports patriarchal power associated
with the penis-phallus conflation. This hiddenness of the penis enables the
phallus to appear as its equivalent, thus reinforcing the mystique of phallic
power. Peter Lehman argues for the necessity of exposing the male body as a
way to overcome the invisibility that secures this cultural dominance. He
argues that such an unveiling will demonstrate "that all penises are inade-
quate to the phallus" (Lehman 10). In supporting his point, Lehman con-
trasts the prevalence of penis jokes within films with the rarity of actually
showing a penis and then asks, "What is at stake in so carefully and systemat-
ically denying us the view of what we are hearing about?" (119).

This question is addressed poignantly by Susan Bordo, who recalls that,
due to a combination of her father's exceptional modesty, her lack of broth-

ers, and the absence of penises within visual cultural imagery, she hit puberty without having seen a penis. The mystique surrounding the penis was so strong that when she eventually saw one, she expressed incredulity that *this* "could possibly be the same thing that my father was hiding" (Bordo *MB* 17). Exposure of the penis demonstrates that it "can never live up to the promise of the phallus" (Creed 5). In thus disarticulating the penis from the phallus, it is, however, crucial to remember that it is not only the phallus that "haunts the penis" but that the penis "also haunts phallic authority, threatens its undoing" (Bordo *MB* 95).

The project to decouple the penis from the phallus through its exposure is, however, fraught with difficulty. The penis is rarely completely unveiled in dominant visual culture; its display is usually overlaid with underwear, or if it is stripped bare, it is shown only to a diegetic audience, rather than an actual one. Both of these forms of semiexposure work to reproduce its mystique. Bordo's comparison of underwear ads featuring women and men illustrates the point. By showing the model in motion (usually engaged in activities of a "manly" sort, such as lifting weights or other heavy objects) ads that depict seminaked men tend to avoid making the male body a spectacle. Or, if the model is not moving, his body is framed in such a way that he exudes what Bordo calls a "dominating subjectivity," which by emphasizing "the model's muscularity, his bodily stance, his expression...code his (semi-)revealed genitals in terms of phallic armor rather than fleshy exposure" (Bordo *TZ* 160, 155). Rather than objectifying the male body, such images make the viewer feel him/herself under the scrutiny of an aggressive gaze.

The second mode of semiexposure works to objectify the spectator, rather than the man on display. In the case of films where male characters strip naked, viewers rarely see the character's penis but instead are shown the response of the female character(s) within the film to whom it has been revealed. As Lehman describes, "in place of the logical objectification of the male body, we have the fetishistic objectification of the woman who looks.... [T]he filmic structure makes clear that we would rather watch her see...than observe what she sees" (Lehman 123, 124).

The culminating scene of the 1997 film *The Full Monty* plays with this structure. In the film a group of out-of-work steelworkers in industrial northern England devise a money-making scheme; they set out to perform a "one-night-only" strip show in which they promise to "do the full monty"—to bare all for the audience. The idea of the strip show comes to them after they see the excitement sparked in the women in the town by the arrival of a male dance troupe. Gaz (Robert Carlyle), the ringleader of the group, initially disparages a photograph of the visiting dancers in an advertising poster

by pointing out that one of the dancers (wearing tight underwear) "hasn't got a willy to speak of." This remark, however, does not strip the dancer of an association with the phallus. On the contrary, however unconventionally, he remains firmly aligned with both breadwinning and sexual potency, much to the envy of the unemployed protagonists, whose sense of emasculation—born of both financial and sexual insecurity—is exacerbated when Dave (Mark Addy) confesses that his wife, much to his chagrin, will be attending the show. As he concedes to his cringing mates, he cannot stop her, because she is now the breadwinner: "[I]t's her money, isn't it?"

In becoming bearers of the look, the women in the film take on several traditionally "masculine" behaviors, such as crudely commenting on the performers' sexual appeal. We see this in the scene where, intrigued by what the women are up to, Gaz and Dave try to sneak into the club during the show. Gaz hides in the men's bathroom when he hears the women approaching. To his surprise, they enter the men's bathroom, where one woman proceeds to urinate standing at the urinal—a sight that becomes emblematic of the men's fear of having "become redundant."[29] Gaz gives voice to this anxiety, exclaiming, "When women start pissing like us, that's it. We're finished...extincto...they're turning into us. A few years and men won't exist...I mean we're not needed anymore!" In short, the male characters in the film are being deprived of the symbolic trappings that "define maleness" (Bronski 3).

In his review of the film in *Z-Magazine*, Michael Bronski comments that the men respond to this plight by "showing the world they really are men...[By going all the way, doing the "full monty," they] show that they have the balls to show their balls." Yet, as Bronski points out, "it is obvious that none of them have the standard, regulation equipment for this new line of work. In scene after scene the men worry about their scrawny bodies, their flabby middles, the size of their dicks, and the possibility of complete and total humiliation."

Dave, the most overweight of the men, who almost backs out of the performance because he is deeply self-conscious about his body, introduces the act to the intradiegetic audience (mainly) of women by saying: "[W]e may not be good, we may not be pretty, but we're here, we're live, and for one night only, we're going for the full monty." When the key moment in the performance arrives (a scene that doubles as the concluding still shot of the film), the men show their naked fronts not to us but instead to the wildly enthusiastic and supportive audience within the film; the filmic spectators must content themselves with a freeze frame of their naked backsides.

At first sight this dodge falls neatly into Lehman's account of how the exposure of the penis often leads to the odd filmic objectification of the women to whom the penis is displayed. But, I suggest, although the men are indeed successful in avoiding objectification, this success is due neither to the concealment of their penises nor to the objectifying exposure of the cheering crowd of women (and some men) to whom their penises are diegetically revealed. Rather, it is their rare ability to inhabit symbolic failure, to recognize that no one can possess the phallus. The onscreen flaunting of their flaws (which Dave painstakingly enumerates in his introduction to the show) deprives spectators of the pleasure of "seeing through," which is usually achieved through a spectatorial position of mastery. Consequently, viewers are left to experience a different sort of pleasure, one that comes from engaging an opportunity to revel in a symbolic chasm that exposes the hollow foundation on which the symbolic rests.

Specifically, viewers are faced with the ambiguity of a film that appears to exhibit the standard opportunities for a comfortable viewing position but even so undermines our ability to settle on a definitive spectatorial position. Thus, instead of the usual pleasures of voyeurism or identification, viewers are offered a pleasure similar to the one enjoyed by the on-screen characters: Thrown into symbolic flux, spectators, too, are offered the opportunity to engage in the pleasures of "doing the full monty," of surrendering the suffocating symbolic cloaks into which we hopelessly struggle to fit, and that nevertheless offer us some protection from the risks (but also thrills) of symbolic rupture. In the next chapter, I develop an alternative politics of spectatorship, which, rather than following Doane and Rodowick in elaborating a strategy for the distancing of phallic identity, takes such opportunities to "do the full monty," as a basis for a subversive feminist spectatorship that, following Lacan, foregrounds the phallus (albeit stripped of its connection to the penis) to be central to the subject's sexed identity.

Before closing, however, let me include a few final remarks on Lacan's account of the signifier. For Lacan, not only does the signifier permeate the signified, but it also infiltrates, indeed colonizes, the unconscious. Fink more radically elaborates the Lacanian view by asserting that "we can...completely ignore the whole issue of meaning, that is, the whole of what Lacan calls the signified...in discussing the unconscious" (Fink 21). Although signifieds may yield "knowledge," for Lacan, it is only signifiers that generate and index the "truth" of the unconscious. As Verhaeghe describes, "truth starts with [the] realm [of the signifier] but evokes a dimension beyond it.... [T]his dimension beyond the signifier is the Lacanian real" (Verhaeghe 39). Signifiers persist in

the unconscious, adhering to one another through relationships that have no necessary basis in meaning.

Freud makes this point in his discussion of the "Rat Man." Unconscious associations among signifiers, he tells us, function through "verbal bridges" in which the signifiers "jar upon certain hyperaesthetic spots in the unconscious" (Freud "CON" 213, 210). Such connections, according to Freud, "happen by chance—for chance may play a part in the formation of the symptom, just as the wording may help in the making of a joke" (210). The analyst then endeavors to unravel the signifiers from their associative chains in order to (as Lacan puts it) cipher their particular logic of assemblage. (This offers us one way in which to interpret Lacan's well-known adage, "the unconscious is structured like a language.")

For example, certain elements of the Rat Man's obsessional neurosis are grounded in his childhood association with rats as "biting creatures that are often treated cruelly by humans, he himself having been severely beaten by his father for having bitten his nurse" (Fink 22). But, as Fink notes, such explanations grounded solely in associative meanings fail to account fully for ways in which the signifier "rat" came to function as a node around which a complex of symptoms constellated through processes of condensation (metaphor) and displacement (metonymy). In Fink's words, some "ideas become grafted into the 'rat complex' due to the word *Ratten* itself, not its meanings" (22). For example, through the signifiers *Ratten*, which refers to payment installments, and *Spielratte*, which means gambler, "the Rat Man's father, having incurred a gambling debt, becomes drawn into the rat complex" (Fink 22). The Rat Man, whose obsessions revolved largely around money,

> little by little... translated into this language the whole complex of money interests which centered round his father's legacy to him; that is to say, all his ideas connected with that subject were, by way of the verbal bridge... carried over into his obsessional life and brought under the dominion of his unconscious. (Freud "CON" 214)

Such a process returns us to Lacan's dictum that the subject "is nothing but a signifier." As Fink tells us, drawing upon the Rat Man analysis, "insofar as [literal relations among words] give rise to symptomatic acts involving payment..., it is the signifier itself that subjugates the Rat Man, not meaning" (Fink 22).

In discussing the subject's subjugation to the signifier, Lacan evokes the "famous example" of which people "always ma[k]e a big deal," that "smoke cannot exist without fire" (Lacan *Encore* 49). This phrase figures promi-

nently in Freud's analysis of Dora, who, "when she used to assert that there was nothing concealed behind this or that," would prompt Freud to say that "by way of rejoinder: 'there can be no smoke without fire'" (Freud "FACH" 73). Yet, as Lacan points out, and Freud's analysis can be seen to suggest, "smoke can just as easily be the sign of a smoker.... There is no smoke that is not the sign of a smoker" (Lacan 49). Rather than read a sign in terms of the referent that it indexes, Lacan suggests, we should look to a signifier in order to find the subject that it evokes. Just as smoke leads to fire, the signifier leads to the subject.

In this way we can understand Lacan's frequently quoted enigmatic elaboration of the signifier as "that which represents a subject to another signifier." Lacan illustrates this dictum in the context of seeing smoke emanating from a deserted island. Rather than contenting oneself with an inference to the existence of fire, one is drawn into a search for the subject. According to Lacan, "you immediately say to yourself that there is a good chance there is someone there who knows how to make fire. Until things change considerably, it will be another man" (49). This view encourages us to look at signifiers, not so much as an effect of a "thing" or meaning, but rather as an effect of another signifier, namely, the subject herself.

Freud's analysis of Dora anticipates this Lacanian proposition. After applying techniques of analysis to Dora's recurring dream, Freud initially concludes that the "interpretation of the dream now seemed to me to be complete" (Freud 73). Yet when Dora returns the next day and recounts a forgotten detail, specifically, that upon waking from her dream on each occasion she had smelled smoke, Freud must look beyond the fire. He determines that, for Dora, the signifier of smoke "had a special relation to me" (73). Through a series of associations within the framework of Dora's analysis, including Freud's repetition of the "famous phrase" ("there can be no smoke without fire") and his self-described "passionate" smoking, Freud takes the smoke as an indication of her transference to him, "that she would like to have a kiss from me" (74). In what follows, we shall trace a similar trajectory—not from signifier to meaning, but rather from signifier to subject.

Chapter Four

How Should a Woman Look?
Scopic Strategies for Sexuated Subjects

In this chapter I build upon the exploration of both Roland Barthes'
notion of the *punctum* and the theoretical connections between Barthes
and Lacan that I have developed in previous chapters, with a view to
elaborating a feminist strategy for spectatorship. In particular I situate
Barthes' concept of the *punctum* within a Lacanian architectonic by arguing
that the *punctum* follows the logic of the object that Lacan calls the "signifier
of lack in the Other," which, he contends, is also the position with which the
female subject identifies. I then draw upon Lacan's schema of objects and the
formulae for sexuation that he develops in *Seminar XX*, in order to lay out an
approach to the problem of feminist spectatorship that differs from orthodox
feminist film theory accounts.

PLEASURE, POLITICS, AND THE *PUNCTUM*

In her highly influential polemical 1975 article "Visual Pleasures and
Narrative Cinema," Laura Mulvey argues that "woman is an indispensable
element of spectacle...displayed for the gaze and enjoyment of men"
(Mulvey 11, 13). If under the male gaze, woman is the object of what Mulvey
calls "fetishistic scopophilia," the political question then becomes: How
should *women* look in order to avoid both the masochism of taking up the
viewing position of man as well as the narcissism of identifying too closely
with the fetishized image of woman on-screen?[30] As I indicated, subsequent
feminist media studies scholars have often advocated a strategy for female
spectatorship that involves "distancing" the image as a means of opposing the
voyeurism of the male gaze. Griselda Pollock, for example, calls for a
Brechtian strategy of "'distanciation'" developed along psychoanalytic, femi-
nist lines as a technique for reading a text against its patriarchal inscriptions.

Pollock contends that the practice of "'distanciation'" disrupt[s] the 'dance of ideology' which engages us on behalf of oppressive regimes of sexist classifications" (Pollock 163, 158).

Yet, if one follows Slavoj Žižek, rather than "disrupt" the "dance of ideology," the practice of "distanciation" contributes to its success. As I indicated in the previous chapter, by neglecting to account for the ways in which viewers are trapped by the hidden pleasures produced by "seeing through" the "dance of ideology," one overlooks the way that "this very distance *is* ideology" (Žižek *PF* 20). As Žižek argues, "distance . . . far from signalling the limitation of the ideological machine, functions as its positive *condition of possibility*" (20). By neglecting the constitutive role of the ideological fantasy, ideology critique fails to make any real impact. Ideology, as Renata Salecl claims, is "the way society deals with the fundamental impossibility of it being a closed, harmonious totality. . . . Behind every ideology lies a kernel of enjoyment *(jouissance)* that resists being fully integrated into the ideological universe" (Salecl *SF* 6). The ideological fantasy works to conceal this kernel by providing a scenario that disguises inconsistencies, excesses, and antagonisms in the social order.

Mary Ann Doane's position differs from Pollock's. Doane argues for what she calls, following Joan Riviere's 1929 essay, the "feminine masquerade" (the "flaunting" of signifiers of femininity) as a strategy for spectatorship that resists "patriarchal positioning [through its] denial of the production of femininity as closeness" (Doane *FM* 78). According to Doane, female viewers can occupy the masquerade in order to resist identifying with the fetishized onscreen representation of woman. The masquerade institutes a critical distance for the female spectator since, by "producing herself as an excess of femininity . . . [the female spectator] acknowledge[s] that it is femininity itself which is constructed as a mask . . . which conceals a non-identity" (81). As Rose describes, the masquerade's "very artificiality [indicates] that something [is] being forced" (Rose 92–93).

The strategy of masquerade, Doane claims, avoids the problems (and pleasures) of "masochism" which result from the position of "transvestism," where woman takes up the viewing position of man. Doane warns against the temptations of transvestism since, for the female spectator, it is only from this position that she can "'get' the joke. . . . [I]t can give her pleasure only in masochism" (87). By donning the mask, Doane contends, the spectator will be able to "see in a different way"; the mask will enable the viewer to "manufacture a distance from the image, to generate a problematic from within which the image is manipulable, producible" (87).

For Doane, the subversive effect of reading from within the mask emerges in part from its foreclosure of pleasure. But, just as pleasure hides

within the strategy of ideological critique, one might argue it also lurks within the mask. And, if this is so, does it rob masquerade of its subversive potential? This is the question that situates this chapter. More generally, I pose the question: Can there be a subversive, feminist viewing practice that allows for pleasure?

The authority that Mulvey's critique of pleasure commands makes it difficult to keep this question open. Mulvey derives her critique of pleasure from an explanation of how filmic texts compel viewers to take up particular roles or subject positions. For Mulvey, it is not necessary that spectators actively believe that films show how men and women are or even should be. The influence of films is much more subtle and, thus, more invidious: Because films are incredibly pleasurable to watch, we allow ourselves to be carried along by the story. Thus, by enjoying the film, we tend to inadvertently consent to the fantasy world that unfolds before us. Since the world of the film, in both its content and form, reproduces the objectification of woman, Mulvey contends that we are left with no choice but to "destroy the pleasure" the film provides. As feminists and spectators, it seems, we must resist participating in the enjoyable fantasy world offered by the film.

In spite of the influence of Mulvey's work, there have been attempts to recognize the potential of pleasure to act as a resource for expressing political resistance.[31] As John Fiske points out, "Pleasure may be the bait on the hook of hegemony, but it is always more than this, it always involves an element that escapes the system of power" (Fiske 278). Ien Ang, in discussing the relationship of pleasure to a specifically feminist politics, worries that the critical practice of dismissing women's pleasure in media consumption risks complicity with the patriarchal discourse of the "ideology of mass culture," in which women are "'seen as the passive victims of...deceptive messages... [their] pleasure...totally disregarded'" (as quoted in Storey 24). Similarly, Amelia Jones (drawing upon the work of Luce Irigaray) points out the ways in which the refusal of pleasure is complicit with "a masculinist project," which aims to "control the chaotic and unpredictable pleasures of the erotically engaged body" (Jones 393). This paradigm, for Jones, "demands the rigorous separation of embodied pleasure from so-called theory" (393).

It is this separation that I would like to challenge by theorizing a feminist spectatorial position whose key component is pleasure. In particular, I take seriously the suggestion that, in Fiske's words, there is a dimension of enjoyment that "escapes the system of power." Furthermore, I suggest that feminist media studies should take seriously this dimension of enjoyment (*jouissance*) as a way of working toward "traversing the [ideological] fantasy" that conceals the contradictions and incompleteness of the social system.[32] I take my approach from the logic of what Jacques Lacan calls the "signifier of lack in

the Other," the position with which the female subject identifies, but also the point where *jouissance* breaks through and disrupts the ideological fantasy. I also show that the approaches advocated by Pollock and Doane, by contrast, derive their logic from the phallic signifier, the position with which the masculine subject identifies. It follows that, from a Lacanian point of view, the strategy suggested by Doane, Pollock, and Mulvey unintentionally follows the masculine logic of the phallic signifier by focusing on points of consolidation of the symbolic. By contrast, the strategy that I suggest proceeds from the feminine logic of the signifier of lack in the Other with its emphasis on moments of symbolic disruption and the eruption of pleasure.

In addition to taking into account the production of pleasure, the strategy I suggest overcomes an impasse in much earlier feminist work on the visual. Although Doane's, Pollock's, and Mulvey's analyses provocatively grapple with the important question of the relationship of feminism to the visual, they reproduce a difficulty characteristic of most feminist scholarship of the 1970s and 1980s: the bifurcation of "sex" (as biological) and "gender" (as cultural). As Ellie Ragland-Sullivan explains, "either feminist position—reducing oneself to the sexual body as a way of attack, or [claiming] that sexual differences do not really exist except in language—ends up in an *impossible* feminism that leads right back to the *Real* as the encounter with an impasse Lacan calls the sexual-non-relation" (Ragland-Sullivan "SM" 55).

More recent work, particularly by Lacanian scholars Joan Copjec, Parveen Adams, Elizabeth Wright, and Ragland-Sullivan, follows Freud in asking us to consider sex beyond the polarized categories of either "anatomy" or "convention" (Freud "Femininity" 114). As Adams explains, "for Freud sexuality is a drive which inhabits and determines the space of psychical reality. There is a chasm between this [view] and the [usual oppositon:] ... the naturalness of sex [versus] the constructed nature of gender" (Adams "OFB" 247). On the one hand, the Lacanian view avoids the trap of essentialism by conceptualizing "the 'essence' of each of the two sexual positions as a specific form of inconsistency ... not some positive entity but an impasse" (Žižek *ME* 159). On the other hand, Lacan avoids lapsing into an account of sexual identity as "gender," a culturally constructed category; according to Lacan, rather than arising through a symbolic "performance" of signifiers, sexual difference is "the name for a certain fundamental deadlock inherent in the symbolic order" (Salecl *SF* 2). Both men and women, for Ragland-Sullivan, are "framed, then, not by language or biology, but by the desire that covers over whatever *jouissance* has been sacrificed, but remains in language or the body as an excess" (Ragland-Sullivan 60).

In order to explain the theoretical basis of my strategy of spectatorship, I turn to a discussion of the relation between Lacan and Roland Barthes and their respective accounts of points of disruption in visual images. Barthes, as we have seen, describes the *punctum* as a concrete, seemingly ordinary detail within a photographic image, which, due to contingent metonymic associations, takes on unexplained resonances. The presence of this accidental detail gestures toward an aleatory meaning that overreaches the image. In short, the *punctum*, which cannot be expressed in language, embodies the failure of the symbolic and thus belongs to what Lacan calls the domain of the "Real," which, as he describes, "can only be inscribed on the basis of an impasse of formalization" (Lacan *Encore* 93).

Through his concept of the gaze—as the "stain of the Real," which violates the image's symbolic consistency—Lacan theorizes visual disruptions of the symbolic field differently than Barthes. The gaze, like the *punctum*, arises from eruptions of the Real, but whereas the *punctum*'s uncanny quality emanates from the sense of the referent's concreteness, from its "overpresence," the gaze emerges as a vague, indeterminate, enigmatic blur in the viewers' visual field. In trying to make sense of the image, viewers are provoked not only to question what they see, but to also respond to what Lacan calls the *chè vuoi*: "'What do you want?'" (Lacan *Ecrits* 300). This, for Lacan, "is the question that best leads the subject to the path of his own desire, assuming that...he takes up that question...in the following form: 'What does he want from me?'" (300). Thus, by interrupting the image's symbolic coherence, the gaze becomes the place where the object appears to interrogate the viewer. It gazes "back at the subject, but from a point at which the subject cannot see it" (Evans 72).

Confusion between Barthes' concept of the '*punctum*' and Lacan's notion of the '*gaze*' persists in spite of Barthes' not so veiled reference to the distinctiveness of the two phenomena. Barthes, somewhat mockingly, distances his idea from Lacan's by making clear that "this photograph which I pick out and which I love has nothing in common with the shiny point which sways before your eyes and makes your head swim" (Barthes *CL* 18–19). Rather than simply amuse us as another occurrence of French poststructuralist rivalry, the confusion between gaze and *punctum* interests us for deeper, structural reasons. As I will explain, the gaze and the *punctum* partake differently in Lacan's economy of "objects." Whereas the gaze is an instantiation of the most famous Lacanian object, the *objet petit a*, I contend that the *punctum* corresponds to the object that Lacan calls "the signifier of lack in the Other," which he denotes by $S(\emptyset)$ (fig.7).

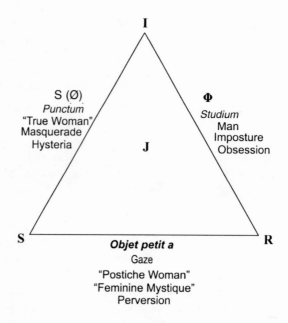

Fig. 7. Adaptation of Lacan's object diagram.

Before explaining the S(Ø), let me make a key point. In explicating his formulae of sexuation in *Encore*, Lacan alerts us that, under the masculine regime (of the phallic signifier), a confusion occurs, one which, I argue, is analogous to confusing the gaze with the *punctum*. The error, described by Lacan, involves "coalesc[ing] the *a* with the S(Ø)" (Lacan 73). Man, according to Lacan, mistakes the signifier of lack in the Other (the place where woman locates herself) with the *objet a* (the place of man's fantasy of woman). As I will be explain later, this means that man confuses the masquerade associated with the S(Ø) (through which woman conceals that there is really nothing—no "true" feminine essence—to conceal) with the ineffability associated with the *objet a*, (that which gives the misleading impression that there is an inexpressible essence to woman.) In short, man mistakes the masquerade through which woman conceals her lack as a sign of her mystery, her "feminine mystique." (As I indicated in the previous chapter, the lack to which Lacan refers here is common to both sexes—the difference between them, as will be discussed, lies only in the ways that they conceal it.) The analogy between the two mistakes—on the one hand, mistaking the *punctum* for the gaze and, on the other hand, mistaking woman's masquerade for mys-

tery (which, in turn, recapitulates mistaking a "coalescence" of S(Ø) with *a*)—will further compel an examination of the interrelationship of the scopic and the sexual through the Lacanian economy of objects.

VISUAL OBJECTS

To explicate the notion of the Lacanian object, I turn to Žižek who, characteristically, offers us a joke, one appropriately about a visual image: A Moscow art exhibit displayed a picture, entitled *Lenin in Warsaw*, that shows Lenin's wife in bed with "a young member of the Komsomol." A confused visitor, after closely examining the image asked the guide, "[B]ut where is Lenin?" As Žižek tells it, "the guide, quietly and with dignity, replied, 'Lenin is in Wasaw'" (Žižek *SOI* 159). The visitor's mistake occurs because he presumes a Saussurian relationship between the image and its title—as if between sign and referent. In the case of the picture described by Žižek, however, rather than commenting metalinguistically on what is in the picture from "outside" as a Saussurian title would, the title *Lenin in Warsaw* functions as what Lacan (following Freud) calls "the *Vorstellungsrepräsentanz*." The title embodies what is *missing* from the picture from "inside" the same signifying plane as the picture itself occupies. In particular, it functions as a part of the picture rather than as an explanation external to it. In other words, the picture becomes the materialization of Lenin's absence, while conversely, Lenin's absence constitutes the positive condition for the image's existence (since as Žižek points out, "if Lenin were not in Warsaw ... [his wife] would not be ..." (160).

Whereas the Saussurian signifier evokes a concept, the Lacanian object, as *Vorstellungsrepräsentanz*, materializes "its lack ... this hole in the Other" (160). For Lacan, therefore, the object is in "no way in the same register or made of the same stuff ... as the signifier" (Lacan *Encore* 29). The "object" by embodying the lack in the symbolic order functions both as "the hole *and* that which stops it" (Adams 104). In *Encore*, Lacan details a typology of three such objects, each of which represents a different way to avoid the unbearable *jouissance* around which it circles. The three Lacanian objects each functions as a special form of *Vorstellungsrepräsentanz*, palliating our encounter with eruptions of the Real. Each of the three objects, each, as Lacan says, designated by a "different letter ... because they do not have the same function," tames the threat of the Real by filling out its place, each according to its own specific modality (Lacan 29).

Although themselves disturbing remnants of the Real, each object, nonetheless, offers a psychic structure enabling us to produce pleasure in the face of brushes with the Real.

The *objet petit a*, a little piece of the Real that resists symbolization, is the first object. It can be thought of as both the privileged object around which the drive circulates and the object cause of the subject's desire. Located across from the Imaginary register in the Lacanian diagram of objects, it takes the appearance of what Lacan describes as an "imaginary envelope," a concrete but imaginary appearance that acts as a lure for the gaze. Evanescent, upon close inspection the lure gives way to a void. Although it lacks ontological consistency, it appears in the form of a *semblant* (a pure semblance), a partial object that both fascinates and repels, yet "dis-sembles" under our scrutiny. In Lacan's words, the *objet a* "would have us take it for being.... But it only dissolves in the final analysis, owing to its failure, unable, as it is, to sustain itself in approaching the real" (Lacan *Encore* 95).

The gaze, a "meaningless stain," which threatens the image's symbolic coherence, belongs to the order of the *objet a* as the object of the scopic drive. As Henry Krips explains, through the gaze, the dual needs of the scopic drive—to see and to be seen—are . . . engaged, bringing pleasure to the viewer "by stabilizing the libidinal flux associated with such paired needs, neither of which fully fixes upon its object" (25). By provoking anxiety from the viewer who is unable to master her visual field, the gaze seduces viewers to "look back at what they have seen, thus scrutinizing themselves, and specifically their own role as viewers.... [T]hey feel themselves to be the object of a 'look' coming from the object's vicinity" (Krips 27).

The way a subject responds to the encounter with the gaze depends upon her or his libidinal economy. The obsessive, for example, threatened by the question of the Other's desire, struggles to understand this object, attempting to integrate it back into the symbolic framework. The hysteric, by contrast, engages the question of the Other's desire; she perceives the lack in the Other and wonders what type of an object she can be for the Other. Both the obsessive and the hysterical structures emerge as responses to the drive initiated by the gaze.

In addition to functioning as the object around which the drive circles, the *objet a* emerges as the object-cause of desire. In particular, according to Lacan, Man relates to Woman and engages desire through the function of the *objet a*. As Lacan explains, Man "is unable to attain his sexual partner . . . except inasmuch as his partner is the cause of his desire . . . [thus rendering the sexual relationship] nothing other than fantasy" (Lacan *Encore* 80). In part, the sexual relationship can never exist since, as Žižek describes, "the feminine mystery beneath the provocative masquerade forever eludes the male grasp" (Žižek *FRT* 91).

Here one should avoid confusing the *objet a* (the object cause of desire) with the object of desire (the desired object). As Adams describes, the *objet a* "comes before desire. Desire... misrecognizes the object because when it pursues the object, it fails to recognize that the object is not in front of desire, but before it" (Adams 78). Man, while desiring Woman (the object *of* his desire), nevertheless tends to focus his energies around the elusive "feminine mystique" (the object *cause* of his desire). Woman's mystery, thus, fascinates man, sparking his desire, while at the same time standing in his way of relating to the true Woman whom he desires. Through Krips' fertile example of the elderly chaperone, we can better understand how the *objet a*, while appearing as an obstacle to attaining the true object of one's desire, turns out also to be the cause of that desire. Although officially the barrier for the suitor in his quest for the beloved, the chaperone "becomes part of what causes his desire," "without her, the whole economy would collapse" (Krips 9; Salecl *SF* 5). The figure of the chaperone thus emerges at "the center of the evasive activities through which [the suitor] produces his pleasure" (28).

Through this example, we can see how a perverse subject, "afraid of getting what he wants," can identify with the position of the *objet a* as a way of regulating his *jouissance* by taking on the desire of the Other. By identifying with the *objet a*, the subject, as Krips puts it, "'gives up on his own desire' and dedicates himself 'perversely' (as we say) to abetting the *objet a* in its function as impediment to desire" (Krips 29).

Although (as I will argue in more detail in the next section) the "True Woman" refuses to identify herself within the perverse structure offered by the *objet a*, I suggest, following Jacques-Alain Miller, that there exists a "fake" woman who is indeed perverse (and in this sense I sustain the standard Freudian reading that real women are not perverts; the perverted woman here, turns out to be a "fake.") This woman to whom Miller, reworking Lacan, refers as the "postiche," or "fake woman," conspires with Man to support the illusion of symbolic closure. She refuses recognition of her lack by "placing [her]self in the real [as *objet a*], the only place where nothing is lacking, where knowledge is certain" (Copjec 109). The "postiche" woman asserts herself as the impossible archetype of true womanliness (fulfilling expectations as wife and mother), giving the impression of "a firmly anchored being," around which "her man has to run... wildly" (Žižek "TFIS" 232).

The perverse "fake" Woman (who gives herself completely to her husband and children, putting their desires ahead of her own) trades in her desire for the desire of the Other. As Miller, following Freud and Lacan, puts it, "to become a mother, to become the Other of demand, is to become 'she

who has' par excellence'" (Miller 16). Žižek, too, stresses that for Lacan, "there is an ultimate antagonism between Woman and Mother: in contrast to woman who does not exist, mother definitely *does* exist" (Žižek 232 "TFIS"). Yet, as Žižek emphasizes, one must be careful not to view this putting of one-self aside as simply a matter of sacrifice. Not only is the subject rewarded by the pleasure produced by her perverse activity, but it is also, for Žižek, a "false" sacrifice in the sense that it serves to "dupe the Other" (246). By engaging in the structure of what seems to be a sacrifice, the subject, in effect, stages "confirmation" that s/he indeed possesses, or rather would possess what s/he is giving up. For example, the woman who "sacrifices" career, other lovers, and so on, for the "good of her family" "demonstrates" that she would indeed have these things if not for commitment to her family.

The second of the three objects is the signifier of lack in the Other, S(Ø), a not-so-obscure object, an ordinary object that, due to mere contingency, becomes elevated to the dignity of "the Thing." According to Lacan, the signifier of lack in the Other is the object with which the feminine subject identifies. The connection of the signifier of lack in the Other to the opposing realm of the Real in the Lacanian diagram characterizes it as an excess of the symbolic function. Woman, as Bruce Fink explains, "is not alto-gether subject to the symbolic order.... [She is] *not* ... wholly hemmed in" (Fink 107). This feminine libidinal economy operates beyond the phallic function. One must be careful, however, when interpreting the sense in which Woman is "beyond" the symbolic function. As Jacqueline Rose cautions, it would be a mistake to say "woman is excluded *from* the nature of words, [that she is] outside language. [Rather,] woman is excluded *by* the nature of words, meaning that the definition poses her as exclusion" (Rose 73). Salecl poses an even more radical interpretation, contending that because there is no "ineffable feminine secret ... there is nothing in her which is *not* caught in the symbolic order" (Salecl *SF* 8).

Woman distinguishes herself in relationship to the symbolic, particularly in terms of how she conceals the lack in the symbolic. Drawing upon Miller's distinction between the "True woman" and the "postiche (or fake) woman," one should specify that only the "True" Woman identifies herself with the signifier of lack in the Other. The True Woman, unlike the postiche woman, "flaunts her lack" rather than disavowing it. In this sense, like the signifier of lack in the Other (as well as its particular instanciation of the *punctum*) the True Woman emerges as a "*tuché* of the Real ... a jolt of surprise" (Miller 17). The "True Woman," paradoxically, renounces the expectations usually associated with being a "true woman"; she does not seek refuge in the stability of

maternity and domesticity but rather embraces "a hysterical composite of semblances" (Žižek "TFIS" 231).

The True Woman rejects her association with the *objet a* as staged by Man's fantasy. Here we encounter an instance of what Salecl describes as "the major problem of the male and the female subjects[:...] that they do not relate to what their partner relates to in them"(Salecl *SF* 304). The incongruity between aligning oneself with the S(Ø), but being related to by Man through the structure of *objet a*, leads the True Woman to enact a structure of hysteria in which she continually questions what it is about her that Man desires. Her fundamental question, therefore, becomes a variation of, What is the desire of the Other? What does the Other want from me? Why am I what the Other desires?

In asking these questions, the hysteric both occupies and foregrounds the abyss(m)al place that the symbolic order falls short of integrating. As Žižek explains, "the hysterical question articulates the experience of a fissure, of an irreducible gap between the signifier that represents me...and the nonsymbolized surplus of my being-there" (Žižek *LA* 131). True Woman, in the position of the signifier of lack in the Other, "assumes her nonexistence, her constitutive lack...that is, the void of subjectivity in her very heart" (Žižek "TFIS" 231). The "True" (hystericized) Woman, in brandishing and interrogating her lack, "poses the serious threat to...the firm male substantial self-identity" (232). Woman's incessant questioning challenges Man as an affront to the symbolic system on which he stakes his identity. Yet for Woman, the hysterical response offers her a way to regulate her distance to the *jouissance* that swirls around her. In flourishing the signifiers of femininity (and here think of Marilyn Monroe), the True Woman exposes their very artificiality, thus "reveal[ing] to man the absurdity of having [the phallus]" (Miller 22). In this sense, Miller claims that a "true woman...is man's ruination" (22). By contrast to the "True Woman" who unsettles Man, the Postiche Woman, by putting herself in the position of the *objet a*, props up Man's fantasmatic structure. "Not only," as Žižek contends, "does [she] not pose any threat to the patriarchal male identity, but [she] even serves as its protective shield and support" (Žižek "TFIS" 232).

While the Postiche Woman, like the set of cultural conventions that Barthes terms the "*studium*," supports the illusion of a symbolic whole, the True Woman, like the disruptive *punctum*, pokes at the symbolic's holes. The *punctum* detail unleashes itself from its banal symbolic existence and circulates as a fascinating source of *jouissance*. This release of enjoyment, provoked by the *punctum*, shares a similar structure to what Lacan calls "the *sinthome*,"

a fragment of the symptom "stripped of its symbolic parts" that not only resists symbolization but also gives rise to a *jouissance* that provides the subject with points of identification (Verhaeghe 144). According to Lacan, psychoanalysis requires the subject to move beyond the symbolic realm of fantasy that "protects the real" and to identify with the *sinthome* (Lacan *Sem XI* 41).

In Miller's description, the end of analysis occurs when analysands "attest to the fact that psychoanalysis has cured them of their lack of being" (Miller 26). In the *sinthome*, that persistent bodily residue of the unsheathed symptom, the subject recognizes "the element that guarantees [her] consistency" (Žižek *LA* 137). By identifying with the *sinthome*, the subject accepts that these "formations with no meaning guaranteed by the big Other, 'tics' and repetitive features,...merely cipher a certain mode of *jouissance*" (Žižek *FRT* 98). According to Miller, "it is the revelation of this *jouissance* that eliminates their lack of being" (Miller 26). In this sense, Miller reminds us that "Lacan privileged the end of analysis on the feminine side" (27).

The last of the three objects is the phallic signifier, Φ an object with a fascinating material presence that represents the Real. The phallic signifier, located across from the Symbolic register in the Lacanian diagram (and therefore governed by the signifier) interrupts the endless unfolding of signification by imposing a "stopping point...that puts an end to association" (Fink 135). The phallic signifier thus provides the illusion that the symbolic is complete after all. The pretence of the fullness of meaning associates the phallic signifier with the *studium*. The *studium*, in contrast to the *punctum*, is the level of the photograph, that whether shocking or banal, can always be named, is "ultimately always coded," and as such exists completely under the reign of language (Barthes *CL* 51). For Barthes, even the most sensationalist journalistic photograph belongs to the register of the *studium*. As he describes, "in these images, no *punctum*: a certain shock—the literal can traumatize—but no disturbance, the photograph can 'shout,' not wound" (41).

According to Lacan, although both men and women are "free to situate themselves [under the phallic signifier] if it gives them pleasure to do so," the phallic signifier is nonetheless "the pole where Man is situated" (Lacan *Encore* 71). Man's libidinal economy is structured according to the logic of the phallic signifier in that, as Lacan puts it, "it helps men situate themselves as men and approach woman" (71). Although Man may "approach" Woman, in a Lacanian sense, the two sexes may never come together. Again we encounter, in a slightly altered form, the "major problem" of the sexes to which Salecl draws our attention: that men and women do not relate to what their partners relate to in them. The phallic signifier, although located under

Man's pole (so to speak), is, in Salecl's words, "nothing a man can be happy about. Although a woman relates precisely to this phallus, the man is not at all in control of it" (Salecl SF 304). By committing himself obsessively to upholding the symbolic function (often by taking great care to establish routine and order), Man attempts to stave off encounters with the desire of the Other that might destroy his fantasy of wholeness. Man fears, as Salecl describes, that he "will...be stripped naked, exposed in his essential impotence and powerlessness" (306).

Although the "real" Woman "ruins" Man, it must be said that, to some extent, she also *creates* him. It is in this sense that we may interpret Lacan's adage, that "woman is the symptom of man." As Žižek explains through the example of Wagner's *Parsifal*, the very same wound that is killing Amfortas is simultaneously the only thing keeping him alive: "as long as his wound bleeds *he cannot die....* It is destroying him, but at the same time it is the only thing which gives him consistency.... This is the symptom: an element which causes a great deal of trouble, but its absence would mean even greater trouble: total catastrophe" (Žižek SOI 76, 78).

Similarly, Man's identification with the phallic signifier (which lends him the impression of authority and knowledge) is not only threatened by Woman's ceaseless provocations, but it is also constituted by them. She functions as both his impediment and his condition of possibility. Thus, the "hysterical subject makes a master out of the other" (Verhaeghe 27).

Whereas Woman's response to lack manifests in a hysterical structure, Man's response, to avoid the desire of the Other, takes on the characteristics of obsession. As Ellie Ragland describes, "the feminine masquerade automatically poses a question, while masculine identification with law, logos, or authority tries to stop the question" (Ragland-Sullivan 75). As I will point out, Man's efforts in this respect are not without reason, since there is great risk involved in staking one's identity on the rigidity of the phallic signifier. The phallus, marked by its "pretence to meaning and false consistency" turns to the Other to "seek authority [but] is refused" (Rose 75). "The hitch," as Lacan puts it, "is that the Other, the locus, knows nothing" (Lacan 98).

SEX OBJECTS

By "Woman" and "Man" in the previous discussion, I am not, of course, referring to biological categories, nor to their cultural overlays, but instead to the two positions that a subject can take in response to the symbolic system's failure to confer an identity. For Freud and Lacan, sexual difference, like the visual disturbances of the gaze and the *punctum*, emerges from this failure of the symbolic. As Joan Copjec puts it, sex comes into being

"only where discursive practices falter—and not at all where they succeed in producing meaning" (Copjec 204). The two sexes mark the two logically possible ways in which the symbolic fails; they represent its two "modalities of misfire" (Copjec 213).[33] In Lacan's words, "there is a male way of botching the sexual relationship, and then another...the female way" (Lacan *Encore* 58, 57). "This botching," Lacan claims, "is the only way of realizing that relationship if, as I posit, there's no such thing as a sexual relationship" (Lacan 58). For Lacan, the masculine mode of misfire corresponds to the phallic signifier, whereas the feminine mode corresponds to the signifier of lack in the Other. Positions of sexuation, therefore, arise not as a matter of convention or nature, but rather as a matter of logic, as demonstrated by the mathematical formula introduced by Lacan and analyzed with particular acuity by Joan Copjec in *Read My Desire*.

In this approach, the position of the feminine subject is characterized by the famous "not-all." To be specific, the formula for Woman is given in terms of the following apparent contradiction: *Not all* are submitted to the phallic function, but at the same time there is not one who is not submitted to the phallic function. Woman is, by definition, that which impossibly satisfies this contradiction, from which Lacan's provocative claim that "[The] Woman does not exist" follows. Unlike Man who is governed by the phallic signifier's imposition of a limit to signification, Woman, as Copjec explains, "is there where no limit intervenes to inhibit the progressive unfolding of signifiers, where, therefore, a judgment of her existence becomes impossible" (Copjec 234). In short, according to this formula, although there are certainly individual "women," there is no archetypal Woman. Of course, women, like the $S(\emptyset)$, appear in everyday life, in a concrete form, but they contain no essence. Through the masquerade, women, like the $S(\emptyset)$, *seem* to exude an essence; it comes, however, not from being the "transcendent Thing-in-itself," but rather from "occupy[ing] [its] place, [from] fill[ing] out the empty place of the Thing" (206).

The position of the masculine subject, by contrast, emerges from a different apparently contradictory formula: there is at least one who is NOT submitted to the phallic function, but at the same time every one is submitted to the phallic function. The "one" refers here to the primal father—The Man—whose unlimited *jouissance* provides the point of exception through which existence can be conferred on "every man." This point of exception connects men to the phallic signifier by providing a place for the illusion of a complete symbolic male identity. In an inversion of the feminine case, however, although there is an essence of Man (as realized by the exception of the primal father), no *individual* men exist who embody this essence.

As Copjec explains, "Lacan defines man as the prohibition against constructing a universe and woman as the impossibility of doing so. The sexual relation fails for two reasons: it is impossible and it is prohibited. Put these two failures together; you will never come up with a whole" (Copjec 235). Rather than function as a positive designator of identity, "masculine" and "feminine" function as "a purely negative determination, one which merely marks a certain limit" and attest to what Copjec describes as the "fraudulence at the heart of every claim to positive identity" (Salecl 116; Copjec 234).

In this sense, "masculinity" and "femininity," both, in their different ways, involve elements of deception: as Copjec tells us, "all pretensions of masculinity are...sheer imposture [since there really are no men who can be the "real Man"]; just as every display of femininity is sheer masquerade [since woman recognizes there is, in fact, no feminine essence]" (234). Clearly, these strategies of imposture and masquerade do not correspond directly to the subjects we identify as biological men or women but instead may be taken up by either men or women in different discursive situations.

An asymmetry exists between the masculine side and the feminine side, however. The excessive "display" of masculinity often appears feminine. Lacan, himself, observes that "virile display in human beings seem[s] feminine" (Lacan *Ecrits* 280). We may want to think here about men's professional bodybuilding, in which a man displays extreme attention to his appearance, intently watching his shaven and oiled body in the mirror while he flexes his muscles. An excessively feminine display, by contrast, does not risk shading over into the side of the masculine. Here I oppose Emily Apter's claim that strategies of femininity are more "tenuous" than strategies of masculinity. On the contrary, I argue that this asymmetry suggests a precariousness within the masculine strategy of imposture that is unparalleled by the more flexible, and thus more stable, strategy of masquerade, a distinction that I will elaborate further.

Elizabeth Cowie links the differences between masquerade and imposture to the role the phallus plays in each strategy. Although the phallus gives the impression of power, it is, after all, as Lacan reminds us, "a signifier that has no signified" (Lacan 81). The phallus' status, according to Rose, "is a fraud.... [A]ny male privilege erected upon [it] is an imposture" (Rose 75). As another critic puts it, "if the penis was the phallus, men would have no need of feathers, or ties or medals... [Imposture], just like the masquerade, thus betrays a flaw: no one has the phallus" (as quoted in Cowie 245). Since "no one has the phallus" (the privileged object of the Other's desire), imposture can be thought of as the strategy man employs to hide this "flaw." As Stephen Heath explains, man demonstrates "all the trappings of authority,

hierarchy, order, position," but according to Cowie this fools no one, since "what is signified in a making present of something is in fact a statement of what is absent" (Heath as quoted in Cowie 244; Cowie 245).

One can liken this masculine modality of imposture to one of the two strategies Erving Goffman offers as ways to cover over a balding head.[34] The response of wearing a toupée follows the logic of imposture; it functions as an attempt to hide "the flaw," but if its presence becomes apparent, it works instead to draw attention to what is absent. In that respect, then, rather than mask one's lack of hair, a toupée functions as a signifier of that very lack. In short, imposture is a precarious strategy that carries high stakes—the claim to possession is complete—but if it goes awry (and there are endless ways that it can and does), everything is lost. Thus, in contrast to Apter's insistence on the stability of masculinity, Kaja Silverman is correct in suggesting that "masculinity is particularly vulnerable to...unbinding...because of its ideological alignment with mastery" (Silverman 46–47). Or as Ragland-Sullivan points out, "paradoxically [Man's very] effort at mastery shows a lack—a lie as the basis of the symbolic" (75–76).

The feminine strategy of "masquerade," by contrast, retains an ambiguity concerning the nature of the deception; through a strategy of masquerade, woman keeps us guessing. Where, exactly, does her dissimulation lie? Cowie follows Riviere in considering masquerade as a "mask of womanliness... [to be] assumed... both to hide the possession of masculinity and to avert the reprisals expected if she was found to possess it—much as a thief will turn out his pockets and ask to be searched to prove that he has not the stolen goods" (Riviere 176). Rather than follow Apter in indicting the masquerade because it carries the danger for woman "to get caught in her own act," I suggest that the strength of the strategy of the masquerade emerges precisely from this ambiguity.

Thus, the feminine modality of masquerade functions analogously to Goffman's second strategy for covering baldness: wearing a hat. A hat does not carry the pretence of hair but instead functions enigmatically in relation to the balding head. Does one don the hat to conceal the lack, or could it be worn simply for fashion or to keep warm? In masquerade, it is never certain what exactly is being claimed, and what, if anything, is being concealed. It follows that, unlike a toupée, a hat could fall off at very little cost to its wearer. Masquerade thus emerges as a far more stable strategy than imposture. Whereas imposture carries the burden of accomplishing an identity based on the illusion of knowledge, masquerade accepts the knowledge that identity is itself an illusion.[35]

TRANSGRESSING "THE LAWS OF URINARY SEGREGATION"

The Lacanian strategies of "masquerade" and "imposture" can perhaps be illustrated through a final bathroom story, this one an experience recounted to me by my aunt.[36] Having mistaken the signifiers on the otherwise identical bathroom doors, my aunt entered into the men's toilet. The sight of a man at the urinal immediately prompted her quick retreat, during which she muttered (by way of an attempted apology?) "Sorry—I didn't see anything." The man very quickly called out after her: "You didn't see *anything?*!"

This final story, like the ones in the previous chapter, depicts sexual difference as a "misrecognition of place." It picks up resonances of both the Freudian and Lacanian scenarios, while avoiding the equation of penis as phallus that we encountered in Rodowick's story. (If only things were that simple for Man!) But, in this final story, sexual identity has nothing to do with the presence or absence of the penis but instead is predicated upon the failure of the symbolic to ultimately ground our identity. The symbolic, exemplified by the signifiers above the doors, never comes with a guarantee. But, although in this sense the symbolic always and already lets us down, it is all that we can depend upon. As Yannis Stavrakakis explains, "if the imaginary...is always built on an illusion...[our] only recourse is to the symbolic level, seeking in language a means to acquire a stable identity" (Stavrakakis 20).

In this final story the woman displays the masquerade, the man enacts the impostor, and they experience the "nonrelation" that ensues. At the level of form, the woman's statement acts as a gesture to save man's integrity. Unfortunately for the impostor, however, it is no more effective than trying to reassure a man whose toupée slips by saying, "It's okay, I didn't notice!" This difficulty manifests itself quite literally in the content of my aunt's words ("I didn't see anything") through which she confronts the lack (i.e., that there isn't *anything*) at the root of our sexual identities. In this remark, she expresses the truth that Man elaborately tries to avoid: not just that he has *something* that he would not want her to see, but worse yet, he indeed has *nothing to see.*

Rather than ask the Woman to confirm that he does have "it" (penis = phallus), the Man in this last example helps us to see the more precisely what is at stake for the impostor. What the impostor works hardest to sustain is what Salecl refers to as "the symbolic fiction"—the belief in the authority of the Other (as the symbolic order—with its laws and rituals—upon which he can construct an identity as master). But once this symbolic fiction falters, people want to see what is behind the fiction (Salecl 151). Such inquisitiveness leads one to encounter the traumatic "nothing" so laboriously disguised

by Man's attempts at mastery. But, without a belief in the big Other, Man's claims to completeness are shattered. He, therefore, appeals to Woman to reinvest in the symbolic fiction, to believe "in *words*, even when they contradict one's own eyes" (151). Such an investment characterizes the obsessive economy of the imposter, whose identity, uniquely vulnerable to symbolic disruptions, perches delicately upon a shaky foundation.

CODA

I return to the question with which I began this chapter: Can there be a feminist spectatorship that, while avoiding viewer identification with the fetishized onscreen image of woman, preserves the possibility of pleasure? I argued that psychoanalytic, feminist film theory, exemplified by the work of Mulvey, Doane, and Pollock, has approached the question of subversive female spectatorship through the masculine logic of the phallic signifier. They structure their concerns around "unpleasure," distance, and meaning (as associated with the cultural inscription of meaning characteristic of the *studium*). Thus, like the obsessive masculine impostor, followers of this approach obsessively look for answers in order to prevent any questions from being asked of them. By contrast, I suggest a feminist approach to female spectatorship, one that, insofar as it takes seriously moments of enjoyment, derives from the feminine logic of the $S(\emptyset)$, focuses on points of identification: seeking out eruptions of the Lacanian Real (as glimpsed through the *punctum*'s disruption of meaning) and thus enticing viewers to take seriously the question of their desire.

Doane's suggestion that feminine spectators should inhabit the masquerade sends us in the right direction. But whereas Doane suggests the mask as a way to foreclose pleasure and forge a critical distance between spectator and image, I want to recognize and embrace the pleasure afforded by identifying with the mask. In particular, I seek to supplement the purely interpretative projects of the sort envisaged by Mulvey, Doane, and Pollock with a procedure for articulating the "kernel of *enjoyment*" that resists incorporation into the ideological field. But whereas Mulvey, Doane, and Pollock concentrate on the consolidation of the ideological fantasy, my suggestion focuses, also, on its points of inconsistency, which are made "palpable" through the "eruption of enjoyment in the social field" (Žižek *SOI* 126). In Žižek's terms this ideological fantasy "is not to be interpreted, only 'traversed:'... we have to...experience how there is nothing 'behind' it, and how fantasy masks precisely this 'nothing'" (Žižek 126).

In particular, I suggest that feminist media studies take seriously what Žižek credits as "Marx's great achievement:" the demonstration that "all phe-

nomena which appear [as] contingent deformations and degenerations of the 'normal' functioning of society [such as the "accident" of the *punctum*] ... [are] necessary products of the system itself—the points at which the 'truth,' the immanent antagonistic character of the system erupts" (Žižek 128). This view converges with Freud's contention that rather than study an analysand's coherent narrative, the analyst must look instead to "dreams, slips of the tongue, and similar 'abnormal' phenomena"—phenomena which, exceeding the symbolic integration of the phallic economy, are marked by the production of *jouissance* (128). This approach involves a commitment to what Richard Howard describes as "instanc[ing] our ecstacy, our bliss ... against the prudery of ideological analysis" in order to severely undermine the fantasy that lends ideology its support.[37]

Finally, let me emphasize that although the approach I develop takes its form from the feminine structure of the S(Ø) and the *punctum*, I do not take *this* as the basis of its appeal. In particular, it is not the "feminine" nature of the strategy that makes it advantageous for feminism. On the contrary, to emphasize its "feminine" nature runs the risk of reproducing the essentialism and the valorization of the feminine that we find in difference theory feminism. Rather, my interest in this particular scopic strategy lies in its potential as a *strategy* for a subversive politics, which arises from the fact that, as Miller points out, the feminine side of the Lacanian strategies of sexuation is the province of the subversive, the political, but also of the cure. Although it must immediately be stated that, from a feminist perspective, any politics based on the categories of feminine and masculine (woman and man) must attempt to displace the ideological and fantasmatic structures which ground these very distinctions. The true challenge, then, is how to keep these distinctions in play while avoiding the risk of essentialism.

Chapter Five

Opening up to the *Punctum* in Jamie Wagg's *History Painting: Shopping Mall*

In May 1994, a carload of five fervent men from Liverpool, armed with ink-filled syringes, made its way to London's Whitechapel Gallery. Upon entering the gallery they demanded to be escorted to the painting that had motivated both their wrath and their journey, Jamie Wagg's adaptation of two-year-old James Bulger's abduction by two ten-year-old boys from a Liverpool shopping center, entitled *History Painting: Shopping Mall*. Although emotionally and combatively equipped, the men were, nonetheless, totally unprepared for the sight that would greet them. Expecting to see what one of the men described as "blood and guts," they discovered only a computer-generated ink-jet painting of the already familiar surveillance camera footage that widely circulated in Great Britain's newspapers and tabloids: a picture of a toddler holding hands with a bigger boy, striding alongside another child in a shopping center in Liverpool—a scene that would later be scrutinized as the main clue in the abduction and subsequent murder of Bulger by the older boys. Apparently disappointed by the anticlimactic conclusion of their mission, one of the men exclaimed, "What was all the fuss about? I've seen this a million times!" and with that turned around and motioned his buddies back to the car for their six-hour journey home. The painting itself failed to sustain the passionate posture that talk of it had sparked (fig. 8, 9, and 10).

Yet, for many other visitors, confrontation with the painting nourished their outrage. One visitor did indeed vandalize the painting by scratching it with a key (which poses only a minor nuisance for creators of computer-generated art), while others mobilized child activist groups to stage protests, and still others turned to intimidation and harassment of the artist himself—sending death threats and making menacing phone calls to his home.

69

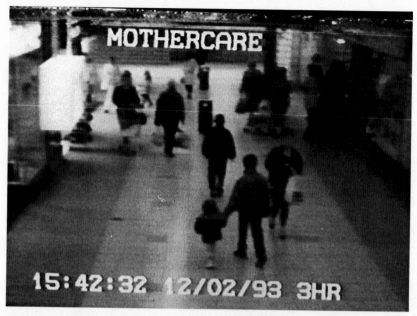

Fig. 8. Surveillance footage of James Bulger's abduction.
Mercury Press Agency, Liverpool.

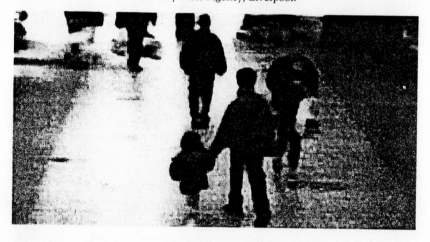

Fig, 9. Press image of James Bulger's abduction.
Mercury Press Agency, Liverpool.

Although these two sets of responses—retreat and aggression—initially appear to be opposed, I suggest that they are both expressions of the same logic: the attempt to cover over and avoid confrontation with the senseless reality that the image indexes. The response of the would-be vandals can be

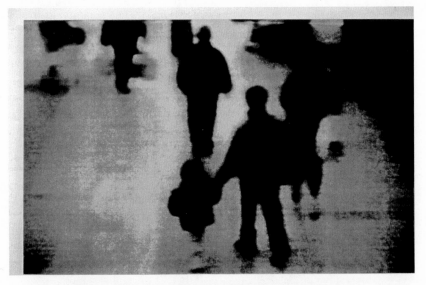

Fig. 10. Jamie Wagg, *History Painting: Shopping Mall* 1994.
Courtesy of the artist.

seen as an attempt to regain mastery by calling upon the "belongingness" of the image in the newspapers. Framing the unfathomable horror in terms of the familiar, routinized codes of the press works to constrain the polysemy of the image that the gallery context unleashes. The vandals, protestors, censors, and harassers also attempt to reinscribe the incomprehensible into the expected order of things. Their approach tries to regain mastery by extinguishing any embers of ambiguity and inscrutability. Both attempts, I will argue, coincide with the strategy of deception to which I refer in the previous chapter—what Jacques Lacan calls "imposture."

But it is a third group of responses that interests me most, responses that often go unremarked in part due to their private nature, namely, responses of viewers who, allowing themselves to be challenged by the questions that Wagg's image provokes, identify with, rather than retreat from, the incomprehensibility with which Wagg's image confronts them. What does he want from me? Why am I looking? These responses, I shall suggest, correspond with the strategy of deception that Lacan calls the "masquerade." A viewing strategy, which engages the strategy of "masquerade," involves articulating, rather than covering over, points of symbolic dissolution. By identifying with, rather than disguising, the inconsistencies, excesses, and antagonisms in the symbolic, such strategies move toward "traversing the [ideological] fantasy," which, in turn, opens the possibility of political subversion. Wagg's image, as it intersects the social and the psychic, not only creating and embodying

social practices but also precipitating viewer anxieties and pleasures, provides us with an opportunity to explore how this may be accomplished.

Although the original image from which the painting was made circulated frequently in the press without controversy, when the reworked image moved into the field of "art," it provoked intense debate. I consider this movement and change in reception in three stages: (1) the image starts life as a "police"/"identity" image (as surveillance camera footage); (2) the image enters the popular press, where it mass circulated and became commodified as a recognizable and evocative visual signifier; (3) the image is reworked and enters the space of the art gallery, where it becomes a central target of what amounted to a major moral panic. The question upon which I focus is why the image met no protest in its second stage when it circulated in newspapers to millions of viewers, but in its third stage as "art" in the confined space of the gallery, it provoked intense reactions? I shall focus primarily on the image in its last incarnation as art, drawing only briefly upon certain significant, and perhaps stealthily problematic, features of the image's appearance in the earlier two stages: first as "police" image and then as press photograph.

SECURITY IMAGE

The shopping mall security camera that shot the image of the abduction-in-process was installed to deter theft; its purpose was to protect things and not people. As Mark Cousins explains, "the more 'secured' a territory is in respect to property, the less safety of humans becomes an objective. For the purpose is to protect territory and...property against humans" (Cousins 7). This is easy to forget since by the time we see the footage from the tape, we retrospectively impose the narrative of abduction, which did not inform its production but nonetheless serves to justify the illusion that surveillance cameras are installed to protect people, thus masking their actual purpose: to protect private property *from* people.

PRESS IMAGE

The surveillance image moves smoothly into the realm of the "press" photograph. Its transition is facilitated by the fact that the press draws upon the authority of police images, to legitimate its own status as objective and reliable, which in turn fosters the illusion that the news is "unbiased," unaffected by commercial or political values, and free of institutional constraints. Yet, as Stuart Hall and others have emphasized, newspaper editors, in large part, base decisions concerning what to print and how often to print it on bureaucratic restrictions, such as time deadlines and the need to make a profit in a context

where they have limited financial resources, as well as on the need to maintain an appearance of professional values, particularly, the commitment to an ethics of objectivity (Hall "SPN"). These criteria for selection, according to Hall, have the unintended consequence of newsmedia "over-accessing institutional spokespeople," who obligingly provide ways of "fitting" potentially "problematic realities" within conventional understandings of the world. This process erases the newspapers' status as a commodity and its contents as editor-selected items. Yet, I shall argue, these two features of the image, as both commodity and editorialized artifact, were central to the controversy surrounding Wagg's rendition.

Critics expressed great outrage that *Wagg* had turned the security image into a commodity, accusing him of making money from the tragedy. For insurance purposes Wagg had indeed placed a price on the image while it was displayed at the Whitechapel, but it was not for sale. Yet many critics cite the "price tag" as the sickest aspect of Wagg's painting, ignoring both that it was the tabloids rather than Wagg who were making a profit from the image and that art costs money to produce, requiring its practitioners to safeguard the products of their labor. Although newspaper editors *elected* to include this image in their papers, only *Wagg* was called "sick" for *choosing* to include the image in his work.[38]

The press officially justified publishing the picture by claiming that it would help to identify the abductors. By contrast, Wagg's image, exhibited long after Bulger's body was found and the boys apprehended, could call upon no such justification. At first sight then, the divergent receptions of the images are easily explained: Wagg's image, it seemed, lacked proper justification and thus directly confronted viewers with their own prurient curiosity. But a difficulty arises for this explanation. The official justification was clearly a pretext. The grainy, shadowy images of the backs of the figures were impossible to recognize. Thus the following paradox emerges: if in the case of the press image the pretext was seen through, then why would its absence in the case of Wagg's appropriation drastically alter its reception?

I suggest that although the pretext of public safety as a justification for the press image was "seen through," it nevertheless provided strong support for the circulation and reception of the image. Not because it was credible, but rather because of its very *transparency*, the pretext provided viewers with a pleasurable opportunity for ironic distance, thus performing the ideological function of allaying anxiety. In short, the transparency of the pretext allowed viewers to look, while keeping their ideological fantasy intact. "Seeing through," as Slavoj Žižek puts it, "blinds [us] to the structuring power of the ideological fantasy: even if we do not take things seriously, even if we keep an

ironical distance, *we are still doing them*" (Žižek *SOI* 33). By contrast, because
it lacked this framing pretext, Wagg's image lost the potential for producing
pleasure and thus was unable to assuage anxiety.

WAGG'S IMAGE

But here we strike a theoretical difficulty, which will point us to a construc-
tive rethinking of both the Lacanian concept of the gaze and also Barthes'
notion of the *punctum*. The initial surveillance image of Bulger's abduction
and its subsequent reproduction in the tabloids share a distant, grainy quality
that highlights the conditions of the image's production. According to tradi-
tional accounts of the Lacanian gaze, such distortions in the visual field are
ripe with gaze-provoking potential, since they reveal "the mechanics of image
production" and "afford a glimpse of its own nature as constructed image"
(Krips 102). Such formal irregularities, or "stains," inaugurate the gaze, that
is, function as sites where viewers become "circumscribed... [made into]
beings who are looked at" (Lacan *Sem XI* 75). It is, then, from these points of
uncertainty that the "picture itself looks back at us," confronting the viewer
with the question of her investment in viewing the image. Yet, for reasons
that I discussed in the previous section, in spite of such formal irregularities,
the surveillance image circulated in the press without controversy, and it was
only Wagg's highly aestheticized, formally coherent image that evoked not
only the sort of anxiety that we expect from the gaze but also the more
extreme response that the *punctum* may evoke. How can we reconcile this
with Lacan's account of the gaze, which seems to offer no way of distinguish-
ing between a gaze associated with the press image and a gaze associated with
Wagg's image?

I suggest that, rather than a gaze, Wagg's image contains a *punctum*: a
disruptive, anxiety-producing element that denatures the image and which I
argued is associated with the signifier of lack in the Other, rather than the
objet a qua gaze. Wagg's image invites us to think about the *punctum* as exist-
ing, not simply within the image's composition, but within the relationship of
the image's form to the cultural context that embeds it.

Whereas the gaze appears as a blur or stain of indeterminacy, like the
Lacanian *objet petit a*, the *punctum*, by contrast, emerges from an ordinary,
determinate detail that, due to structural contingency and unconscious reso-
nance, takes on the uncanny quality of that object that Lacan designates as
"the signifier of lack in the Other," $S(\emptyset)$.

But, in Wagg's image nothing is, to use Lacan's terminology, "out of
place *in* the picture" (Lacan 96). Indeed, everything *in* the picture seems to
be *in place*. To be specific, Wagg's image, on the level of both form (a brightly

hued, softly delineated painting) and content (a young boy holding hands with a toddler) exudes benevolence, giving the sense that things are as they should be. How, then, does the image incorporate a *punctum*? I contend that the image's point of violence, its *punctum*, takes the form of a "surplus knowledge," a detail that resides *outside* the picture. As Wagg himself suggests of the image, "it could quite easily be a sentimental picture postcard. It is so 'benign.' It is so 'wonderful,' little boys...walking hand in hand, 'ah how sweet,'...but actually [it] isn't, because...before anyone had actually seen the image, that baby was already dead" (Imperato's interview with Wagg in Friedlander 23).

In itself, such an image of boys holding hands in a shopping mall is hardly exceptional. Thus, without knowing the context, the image carries only a *studium*, a culturally coded meaning, or in Barthes' words, "a polite" human interest" (Barthes CL 27, 26). The *studium*, like the object Lacan designates the phallic signifier, carries the pretense of fullness of meaning; it provides the illusion that the symbolic is really complete after all: that whether shocking or banal, things can always be named and thus exist completely under the reign of language (51). By contrast, Barthes explains, "a photograph's *punctum* is that accident which pricks me (also bruises me, is poignant to me)" (27). We are "pricked" by an external detail that does not fit the picture—in the case of Wagg's image, by the horrific surplus knowledge that this is an abduction and that the small boy, who is alive at the time of the image's recording, is by the time of its viewing, dead, by the very hand he is holding. As Žižek puts it, "a perfectly 'natural' and 'familiar' situation is denatured, becomes 'uncanny,' loaded with horror and threatening possibilities, as soon as we add to it a...supplementary feature, a detail that 'does not belong'" (Žižek LA 88). Once the *punctum* detail becomes apparent, we read the entire image through its presence. Everything about the image that may have initially seemed ordinary now "acquires an air of strangeness" (88). In a sense, every detail now becomes horrific; in effect we "know too much" (88). Indeed, paradoxically, the more we "know," the stranger things become. Knowing too much prevents us from symbolically integrating an image that would easily cohere if we knew too little. The *punctum*, as a "surplus knowledge," overflows the image; it gestures beyond signification, resisting symbolic integration. The newspaper image was unable to produce this same surplus knowledge because, as I argued in the previous section, it was fully accounted for within the symbolic order—viewers "know" why the image is there and accept it. The press image, thus, falls under the *studium* and the phallic signifier (rather than the gaze or the *punctum*).

In order to explore further viewer responses to this traumatic surplus that violates the symbolic coherence of the image, I shall extend Lacan's insights regarding what he calls the "formulae of sexuation." In formulating the two logically possible ways in which the symbolic can fail—what he calls its "two modalities of misfire," the masculine way and the feminine way—Lacan suggests two strategies for dealing with the impossibility of symbolic closure.

One response, characterized by the masculine structure of imposture (which shares its logic with the phallic signifier and the *studium*) is to cover over the irrationality—what I called the "strategy of the toupée." The other response to lack, characterized by the feminine strategy of masquerade, that shares its logic with the S(Ø) and the *punctum*, consists in what I called the "strategy of the hat." The viewer engages this strategy by *identifying* with the "senseless traumatism" with which Wagg's image confronts us: *opening* her/himself to the eruption of the *punctum*, rather than trying to seal it over through attempting to "make sense" of it. This strategy derails the process of interpellation by refusing to answer the call of ideological closure.

The masculine strategy of imposture, by contrast, involves trying to make sense of the image, thereby consolidating the viewer's own identity as one who knows. By following the trajectory of interpellation to its end, the strategy of imposture reproduces the phallic logic of the *studium*. For Barthes, the paradigm of the *studium* is the banal sensationalism of the newspaper photograph. The news reproduction of the surveillance image of Bulger's abduction provides an instance of this. To be specific, the newspaper image's circulation and reception facilitates the "seeing through" of the official justification for publishing the surveillance image, a "seeing through" that Žižek claims characterizes the workings of ideology.

How, then, do we resist this "masculine" spectatorial position of "seeing through," which I have argued ends up comfortably reproducing ideology? I have suggested that by retaining an openness to the *punctum*, we can resist the ideological closure that the newspaper image otherwise forces upon us. Wagg's contribution, I have argued, lies in constructing a picture that facilitates such a subversive strategy, albeit one that not all viewers are in a position to take up.

The next chapter takes as its focus Marcus Harvey's painting, *Myra*, a reworking of the widely circulated mug shot of Britain's infamous serial killer of children, Myra Hindley. I will argue that a comparison of the seemingly similar controversies surrounding *Myra* and *History-Painting: Shopping Mall* yields further insight into the importance of both psychic and social dynamics in analyzing visual texts.

Chapter Six

Myra, Myra on the Wall,
Who's the Scariest of Them All?
Sensation and the Studium

In September 1997, Marcus Harvey exhibited the 11' X 9' painting *Myra*, (fig. 11), based on the well-known police photograph of Britain's notorious serial child killer Myra Hindley at London's Royal Academy's *Sensation* exhibit. At first glance, Harvey's *Myra* appears to be nothing more than a computer-generated version of the familiar image (fig. 12) blown up to a larger-than-life size. Then it strikes the viewer that the black and gray pixels are not computer generated, but are instead tiny handprints. Harvey used a mold of an infant's hand to create the illusion of computer-generated pixels, producing a *trompe l'oeil* effect.

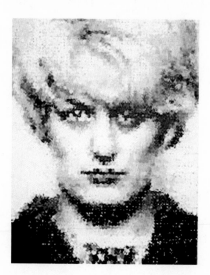

Fig. 11. Marcus Harvey,
Myra 1995.
White Cube,
London.

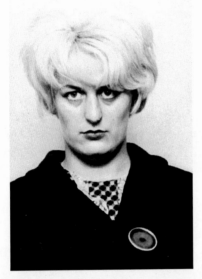

Fig. 12. "Myra Hindley's mug shot." AP Images.

Myra shares many similarities with Wagg's *History Painting: Shopping Mall*. Like *History Painting: Shopping Mall, Myra* moved within three visual systems: (1) surveillance (where it emerged as a mug shot in 1966); (2) the popular press (where, for over thirty years, it circulated and became an evocative visual signifier of what one writer calls "the incarnation of human evil"); (3) the gallery (where Harvey's rendition provoked protests, vandalism, and internal strife at the Royal Academy, resulting in the resignation of several royal academicians).[39]

At first sight the *trompe l'oeil* compositional structure invites an analysis of the image in terms of its ability to confront viewers with the gaze. Such an account, however, does not provide an adequate explanation of the painting's reception. Unlike Wagg's work, which exhibited for weeks while the controversy gathered steam, *Myra* attracted unparalleled wrath *prior to* the image being seen in public. For example, media reports concerning the image's role in the resignation of several Royal Academicians flourished weeks before the show opened, prompting protests and pleas for a boycott of an exhibition that the public had never seen. Thus, explanations of the controversy surrounding *Myra* that draw upon accounts of psychic mechanisms, such as the gaze, which are mobilized only by *actually seeing* the image, seem to be inadequate.

I suggest that we analyze the *Myra* controversy in terms of calculated political maneuvers in response to its symbolism. Evidence for a symbolic and political rather than psychic foundation of the controversy emerges from com-

paring the British reception of the *Sensation* exhibit to the American reception of the exhibit when it traveled to the Brooklyn Museum of Art in September 1999. In particular, I center my argument here on the fact that *Myra* did not create a stir in New York, whereas Chris Ofili's *The Holy Virgin Mary* (fig. 13) (a painting that passed virtually without comment in London) drew harsh criticism similar to the storm raised by *Myra* in London. (Ofili, an ex-Catholic, British artist of Nigerian descent, painted a black Madonna surrounded by small cutouts of pornographic images and elaborately adorned elephant dung.)

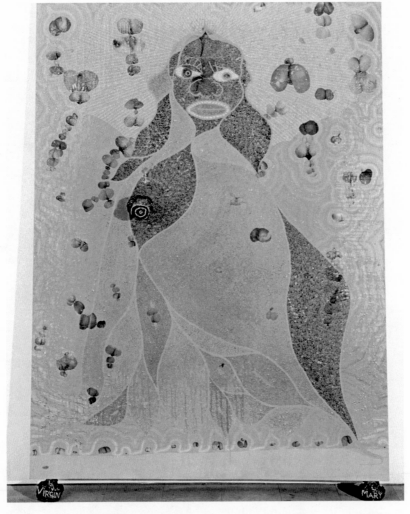

Fig. 13. Chris Ofili, *Holy Virgin Mary* 1996. Courtesy of the artist—AFROCO.

Myra's unremarkable effect on the American audience challenges Lacan's claim that the formal *trompe l'oeil* structure of an image is sufficient to produce a gaze (Lacan *Sem XI* 103). In particular, the divergent responses to the image on the two sides of the Atlantic suggest that the gaze is not intrinsic to the form of *trompe l'oeil* but instead is a relational property of an image and its audience (a conclusion already hinted at in the previous chapter.) I suggest too that in order to understand the image's potency, one should follow Stuart Hall's advice and examine its "inscription into the currency of other discourses, its intertextuality" (Hall "RW" 158).

In the United States and the United Kingdom, *Myra* is woven within starkly different discursive webs. On the one hand, the British press appropriates Hindley's image with such regularity that it has taken on a folkloric status comparable to Jack the Ripper's. On the other hand, in the American context, Hindley and her image are virtually unknown. This suggests that the discomfort surrounding *Myra* for British audiences is shaped not so much by the formal compositional elements that we usually associate with the gaze but rather by an unpleasant confluence of determinate meanings associated with cultural codes and symbolic conventions. In particular, I suggest that, even though *Myra* contains many features associated with the gaze—from its *trompe l'oeil* composition to its apparent provocation of "unrealistic anxiety" —it lacks a crucial element of the gaze, namely, a relationship to the Real.

In particular I claim that *Myra*'s power to unsettle in the British context, its "shockingness," emerges from quite intentional, conventionally coded elements: the juxtaposition of miniature infant hands (as poignant emblems of innocence) with a gigantic child killer's face (as an icon of the grotesque)[40] but also its display in an exhibition advertised to shock, *Sensation*. (The organizers of the exhibit issued the following "warning label"/publicity material for *Sensation*: "the contents may cause shock, vomiting, confusion, panic, euphoria, and anxiety"). In short, I claim that the ominous quality of *Myra* emerges not from a symbolic faltering characteristic of the gaze, but rather from a symbolic integrity that indicates the triumph of coherence. To put it in Barthes' terminology, we could say that *Myra* contains a *studium*, but no *punctum*, since the *punctum* arises only where the symbolic and resources of naming fail, and although *Myra* may disturb us, we are not at a loss to say why.[41]

In short *Myra* may very well be a site where "unrealistic anxiety" gathers, but, I suggest, these "anxieties" are not of a psychic kind. Rather, they are what Stanley Cohen identifies as the features of "moral panic."[42] According to Cohen, moral panic results when the mass media draw attention to transgressions of "the normative contours of a society . . . the boundaries beyond

which one should not venture and about the shapes the devil can assume" (quoted in Watney 39). Cohen describes such panics as "pseudo-events." In Lacanian terms, their force comes not from a surprising tuché of the Real but rather from the simple shock brought on by manipulation of the symbolic.

But strong conditions must be fulfilled in order for an image to create such scandal. In particular, according to Steven Dubin's work on "symbolic struggles," "two critical elements [are] required for art controversies to erupt: 1) the sense that values have been threatened; 2) power must be mobilized in response to do something about it" (Dubin *AI* 6). The controversies surrounding both *Myra* and *The Holy Virgin Mary*, I argue, share these elements.

In both cases, the images' most ardent detractors refused to view the art that they so vehemently opposed. Indeed according to protestors outside the Royal Academy during the *Sensation* exhibit, viewing the image is tantamount to committing the same murderous crimes that Myra Hindley herself committed upon children. Winnie Johnson, the mother of one of Hindley's victims, maintained that no "member of the public [should] go near it [the picture,] and if they do they are as sick as Hindley is" (Reynolds). When caught in the fray of moral panic, it seems that images may be as harshly condemned than the crimes or actions that they recall.

Similarly, without having seen Ofili's *Holy Virgin Mary*, New York's Mayor Rudolph Giuliani judged it "sick," "disgusting," "obscene," and "sacrilegious" (Ross 100; Mitchell 118). Indeed, Giuliani threatened to withdraw funding to the Brooklyn Museum unless it cancelled the *Sensation* show, arguing that "there is nothing in the First Amendment that supports horrible and disgusting projects" (AP September 22, 1999). Why such an extreme reaction? Many critics speculate that Giuliani forged his attack on *The Holy Virgin Mary* in order to galvanize additional support for his anticipated senatorial race against Hillary Rodham Clinton. Dubin makes the point: "Mayor Giuliani has shown himself an expert practicioner of the politics of diversion. That is, he undertakes grandstanding symbolic crusades to draw attention away from his failure to remedy more critical problems" (Dubin "HSBS" 8). And along similar lines, David A. Ross argues that art controversies often provide politicians with "issues that will allow [them] to run for public office without having to address truly serious issues.... [A] good art scandal is far easier to discuss than the police murder of Amadou Diallo any day" (Ross 98).

Such attacks on paintings that have never been viewed by their detractors, I argue, suggest that the formal details of the images themselves are incidental; rather than the true stake of the debate, they serve merely as a

front for political or personal interests. Indeed, as I argue in the next chap-
ter, the United States offers a rich history of such opportunistic political
scandal mongering in connection with art (the "culture wars" provide a case
in point.)

What, then, are the various interests and anxieties that constellate
around *Myra* and that explain the resultant moral panic in purely symbolic
terms? According to Philip Jenkins' social history of changing concepts of the
child molester, "the nature of sexual threats to children was perceived quite
differently" at different historical moments. Britain, at the time of the
Sensation opening, was obsessed with "the return of the sexual predator"
(Jenkins). W. J. T. Mitchell describes the period as wrought with "widespread
hysteria about pederasty and child abuse" (Mitchell 131). And Hindley, as is
often argued, functions as Britain's most hated figure on which to hang cul-
tural anxieties regarding fears about child abuse, a status that has lead many
activists to regard her as a "political prisoner."

In 1985 it was reported that Hindley would serve a minimum sentence of
thirty years; in 1997, at the start of her thirty-first year in prison, she cam-
paigned for parole. On February 4 of that year, Hindley was officially notified
that her parole was denied and that she would spend the rest of her life in
prison.[43] Colin Randall, in the *Telegraph*, explains that the decision regarding
parole is officially based on "retribution and deterrence as well as public
safety" (Randall). But many argue that the decision to never free Hindley was
politically motivated—either a case of then Home Secretary Michael Howard
trying to win public opinion votes or, more likely, a case of needing to pre-
serve the important symbolic function she satisfies.

But, I shall argue, in order to understand the decision to refuse parole to
Hindley, one must look for reasons beyond the home secretary's political
interest in appealing to public opinion. A MORI poll conducted during this
time on the issue of release of murderers serving life sentences found that
77% opposed the policy that lifers may be released after serving a certain
amount of time. The percentage rose only to 83% when the question was
specifically whether Hindley should be released after thirty-one years in
prison. But even so, as *Living Marxism* columnist Ann Bradley points out,
Howard releases "other murderers, far less repentant than Hindley...every
day. In fact the Home Secretary is falling over himself to clear the
cells....Other killers have served their time and been accepted back into
society while she is condemned to serve the rest of her days in prison"

(Bradley).[44] So public opinion seems unequal to the task of explaining the refusal to parole Hindley.

Rev. Peter Timms argued passionately on Hindley's behalf that "the Home Secretary's decision to a give a natural life tariff... is a gross injustice. It treats her differently to every other life-sentence prisoner and it's now clear that she is a political prisoner" (Randall). According to Bradley, Timms, and others, based on official criteria, Hindley should be eligible for release. She was said to have made "exceptional progress in prison and [to have] genuine remorse," completed a degree in the humanities and converted to Roman Catholicism (Randall). As Hindley herself put it: "after 30 years in prison I think I have paid my debt to society and atoned for my crimes. I ask people to judge me as I am now and not as I was then" (Millward). Indeed in appealing to the public and authorities in a Channel 4 documentary, Hindley evoked her own status as victim. She pleaded:

> Words are inadequate to express my deep sorrow and remorse for the crimes I have committed and the pain they have caused. Dreadful as my crimes were, I hope the Home Secretary will take account of the very unusual circumstances in which I became involved in those crimes. (Millward)

On the other side of the argument, however, one might argue that, rather than the question being Hindley's danger to others, it was a question of others' danger to Hindley. Many reporters suggested (paternalistically) that it is for her own safety that Hindley should remain imprisoned, since were she to be released, she would be in immanent danger. As part of the Channel 4 production, Danny Kilbride, brother of one of the victims, pledged, "[W]ithout any doubts, if I ever got the chance I would do her, and the rest of my family would. If I came face to face with Myra Hindley, she's just dead" (Millward). Similarly, Anne West, whose daughter was murdered by Hindley and her partner, Ian Brady, promised to make it her life mission to kill Hindley if she is ever released. She vowed, "If they release her, then she's one dead woman. I would search the world for her and spend everything I have to track her down" (Millward).

But, and here the issue is further complicated, death threats like these are not reserved for those who commit acts of murder; they are also directed toward the artists who produce images that recall the acts. After contemplating the relationship between artists and their subject matters, Maria Tatar finds it "tempting to give some credence to Degas's belief that a painting demands as much cunning, malice, and vice as does a crime" (Tatar 4). And Degas would have found ardent support among many critics of Jamie

Wagg's _History Painting: Shopping Mall_ and Marcus Harvey's _Myra._ Wagg met with threats of violence similar to the ones directed toward Hindley. Wagg recounts:

> When all this was going on, I received death threats, you know, that I "deserve to die for that." They said they were "going to fucking do me"... [M]y name and address is in the telephone book so they said they know where I live and they're "going to come round and get me and do me." (Wagg in interview with Alessandro Imperato in Friedlander 26)

Furthermore, as Winnie Johnson's admonitions to the queuing patrons at the _Sensation_ exhibit demonstrate, complicity in the crime extends not only to the artist but also to the _viewers._

Indeed, in a wonderful irony, this vilification of artist and viewer enabled Hindley herself to come forth as a major detractor of Harvey's painting. In a bizarre, but strategic, alliance, Hindley herself united with child protection groups in common opposition to Harvey's work. Indeed, Hindley seems to have leapt at the opportunity to exploit the scandal in the service of her campaign for parole. She released a statement to the press condemning Harvey's work as "repugnant and repulsive" and "totally abhorrent" (Elliott July 31, 1997). She reserved special venom for the Royal Academy, self-righteously arguing that their decision to display the image disregarded "not only the emotional pain and trauma that would inevitably be experienced by the families of the... victims but also the families of any child victim" (Elliott).

Among those said to be looking for gain from the scandal was the man to whom all the pieces in the _Sensation_ exhibition belonged, private collector and advertising mogul Charles Saatchi. Saatchi and Saatchi (the ad agency Charles Saatchi formed with his brother, Maurice) is perhaps best known in Britain for its major contributions to Thatcher's 1979 election campaign. Thus, Saatchi's investment interests in _Myra_ contributed to the controversy, by making conspicuous business arrangements usually clandestinely conducted behind museum doors. In particular, through the _Myra_ controversy ethical doubts were cast upon the practice of museums displaying privately owned pieces. Such practices, the administrative vice president of the Art Dealers Association of America, Gilbert S. Edelson, explained, "enhance the market value of those works and thereby... confer financial benefit to the lender" (Edelson 172).

Christie's' fifty-thousand dollar contribution to the _Sensation_ exhibit in which _Myra_ appeared further fuelled the outrage, when it was brought to light that Saatchi had previously arranged for Christie's to auction pieces of his collection. (Ultimately, the pieces brought in a total sum of over $2.7 mil-

lion.) But, although Saatchi's particular affiliations and corporate interests with the exhibition may seem unusually close, Lisa Jardine reminds us that Saatchi's influence "in the art world is not new. He belongs to a long line of ...entrepreneurs whose collections form the basis for today's... 'taste'" (Jardine 1). Indeed, contrary to a *New York Times* report, which claimed that museums "'draw the line at displaying privately owned collections,'" not only are such practices common, but also (as Edelson pointed out) "many of these exhibitions have drawn critical praise from the *Times* [itself]" (Edelson 172–73). Nevertheless, as we will also see, such mass-circulated misunderstandings regarding art world practices contribute significantly to the struggles that break out at the scene of public art, such as the *Myra* image.

Child protection group Kidscape, a staunch opponent to the public display of *Myra*, issued a press release in which it, too, attempted to sully the Royal Academy's image by exposing its financial interests. Kidscape announced to the press that the Royal Academy was 2 million pounds in debt and accused the museum of trying to square its figures through "the sick exploitation of dead children" (Smith July 26, 1997). This trend of attacking a museum by pointing out its commercial connections and financial interests prompted Mitchell to exclaim: "the 'greater' scandal of the *Sensation* show was that it revealed (oh marvelous revelation!) that art museums are in competition with movies, shopping malls, and theme parks. Art, it turns out, has something to do with wealth and speculative capital" (Mitchell 125). In a similar vein, Andras Szanto reminds us that art, in spite of its edifying image, is part of the larger entertainment industry. By insulating themselves from the broader culture, museums risk what is said to have brought down the railroad industry in the twentieth century. Railroads, as Szanto puts it, made the mistake of "assuming that they were in the railroad business... when in fact they were in the transportation business, where they lost out to cars and airlines. Analogously, it would be a mistake to think that museums are still in the art business. They are now in what may be called the 'attention business'" (Szanto 191).

The peculiar, almost sacred, status of the museum further helps us to explain how "art becomes a magnet for the issues and politics of its times" (Becker 21). The contemporary museum, according to Teri J. Edelstein, occupies a paradoxical position. On the one hand, it is an often undermined institution, vulnerable to frequent attack, but on the other hand, the scrutiny to which the museum is subjected results from a sense of its "almost unquestioned hegemonic social authority" and "aura of sacredness" (Edelstein 110, 112). Such an institutional critique, together with a critique of the news media, helps us to better understand "how easily the arts are hijacked for political purposes" (Brewer 158).

In "Don't Shoot the Messenger: Why the Art World and the Press Don't Get Along," Szanto furthers this argument. By combining an institutional analysis of the press with an account of the inner workings of contemporary museums, he explains their dual complicity in the eruption of art scandals. Szanto's analysis, in conformity with Stuart Hall's groundbreaking examination of news production, concludes that the news media do not intentionally conspire to paint an unflattering view of the art world, but rather suffer from structural bias as the result of their own internal institutional practices. This structural bias is exacerbated by the art world's aloofness as well as more general public concerns regarding the state of contemporary art and standards of conduct for museums.[45] As Brewer puts it, "the press, even if it had wished to, could not explain [the] normal behavior of [the art world] to its readers because the workings of museums remain shrouded in mystery" (158).

Szanto faults museums, in particular, for being "astonishingly inscrutable" (Szanto 192). The museum, Szanto argues

> perfectly exemplifies the distinction sociologist Erving Goffman made between front stage and backstage behavior. The neatly appointed front stage—the viewing gallery—is intended for the public. The backstage—the 'real' part of the operation, including all the prosaic decisions and activities that keep a museum going—is hidden from view. (192)

Although Szanto is careful to put scare quotes around "real," his subsequent analysis belies this initial caution. Drawing upon Goffman's evocation of a restaurant ("where the decorum of the hushed dining room stands in marked contrast to the noisy and disheveled world of the kitchen"), Szanto suggests that "in a manner of speaking, museums should open their kitchens to the public"(192, 193). Szanto celebrates the "transparency" of contemporary cultural trends, such as "real-life television," cameras in Congress and courtrooms, computers in "translucent casings," corporate towers with "see-through walls and no private offices," and "restaurants where the cooks are in plain view" (193).

But do open kitchens really expose the less savory side of food preparation? Does reality television reveal the inner workings of social relations? Does the sight of the internal mechanisms of a computer tell us anything about electronic communication? Do corporate towers with glass walls make transparent the inner workings of capitalism? As I have argued in previous chapters, by providing the illusion of "seeing through," or in Szanto's words, "uncloaking" and "demystifying," the behind-the-scene practices, institutions consolidate rather than incapacitate their ideological force. This point is reinforced by Barthes' concept of 'inoculation.' Barthes compares one tactic

of ideology to that of a vaccine, which injects small, controlled amounts of disease into the body in order to immunize it against larger exposure. And similarly, ideology acknowledges small doses of "accidental evil" in order to "better...conceal its principial evil" (Barthes *Mythologies* 150). As Barthes puts it succinctly, "a little 'confessed' evil saves one from acknowledging a lot of hidden evil" (42). And in exactly this vein, clear walls, open kitchens, and cameras in private spaces reinforce an ideology of transparency, especially when they allow us to witness some apparent "accidents." Such ideological devices allow viewers to occupy comfortably the favored role of impostor— the one who "sees through" and knows it all. The net effect, then, is that contradictions and antagonisms are safe from exposure, since viewers have no concern that they are being fooled by surface appearances.

Rather than looking for ideology in the hidden recesses of the "back-stage," one would be wiser to notice how the very explicit (and seemingly intended) front stage actions materialize contradictions within the ideological edifice. Žižek recalls the scandal that erupted when allegations concerning Michael Jackson's prurient sexual practices circulated in the media and "dealt a blow to his innocent Peter Pan image" (Žižek *PF* 3). Žižek asks, "Wasn't this so-called 'dark side of Michael Jackson' always here for all of us to see, in the video spots that accompanied his musical releases, which were saturated with ritualized violence and obscene sexualized gestures...? ...[T]o quote the *X-Files* motto: 'the truth is [already] out there'" (3). From this perspective, Szanto's strategy of "uncloaking and demystifation" supports rather than undermines ideology. Instead of this strategy of "uncloaking," which is suited to the pretensions of the impostor, I suggest that the subversive strategy of *masquerade* that I discussed in earlier chapters, encourages a certain degree of transparency but a transparency that, unlike the transparency celebrated by Szanto, flaunts itself *as* transparent. I return to this suggestion below.

The structural bias of news reports about art manifests in careless reporting of the images. Newspapers, Szanto tells us, "relax their standards when covering the arts...[since they are] not counting on its readers seeing the exhibit" (Szanto 188). As Brewer explains, "inaccurate reporting, of a sort that would be impossible in other kinds of coverage, is both prevalent and unrestrained" in art news (Brewer 158). This ubiquity of uncorrected mistakes reinforces my point that the actual images themselves are unimportant. Careless inaccuracies regarding both *Myra* and *The Holy Virgin Mary* circulated widely in the press. To construct *Myra*, Harvey made a mold of *one*

infant's hand, which he used to apply the paint. Nevertheless, several news-
papers reported that *Myra* is made from "the handprints of hundreds of chil-
dren" (Reynolds) or "of thousands of handprints from two small children"
(Smith). Such lack of attention to the details of the actual conditions of pro-
duction suggests that the painting's general function as a cultural symbol
considerably overshadows its status as a particular work of art.

 In a similar fashion, errors riddled press descriptions of *The Holy Virgin
Mary*. Ofili's painting was mistakenly characterized in major newspapers as
"dung tossed," "stained with elephant dung," "covered in elephant dung,"
"smeared with dung," and "splattered with dung" (Szanto 189). And just as
the act of viewing Wagg's image diffused the wrath of its Liverpool would-be
vandals, many viewers, expecting to be disgusted by Ofili's painting, admitted
to being surprised that they found the image "beautiful" (Edelstein 109).

 Steven Dubin claims that the content of images, specifically their trans-
gressive positioning of objects in inappropriate settings, contributes to their
ability to register a panic: "[A]n adverse response is more likely when art
blends together what social conventions generally separate" (Dubin *AI* 11).
The errors committed by the press coverage of both *Myra* and *The Holy
Virgin Mary* support this claim: both errors focus upon an element that,
according to social conventions, is out of place. In the case of *Myra*—an icon
of evil—the out-of-place element that the newspapers misdescribe is the
sacred imprint of a child's hand; Conversely, in the case of the sacred figure
of the Madonna, the description of the profane substance of the elephant
dung has been sensationalized.

 Harvey's larger-than-life-sized image brings together the two things that
our culture works hardest to keep apart: the "innocent child" and the
depraved world of adults; the purity of the miniature and the grotesqueness
of the gigantic. According to Susan Stewart, in art and literature, the "minia-
ture" represents the space of the child, evoking purity, the private, and the
interior; the "gigantic," by contrast, represents the adult world, characterized
by depravity, the public, and the exterior.[46] And just as Hindley synec-
dochally represents the most horrific elements of the adult world, an infant's
hand epitomizes the innocence of the miniature. Thus the image *Myra* exists
in a liminal space between the miniature and the gigantic, the virtuous and
the depraved, and thereby suggests that these categories are not as discrete as
their heavily policed boundaries may imply, indeed, shows that they depend
on one another for their meaning.[47] Hindley, a very young woman at the time
of the crimes, is herself a liminal figure—both victim and murderer; child and
adult; and at least symbolically, woman and man. What, then, are we to
make of the paradoxical mixing of these binary categories in *Myra*, a mixing

that the picture itself embodies by employing the fetishized object of inno-
cence, namely, the child's hand, as the very tool for the creation of an image
that is the "incarnation of human evil"?

One might say that Harvey's image only makes prominent complexities
in Hindley's image that were present all along. As Harvey claims, the fre-
quent appearance of Hindley's mug shot in the press for over thirty years has
given it "a kind of hideous attraction" (Carlisle). And journalist Isabel
Carlisle points out, "the photo that Myra is based on is the [same] one that
news editors turn to every time Hindley's case resurfaces" (Carlisle). But
news reports dealing with the scandal over Myra reproduce Harvey's image
rather than the mug shot. As Carlisle tells us "every story on Myra in the
national press was illustrated by a photo of the Harvey portrait (regardless of
whether that would cause distress to the victims' families or not" (Carlisle).
An account of the mug shot image may shed light on the significance of this
interchange of images.

The 1966 police photograph of Hindley challenges the conventions of
the modern mug shot, by anachronistically resembling an earlier genre of
police photography. This anomaly demonstrates the complementary relation
between the development of photography and the emergence of an organized
police force. John Tagg explains that, "as photographic processes and equip-
ment have been more evolved and refined, so have police forces expanded
and become more efficient" (Tagg 74). This connection endures today.
Police photographs, dating back to the 1840s in Britain, appeared on "deli-
cate glass plates [that were] each mounted in an ornamental frame, as if they
were destined for the mantelpiece" (Tagg 74). The heavy makeup, streaked
hair, sultry lips, and pouty expression that appear in Hindley's mug shot also
distinguish it from contemporary police photographs, which will spend their
lives "enclos[ed] in a cellular structure of space whose architecture is the file
index" (76).

Sandra Kemp confirms that these features of Hindley's mug shot suited
the press, facilitating her launch as an enduring symbolic figure. In making
this point, Kemp considers the mug shot of another British "female murderer
and torturer," Rosemary West (fig. 14) (Kemp 62). Taken thirty years after
Hindley's, West's photograph shares the same head-on, full-face stare. The
similarities end there, however. West's photograph failed to take on the
same iconic status as Hindley's, a difference that Kemp suggests rests on the
dissimilar physical appearances of the two women in their photographs.
Kemp asserts,

Fig. 14. "Rosemary West's mug shot." AP Images.

It was not difficult to construe Hindley's face according to stereotypes (bleached blonde, hard as nails, icily sexy). But in the case of West, reviewers had a hard time linking the nauseating catalogue of abduction, calculated sexual abuse, mutilation and murder with this plump and homely-looking middle-aged woman, with her badly cut brown hair and old-fashioned glasses. (62)

West's frumpy, matronly image, it seemed, posed more difficulty for tidy news accounts than Hindley's aloofly seductive pose.[48]

Because of her gender, Hindley's image created added interest for the press. The most frightening characteristic of the figure of the child abuser is an ability to "pass" for a good citizen. Because of her gender, Hindley embodied this ability. Indeed, in her crimes, Hindley had traded on this ability.[49] She, rather than her male partner, Brady, often lured the children, because as a woman she was less likely to be perceived as a threat. Her crimes were seen as greater atrocities because she betrayed not only her victims but also the rest of us who take comfort in the simplicity of gender stereotypes. As Ann Bradley explains:

Myra Hindley serves her sentence not just as a killer, or even a killer of children, but as a woman who went against everything society expects of women. She is a woman who is not only unswayed by maternal instinct, but a woman who manipulated the fact that her victims trusted her as a woman. (Bradley)

Unlike dowdy West, Hindley's sharp, but unconventional, looks provided the press with greater narrative flexibility. They exploited details of Hindley's life in order to demonstrate ways in which she "fails to play the woman's part" (Bradley). In particular, a cluster of British tabloid articles apearing in 1996 focused on Hindley's lesbian relationship with prison "visitor" Nina Wilde (Hardy). In her article, aptly titled, "Myra Hindley—a Bad Woman," Bradley argues that "the tabloid disclosures about her lesbian love affair with a prison visitor, and the general obsession with her sexual orientation" function as a way of accounting for her incompatibility with the expectations of womanhood. In this sense, as Bradley's title suggests, Hindley functions as an enduring symbol of evil, not only because she is a bad woman, but also because she is bad at *being* a (heterosexual) woman. Bradley argues, that "the papers condemn her for her abnormal sexual tastes, without a moment's contemplation on what could constitute normal sexual expression for someone who has been locked up for 30 years with no hope of a 'normal relationship'—ever" (Bradley).

Other news reports take an apparently opposite path. Rather than show how Hindley fails to be a real woman, they reinscribe her as a woman by calling upon the stereotype of woman as victim (a more comfortable descriptor than woman as murderer). These stories often center upon Hindley's destructive love for the manipulative Ian Brady—her literal partner in crime. By stressing Hindley's status as victim, these accounts reaffirm her status as "woman." Despite their differences, however, both types of accounts share the same stereotype of femininity.

Concerns about class and economics, which implicitly shape (and often provide the subtext of) moral panics, appeared in rare unabashed fashion in accounts of Hindley's crimes. In struggling to understand what led Hindley and Brady to murder, many writers appeal to the powerful influence of the couples' "library," particularly their collection of sado-masochistic and Fascist texts.[50] As Laura Kipnis points out, such accounts rest on a notion of class superiority:

Researchers aren't busy wiring Shakespeare viewers up to electrodes and measuring their penile tumescence or their galvanic skin responses to the violence or misogyny there.... When a South Carolina mother

did recently drown her two kids, no one suggested banning Euripedes. (Kipnis 176)[51]

Pamela Hansford Johnson's 1967 account of the murders blatantly exemplifies such reactionary discourse. Johnson argues that it is too dangerous to make "all books available to all men ... [it is] not desirable for Kraft-Ebing to be available in relatively cheap paperback on the stalls of English railway stations" (Johnson 40, 36). Perhaps the most invidious instance of this discourse appears in Johnson's expression of concern that Hindley and Brady had access to reading materials for which, although they both had "slightly more than the average I.Q.," they did not have the proper educational background. Johnson calls for censorship on the basis that "we are seeing the most fantastic growth of a semi-literate reading public ...: and at the same time we are prepared to offer, to minds educationally and emotionally unprepared, 'total publication' in almost every form of mass media (37). According to this argument, the formally educated, ruling classes decide which material is appropriate for "mass consumption," whereas those for whom texts are regulated are the "less educated" working class and children.[52] Johnson's argument, although less subtle than most, remains representative of many contemporary procensorship arguments, not just for its class bias, but also, as we will see in the next chapter, for its naive assumption in the univocality of texts and images.

I have contended that Harvey's image (which, as we have seen, has been exploited by a variety of factions for different purposes) ultimately operates at the level of the *studium*, reproducing dominant ideological stereotypes and facilitating the viewer position of imposter. But because of its role in unsettling the press' and the public's tidy framing of Hindley, as well as functioning as a lightning rod for moral panic, it also has subversive potential. As one critic points out, "we tend to think of 'moral panics' as unfortunate and disreputable episodes. Yet in so far as they represent eruptions of social anxiety, albeit distorting and ideologically driven, they may be an index of important shifts in public awareness" (A. Cooper 35 in Furedi 48).

In addition, I have suggested, by threatening Hindley's enduring symbolic role as the most "durable object of public hatred" and as the icon of "the incarnation of human evil," Harvey's painting infuses a degree of uncertainty into her image. Even such a small flicker of doubt, inserted into an image whose meanings have been so tightly controlled, creates the possibility of subverting the ideological stereotypes that inform and are reproduced by more usual images of Hindley. We see how the strategy of imposter, understood as an attempt to preserve the conventional meanings that Hindley's image carries, can be overthrown by the introduction of even a small shadow of doubt. By identifying with such moments of doubt, the strategy of masquerade, by contrast, functions subversively to undermine these meanings.

Framing the Child in Sally Mann's Photographs

I n this chapter I extend explorations of photographic realism within the context of Sally Mann's photographs during the 1980s and early 1990s. During this period Mann's work centered on images of her own three children (Jessie, Emmett, and Virginia) and twelve-year-old girls from her rural Virginia neighborhood.* Mann's work has been mired in controversy, in large part, because her images not only complicate the usual understandings of childhood innocence but also trouble the common expectation of photographic innocence. Mann's work and the surrounding controversies, I shall argue, provide rich clues to understanding ways in which contemporary cultural anxieties mount around encounters between the figure of the child and the medium of photography, anxieties that carry weighty historical precedence.

The modern notion of the child emerged around the same time as the invention of photography, and from the start, nude children have figured prominently as photographic subjects (Higonnet *PI*). As Elisabeth Stoney describes, the child has historically figured as a "natural subject for the camera. Childhood and the photograph both deal with what is experienced and lost, only to be retraced" (Stoney 8).

Social historian Philippe Aries finds evidence of the earliest traces of the modern concept of the child dating back as far as the seventeenth century. Prior to this period, he argues, children were not significantly differentiated from adults; they were seen simply as smaller and faultier.[53] This perception reveals itself both through visual imagery from the period that portrays children, dressed like adults, participating in adult activities, as well as in the lack

*Unfortunately Ms. Mann did not give permission to reproduce her images. They can be seen in *Immediate Family* (Aperture, 1992) and *At Twelve* (Aperture, 1988).

of cultural artifacts designed specifically for children. As Aries contends, the medieval period "made no distinction between children and adults, in dress or in work, or in play.... Language did not give the word 'child' the restricted meaning we give it today.... The absence of definition extended to every sort of social activity: games, crafts, arms" (Aries 61).

According to Higonnet, by the mideighteenth century, portraits of children revealed shifts toward the modern day romantic notion of the "innocent child," which reverses its medieval counterpart. Rather than being thought of as a small, imperfect adult, the romantic child, I will contend, exists as the adult's more perfect contrary: sweet and innocent but also vulnerable, by contrast with the adults' more knowing potential for depravity. Higonnet stresses the role visual imagery played in securing this vision of childhood innocence. As she puts it, "precisely because the modern concept of childhood was an invented cultural ideal [rather than a natural occurrence], it required representations" to sustain it (Higonnet 8).

By the mid- to late nineteenth century, due in large part to the advent of photography in 1839, images of the romantic innocent child proliferated in new forms to new audiences. And significantly, it was the expectation of photographic innocence—in particular, its ability to give a true and unbiased account—that made photographs particularly powerful vehicles for conveying the vision of childhood innocence. As Higonnet explains, because it is seen as "more realistic and [natural] than any other medium, photography made it possible for the ideal of Romantic childhood to seem completely natural" (9). Through an examination of Mann's work, I will explore: (1) ways in which photography has not only been influential in consolidating understandings of childhood innocence but has also been pivotal in unsettling them and (2) ways in which our expectations of childhood contribute not only to reinforcing understandings of photographic innocence but also to disrupting them. This inquiry will lead to insights regarding the ability of Mann's work to confront viewers with symbolic disturbances that encourage a strategy of masquerade, thereby disrupting the spectatorial approach of the imposter.

CHILD AND IMAGE

Mann's work powerfully realizes the tension between two notions of photography: on the one hand, photography as a medium for capturing objective reality (the "innocent" photograph) and, on the other hand, the use of photography to contrive and manipulate. Both of these understandings of the photograph (as innocent but also as deceptive) emerged with the medium itself. As historian David Nye recounts, in the early years of photography in

the nineteenth century, people used "photography to embellish the truth, to hide defects, to equivocate" (Nye 37). In particular, from the earliest days of photography, one can find the "familiar realization that someone did or did not look good in photographs, a popular recognition that the medium was neither a mirror of nature nor unproblematic" (37). But for the photograph to deceive successfully requires that people believe that the photographic image is objectively true. In short, while people "believed" or expected the photograph to tell the truth, they were simultaneously aware that the photograph's claim to accuracy was tenuous and quickly developed techniques to take advantage of this ambiguity. For example, during the 1855 World Fair in Paris, as part of the first photography exhibit, demonstrators featured techniques for retouching negatives. But rather than undermining its cultural influence, such revelations regarding the photograph's precarious relationship to reality fueled its charm. As Susan Sontag puts it, "that photographs are often praised for their candor, their honesty, indicates that most photographs, of course, are *not* candid..., [but] the news that the camera could lie made getting photographed much more popular" (Sontag 86).

I argue that a similar logic underpins the modern notion of the "innocent child." Underlying the discourse of childhood innocence lurks an implicit belief in the sexually potent child. Stoney says that "just as a 'respectable woman' might suggest the opposite as a 'potential prostitute' so does the innocent child evoke depravity" (Stoney). James R. Kincaid offers us a 1989 letter to Dear Abby in which one sees this logic at work. A mother writes to Abby that she fears a child molester will abduct her two-and-a-half-year-old son. Her concern stems from her son's overzealousness with "strangers"—running up to them, putting his arms up, and asking them to hold him. "Of course, these strangers pick him up," she writes, fueling her fear that his "friendliness might lead to his being abducted" (Kincaid 361). She turns to Abby for a way of "discouraging [her son's] behavior without offending the stranger." Abby is clearly not at all concerned about the feelings of these "strangers" (read: potential pedophiles) and instead unequivocally insists that the mother, at all costs, prohibit her child from this behavior. "Do more than just 'tell' your son; forbid him to speak to strangers," Abby implores. " If your child defies you, punish him...make that punishment memorable. Be firm, mother. Your child needs to be protected, and it's your responsibility to protect him" (362 from *Los Angeles Times* May 12).

This example reveals contradictory cultural views regarding childhood sexuality and needs, as well as the role adults should play in the lives of children. Kincaid points out that "this fable disguises its own needs. It tells the story about child sexuality,...the story about the monsters who believe in it

and do such harm. It tells the story of how alert the rest of us are to the child's needs" (362). Yet this example goes further; it exposes that "the rest of us," (Abby included)—not just the "monsters"—believe in child sexuality too. The vigor of Abby's response not only demonstrates her belief in child sexuality, but also hints that it is so powerful that by just *talking* to strangers, a child courts—"invites" and even "incites," not merely "is at risk of"—the danger of molestation.

What the child needs, according to Abby, is adult protection; "a memorable punishment...may be required, just so he won't be hurt" (362). But what exactly would constitute a "memorable punishment" for such a young child? Although adult means of child punishment vary, Kincaid suggests that spanking ("for the child's own good") is likely. Thus, Kincaid argues, through invoking the rhetoric of child protection, adults protect "what seems to be the most popular sexual activity with children allowed...spanking....Our culture...claims that undressing a child and beating it on an erogenous zone is benign"—indeed helpful (376, 261). And, indeed, depending on how it is represented, in comparison to physical affection with an adult, spanking may seem to qualify as the lesser of two evils. Consider the following two scenes Kincaid describes:

> in the first an adult is striking a screaming child repeatedly on the buttocks; in the second an adult is sitting with a child on a bench and they are hugging. Which scene is more common? Which makes us uneasy? Which do we judge to be normal? Which is more likely to run afoul of the law? (362)

In carrying out such acts of "protection," Valerie Walkerdine suggests that adults "are not protecting innocent little children so much as protecting themselves" (Walkerdine 176). Specifically, the idea of protecting the child enables adults to express an interest in the child, thereby protecting themselves in their relationships with children.[54] In particular, she argues, the discourse of child protection, by offering adults a means of distinguishing their own "good" intentions from bad intentions, enables adults to self-protectively distance themselves from any potential ambiguity about their feelings and relationship with children.[55] Following this line of reasoning, Kincaid provocatively suggests that conceptually "the pedophile is thus our most important citizen" (Kincaid 5). The figure of the pedophile allows adults to reassert their position as decent people who care about children in appropriate ways. The pedophile reassures "the rest of us" that, by contrast with his behavior with children, our own is safe.

This adult-constructed category of the modern child relies on the assertion of an immobile boundary between childhood and adulthood that masks its complexities and inadequacies.[56] In its crudest form, the modern child is defined by its opposition to the adult. And this rigid separation between child and adults occurs across the line of the sexual. Adults are identified as those who are sexual and children as those who are not: the adult is sexual and depraved; the child is innocent and pure. Thus the disavowal of childhood sexuality becomes the most salient feature of the constructed child. But, as Higonnet and others have observed, the very suppression of sexuality in depictions of children can be unintentionally erotic. As Kincaid argues, the concept of the child is threaded through and through with eroticism:

> [B]y insisting so loudly on the innocence, purity, and asexuality of the child, we have created a subversive echo: experience, corruption, eroticism. More than that... [we are] attributing to the child the central features of desirability in our culture—purity, innocence, emptiness, Otherness. (5)

A historical perspective enables us to sharpen this phenomenon. According to Aries, our "unwritten law of contemporary morality [that]...requires adults to avoid any reference, above all any humorous reference, to sexual matters in the presence of children...was entirely foreign to the society of old" (Aries 100). Sexual jokes, indecent gestures, the exposure and touching of sexual organs were all unremarkable occurrences in the presence of children. Aries suggests that this behavior caused no concern because children were "believed to be unaware of or indifferent to sex. Thus gestures and allusions had no meaning for [them]" (106). By contrast, our own elaborate efforts to "protect" children from such conduct reveal a suspicion that, in spite of our insistence on their innocence and nonsexuality, children are far from immune to impure or sexual influences. As Diana York Blaine describes, "the assertion that childhood and sexuality are mutually opposed has in effect guaranteed their linkage" (Blaine 52).

We also see signs of this hidden linkage in discourses narrativizing the child's developing body. In stories of children's entry into adulthood, for example, the concept of 'puberty' is frequently reified as a sort of barrier or gateway. We commonly say that a child has "hit" puberty, as if puberty exists as a checkpoint between two opposing phases of life. Yet, if one follows Barthes, "the erotic" occurs precisely within the interstices that these narratives labor to obscure. As Barthes describes:

> Is not the most erotic portion of a body *where the garment gapes?*....It is intermittent, as psychoanalysis has so rightly stated, which is erotic:

the intermittence of skin flashing between two articles of clothing (trousers and sweater), between two edges (the open-necked shirt, the glove and the sleeve); it is this flash itself which seduces, or rather: the staging of an appearance-as-disappearance. (Barthes *PT* 10)

Synchronically, but also *diachronically* these seams, spaces, edges, and gaps constitute the space of the erotic. This space is one of *becoming* and not only of *being*. As Kincaid reminds us, when it comes to the erotic, "it is the process, not the thing" that matters.... We are speaking of "a desire that lives on the flash" (Kincaid 31, 32). The liminal space between childhood and adulthood functions as a highly policed erotic zone, the diffuse persistence of which is masked behind its appearance as a well-defined temporal "stage." In misrepresenting the child's transition to adulthood as clear and permanent, our dominant cultural narratives attempt to mask the eroticism that is associated with the uncertainties and disruptions that attend the child's process of becoming. Children spill out of their designated roles, they pop up in unexpected places, they debut surprisingly adult insights, and they seem to know things that adults try not to acknowledge.

In this sense, one might claim that children enact the masquerade; they keep us guessing. The stories we tell attempt to "know" the child, to master it, to locate its contours as a discreet entity, but the child is not a willing accessory to this imposture. The patent lack of success that attends the struggle to ground puberty in objective, concrete, biological occurrences (the onset of menstruation for girls and nocturnal emissions for boys) indicates the level of difficulty involved in sustaining the narrative of puberty as a threshold into sexuality. What, for example, do we make of an eight year old who knows nothing of the significance of the blood which escapes her each month? In the words of Kincaid, such efforts at delineation "seem always to have required some elaborate mental slithering and some brash pseudo-science" (Kincaid 70). Adults try desperately to take the position of imposture—to fix the child within the knowable confines of the symbolic—but deftly the child escapes their clutches. In this context, Kincaid offers a useful way of thinking about the adults' role as "explainers": "The plugging up of gaps... murders desire. And the hit men are explainers.... Explainers detest desire" (32–33).

Although the elaborate adult narratives around childhood and puberty are clearly inadequate, they *are* useful in highlighting the cultural investment adults have in sustaining and rejecting particular conceptions of children— particularly in terms of their innocence, bodies, and sexuality. They help to make adults comfortable—to assure the impossibility of both children desiring and of desiring children, but at the same time, ironically, our insistence

on narrativizing childhood in ways that explicitly contradict our experiences works to underscore the true discomfort we have in our relationship with the child we have constructed. This logic, I shall argue, is paralleled by the way in which our insistence on photographic realism is coupled with our recognition of the photograph's ability to deceive. As we will see, Mann's photographs exhume the laboriously but tenuously concealed underside of both the discourses of childhood innocence and photographic innocence.

MANN'S DEPARTURE

Departing from representations and discourses of the "innocent," constructed child, Sally Mann invites us to consider photographic images of children that have been described as "provocative," "disturbing," "sensual," "audacious," and "inherently exploitative." Her work highlights the limitations of the narratives of the innocent child and provides alternative representations of children, their bodies, and their sexuality. Mann's work is provocative mainly, I argue, because she relishes the erotic moments of becoming. When we look at the "children" she photographs, it is unclear "who" they are; categories of adult and child seem too inflexible to accommodate her images. The constructed child dissolves, for example, when we look at Mann's photograph of a particularly young-looking twelve year old, lying on her bed surrounded by shelves of dolls and toys, with her own real-life infant lying by her side. Is she a child or an adult? Within the narrow cultural framework, it would seem that, since she has a child of her own, she is an adult, yet all signs within the image indicate that she is a child. Mann relishes the potentially erotic moments of offering us a peek at the adult within the child.

A comparison of this image with "The New Mothers" helps us to differentiate masquerade from mere imposture. The girls' game of pretend and the cultural signs that they mimic are familiar. Not only do we recognize their game within a clear symbolic framework, but also, most importantly, the girls look appropriately inappropriate. They do not fit the adult roles that they imitate, and this is just as adults would like. Although both images use deception to make clear the uneasy fit of the child into the adult world, they do so to different effect. Whereas the girls in "The New Mothers" straightforwardly pretend that their dolls are their babies, the twelve-year-old girl, with her real baby situated among her room full of dolls, creates the impression that her real baby is merely her doll. The girls in "The New Mothers" simply pretend, but the twelve-year-old engages in the much more disturbing game of pretending to pretend.

Unlike the comfortably awkward posing of the girls in "The New Mothers," Jessie in "Jessie at 5" carries her adult-like pose with discomforting

grace. Jessie's makeup, jewelry, topless, looking-over-the-shoulder pose should make a five year old look silly, but in fact, Jessie looks serious and seductive. The viewers' attention is so quickly absorbed by Jessie that it may take a moment to notice her companions in the background. The two girls on either side of Jessie appear as if from another image; they are darker, shorter, rounder than Jessie and dressed differently—"differently exposed" both in a technical sense and in a bodily sense. With their shy demeanors, frilly clothes, and chubby fingers, they fit our cultural expectation of the innocent, romantic (nonsexual) child. Jessie, by contrast, is emblematic of the sexual child whom our cultural script requires to remain in the dark. But in Mann's rendering, the repressed emerges: the light shines on Jessie: she is in the foreground. Correspondingly, the spectator is put in the dark— plunged into uncertainty—which, in turn, raises the question of what is it that the child knows? Such confrontations with "knowing children" challenge the conventional view that cultural distinction between children and adults rests, in large part, upon knowledge (particularly about the body) that adults have and children do not.

For Higonnet, Jessie exemplifies the "knowing child," the foil to the innocent romantic child. As Higonnet describes, "these knowing children[57] have bodies and passions of their own. They are also often aware of adult bodies and passions, whether as mimics or only witnesses" (Higonnet 207). Not only do Mann's children seem to "know" about themselves and their bodies, but they also seem to "know" Mann and her desires, a point that circulates to her viewers in both her titles and narratives about her work, which include references to her children's narratives about their participation in her work. For example, "The Last Time Emmett Posed Nude" depicts Mann's son, Emmett, after (we are told) he told his mother that he had decided that he was getting too old to pose nude. *New York Times* writer Richard B. Woodward characterizes Mann's children as "impish, argumentative participants, not robots" (Woodward 33). He recounts that the *NYT* photographer in charge of deciding what image of Mann should accompany his article asked the children what they would like to see: "[T]hey shouted, 'Shoot her naked, shoot her naked,' She did" (33). The children act not only as models, but also as producers, often contributing to the artistic vision of the work. As Jessie at the age of ten explains, "I know what mom likes sometimes, so I point it out to her" (33). Or is this all part of the illusion? Does it function to shield viewers from considering that perhaps we are the ones imposing "knowingness" onto the children?

I suggest that in order to engage these questions, one must look beyond how Mann's work challenges our notions of the innocent child and examine

Fig. 15. Dorothea Lange, "Damaged Child, Shacktown, Elm Grove, Oklahoma," c. 1936. © The Dorothea Lange Collection, Oakland Museum of California, City of Oakland. Gift of Paul S. Taylor.

how her work challenges notions of the "innocence" of the photograph. Mann throws into question expectations of photographic innocence primarily by using three devices: the "posed photograph" (photographs in which the photographer arranges the scene and then tries to hide the fact that the scene was arranged); citation (which occurs when the photograph refers to or resembles an earlier well-known photograph); and captioning (which appears to be an objective description of what is in the image).

Mann often creates posed photos by staging scenes around her children's messiness and accidental injuries that produce images of what appear to be beaten children. The success of this effect depends upon the deeply held assumption that photographs "innocently" capture a spontaneous real event. A critic strikingly illustrates this assumption when complaining that "at moments when any other mother would grab her child to hold and comfort, Mann must have reached instead for her camera" (Malcolm 8). The critic seems strangely oblivious to the possibility that Mann may have planned or "created," these moments, rather than simply recorded or spontaneously "captured" them. Although the critic is (one assumes) well versed in the history and practice of photography, Mann's images seem to throw a wrench in her usual critical judgment.

The critic's comment that I cite above is especially surprising when we consider that Mann's work undermines any sense of spontaneity not only by its highly prepared formal qualities, but also by her use of an 8X10 camera, which Luc Sante explains "requires the use of a cloth over the photographer's

Fig. 16. Edward Weston,
"Neil, 1925."
Collection Center for
Creative Photograph.
© 1981, Arizona Board
of Regents.

head, a tripod and individual sheets of film—a format that requires the sub-ject's full collaboration and does not permit any element of ambush or surprise" (Sante 1). For example, the initial—and one of Mann's most controversial—family photographs was taken in 1984. While playing outside at a friend's house, Jessie, only two years old at the time, had been bitten by gnats. As the result of a slight allergic reaction, her face became "lumpy" and "swollen." Days later, (when all was calm, but Jessie's face was still swollen) using props and stylistic techniques, Mann photographed her daughter and entitled it "Damaged Child," an allusion to Dorothea Lange's famous 1936 photograph of the same name.

In short, it is as if Mann throws a deceptively frayed rope to viewers, who are desperately trying to tether the children in her images to their proper symbolic role, and in their concentrated efforts to batten images of children to innocence, they inadvertently loosen their grip on savvy photographic knowledge. Mann gets you either way; her world is no place for the impos-ture. And, as we will see, it is not only through her images, but also through her commentary about her work, that she makes mastery impossible.

Much of the semiotic work that goes into suggesting that Mann's image is of child battering operates through the use of captioning to "anchor" the meaning of the photograph. If the caption read, "Jessie gets an allergic reac-tion to Gnat Bites," our reaction to the photograph would differ immensely. The caption, thus, goes well beyond limiting the polysemy of the image; it appears to straightforwardly tell us what we are seeing. As Barthes describes,

the caption "appears to duplicate the image" (Barthes "PM" 26). Thus, in contrast with prevailing wisdom that images merely illustrate written texts (as in the picture that is worth a thousand words), Barthes argues that one must consider how "it is now the words which, structurally, are parasitic on the image.... [T]he text loads the image, burdening it with a culture, a moral, an imagination" (25, 26). Barthes offers the well-known example of the caption to a photograph showing Queen Elizabeth and Prince Philip leaving a plane that had encountered a mechanical difficulty: "*They were near to death, their faces prove it.*" Yet, at the moment that photograph was taken, "the two still knew nothing of the accident they had just escaped" (27).

Mann plays with captions not only in order to "confirm" our fears (as in the case of "Damaged Child" where we fear that the child in the picture has been beaten, and the caption seems to authenticate our suspicions). She also uses captions to allay our fears, in the process catching us in our own acts of interpretation, confronting viewers with the revelation that we are the ones attributing horrific meanings—that we are, to refer to the old joke,[58] creating our own "dirty pictures." In one such photo we see Mann's son, Emmett, in a variation on Edward Weston's famous 1925 photograph of his son, Neil. Emmett's torso is contorted and naked. His stomach, penis, and thighs are covered with smudges and thin streaks—perhaps resembling blood. The caption quickly intervenes to interrupt our thoughts of possible injury, abuse, mutilation; it is reassuringly entitled "Popsicle Drips."[59]

Mann's public interviews and the written comments that accompany her photographs provide further context, which influences the reception of her work. As an artist, Mann makes seemingly naïve claims about her work. Although her images clearly challenge our assumptions of the innocent, nonsexual child, her words reinforce this self-same assumption. She goes so far as to insist, "I think childhood sexuality is an oxymoron" (52).

By exposing the child's becoming adult and permitting us to witness the ambiguities of adult/child, sexual/nonsexual, Mann's photographs also make it difficult to deny the potentially erotic quality of her work. But in this context, too, she takes the opposite line. Strongly invoking the idea of puberty as a sharp dividing line between two very distinct phases of life, she tells us she will stop photographing her then ten-year-old daughter Jessie when she reaches puberty. Mann claims, "I swore two years ago that because she was beginning to look more like an adult woman, I was going to have to stop. But it would have been difficult, because she's always naked out here" (Woodward 52). In this quotation, Jessie's nakedness can be read as confirmation that not only is she the "innocent" child but also that Sally Mann's own work is innocent of any charge of eroticism. Although her body is

maturing, Jessie is still an "innocent" child, since part of the image of the "innocent" child involves being "naked and proud of it." Kincaid suggests that, "modesty is associated with corruption, with the fall" (Kincaid 221). Neil Postman also argues that the idea of shame is crucial for the category of childhood to exist since it functions as the root of the division between children and adults. Only adults, because they are sexually knowing, experience bodily shame. It follows, then, that as long as Jessie feels no shame and is happily naked, she is still a child. It seems that adulthood, the realm of the sexual (located on the other side of puberty) is better identified by growing inhibitions than by growing breasts.

Mann's written and spoken comments play an influential role in the reception of her work. In the repressive political climate of the late 1980s, controversial artwork, similar to Mann's, fell under unprecedented legal scrutiny. Indeed from roughly 1989 through 1991, the United States witnessed a series of dramatic political and cultural upheavals and realignments that contributed to what are often called "the culture wars." Art and symbolic representations, especially those involving controversial or ambiguous images of sexuality, religion, and patriotism, have historically garnered harsh criticism, particularly during times of social unrest. But during the culture wars, fueled by anxieties regarding international shifts as well as domestic crises, criticism in this area, especially regarding representations of children, rose to new heights.

Steven Dubin contends that we should understand this unprecedented scrutiny of art in terms of international events, particularly the democratization of Eastern Europe, the fall of the Berlin Wall, and the removal of trade barriers that signaled the end of the cold war. Such changes, Dubin suggests, deprived Americans of the Other in opposition to whom they had secured their own identity. During such times, nations reexamine their own boundaries with an eye to determining "which people, ideas, deserve inclusion....When the threat of an external enemy dissipates...societies search for internal demons" (Dubin *AI* 14). In short, when an external enemy disappears, a nation looks for internal monsters that it can exclude as a way of shoring up its identity. This is hunting season for pedophiles, and artists often get caught in the fire: "[W]henever a society is overwhelmed by problems and its sense of national identity is shaky...a probable response...is to attempt to exercise control by regulating symbolic expression" (19).

The 1980s were particularly hospitable to such attacks on symbols. Domestic crises around AIDS, health care, the declining economic status of

the middle class, the fall-out of financial excesses and deceits of the early 1980s, and so on, facilitated a shift in attention to art, which took the specific form of a privileging of "style" over "substance." A particularly powerful example involves the 1985 project to "cover over" urban decay by fitting the facades of uninhabitable, rotting tenements in the South Bronx with fake windows, complete with *trompe l'oeil* curtains, plants, paintings, and bookcases in the background. Dubin suggests, "these facsimiles were literally window dressings, stand-ins for nonexistent programs to address the manifold problems of urban decay" (17). Yet as we have also learned from the example of the toupée, covers have the potential to work flawlessly only when they remain totally transparent. Once they become visible, they invite more scrutiny of what lies beneath. But, as we have also seen, an erotic pleasure, in the Barthesian sense, attends this possibility of seeing through to what has been concealed. As Susan Stewart puts it, "the cover invites exposure; it always bears the potential of striptease"—a point to which we shall return (Stewart 114).

These claims explain the unprecedented scrutiny lavished upon nude images of children in the 1980s. In 1984 "child pornography" was, for the first time, legally differentiated from the more general category of pornography and legislated more harshly (Higonnet "CBO" 2). Yet what constitutes "child pornography" was never clearly defined. The highly vague and subjective nature of this distinction invited adults to nominate themselves as arbiters of the pornographic, determining when the undefined line has been crossed through their own visceral reaction (remember, for example, Supreme Court Justice Potter Stewart's infamous declaration about pornography: "I know it when I see it.") And as attorney and First Amendment supporter Edward de Grazia explains, "it is a crime to take, sell, give away, exhibit, possess, or just look at, any picture depicting the body of an unclothed or incompletely clothed girl or boy, if an 'average' policeman, prosecutor, judge or juror might be excited, offended, or shamed by it" (de Grazia 50).

Mann's work exists as a potentially irresistible target of such censorship, yet by comparison with her peers, Mann escaped harsh legal scrutiny. How can this difference be accounted for when we consider that Mann's work is more confronting, more alluring, and often more sinister, than her colleagues' comparatively chaste images? I suggest that, by contrast with Mann's work, the images of her peers invited speculation regarding just what horrors these pristine surfaces might obscure. In one representative case, photography student Ejlat Feuer's photographs of his six-year-old daughter landed him in jail for a night and barred him from contacting his family for ten weeks. Other photographers, such as Toni-Marie Angelli (whose images of her son were to be used in a project on childhood innocence) and Alice Sims (who constructs

photographic montages that combine nude babies with flowers in the style of
Anne Geddes) have endured even more serious hardships, including the
destruction of their work, jail time, and temporary loss of custody of their
children. Sante, in relation to the Feuer case, describes the elaborate way a
string of totally open events propels people to look for sinister motives:

> It's conceivable, I suppose, that darkly prurient motives could exist
> even in a case where the photographer was fulfilling a class assignment,
> took the pictures in the presence of his wife and the children's nanny
> and blithely sent the rolls to the Kodalux Service for developing, and
> his now 7-year-old subject, after the ordeal, is eager to be photographed
> again. But does it seem likely? (Sante 1)

In Mann's work, by contrast, the sinister is on the surface; the children
in her images already appear compromised, either beaten, sexualized, or
exploited. We are thus not invited to probe more deeply for hidden horrors.
As Sante puts it, "Mann is clearly no stage mother, with smiles for the
camera and beatings behind the hedge" (Sante 4). Mann threatens any sense
of ideological consistency by taking two contradictory dominant cultural
views and maintaining them both to the letter with flawless sincerity. Thus
through her work she appears to deliver to us the fantasy that underlies our
attempts to police images (evidence that an internal monster—the
pedophile—does exist and that we are not it!). Yet through her words, she
faithfully obeys (indeed overplays) the explicit culturally correct view that, to
use her words, "childhood sexuality is an oxymoron." In this sense Mann
demonstrates Žižek's claim that "an ideological edifice can be undermined by
a too-literal identification" (Žižek PF 22). Rather than through her words or
images alone, it is through the relationship between them that she exposes
the gap between the social system's explicit law (the nonsexuality of the
child) and the underlying fantasies (a belief in the desire for and of the
child). As Žižek describes, "the lesson of this is that—sometimes, at least—
the truly subversive thing is not to disregard the explicit letter of Law on
behalf of underlying fantasies, but to *stick to this letter against the fantasy which
sustains it*" (29). Mann, in effect, calls our bluff; she hands us what we seek,
while reciting our denial that such a thing is possible. The subversive effect of
this dissonance between Mann's words and her images is to disempower her
detractors. In Žižekian terms, Mann has found "the only way to be truly 'sub-
versive'...to act 'naively,' to make the system 'eat its own words,' i.e. to
undermine the *appearance* of its ideological consistency" (Žižek TWN 230).

The relatively few critical responses that attend Mann's work during this
period provide another site at which to examine the split between explicit

arguments and their implicit investments. During 1989, the height of the "culture wars," legal attacks on art, the *Wall Street Journal* censored a nude photograph of Mann's then four-year-old daughter, Virginia, by putting black bars over her nipples and genital area, as well as her eyes. The *WSJ* had caught sight of the photograph when it appeared on the cover of *Aperture* and then produced their own edited version.

Among the significant differences between the two renditions of the image is the absence of the girl in the background of the *WSJ* version. How do we explain this omission? At first blush, the girl in the background appears as the quintessential "innocent" child, yet on closer inspection, does her modest pose, complete with her hands covering her mouth and genital area, betray a certain knowledge? Of more pressing concern is the question of why Virginia's eyes have been blocked out.

Conventionally, of course, the media uses such techniques of blocking out eyes to conceal the identity of a person who has experienced trauma. But, in this case, a desire to maintain anonymity does not explain the erasure, since the article explicitly identifies Virginia by name. The difficulties posed by this altered image, I argue, provide a ripe site for exploring approaches to the gaze and its relation to politics.

Screen theory's[60] influential approach to analyzing visual images, advanced most notably by Christian Metz, Stephen Heath, and Laura Mulvey, combines elements of early Lacanian psychoanalysis, Althusserian theories of ideology, and Barthesian semiotics, with a leftist politics of the image. A screen theory account of the unusual treatment of Virginia's eyes would emphasize the interpellative power of eyes as a means for putting the viewer under scrutiny. Blocking out Virginia's eyes would be explained as a way of avoiding the threat of the gaze by allowing the viewer to see without being seen seeing. Specifically, in the case of the image of Virginia, it would be argued that viewer discomfort emerges not from simply looking at a naked child but rather from being looked at looking at a naked child.

Lacan's later emphasis on the gaze, as an object of the Real, provides a contrasting view. Rather than eliding the gaze, the practice of covering Virginia's eyes actually institutes the gaze, since for Lacan, the gaze emerges from "someone whose eyes I do not see" (Lacan *Sem I* 215). More specifically, the gaze emerges from eruptions of the Real in the form of indeterminancy in the viewers' visual field, which provokes viewers not only to question what they see but also to respond to what Lacan calls the "*che vuoi*," the question of one's desire. Thus, rather than locate Virginia's eyes as the source of scrutiny, the Lacanian gaze emanates from a blot in the image—such as the bars—which, by interrupting its symbolic coherence, becomes the place

where the viewer becomes "inscribed in the observed scene" (Žižek *LA* 91). It is from this point of uncertainty, and not from Virginia's eyes, that "the picture itself looks back at us," confronting the viewer with the question of her/his investment in viewing the image (91).

Here too (as in the case of the *punctum* in Jamie Wagg's image), we see how the Lacanian gaze is relational, since it depends, not solely upon the image's composition, but upon the relationship of the image's composition to factors such as media conventions and cultural expectations.

By situating this Lacanian account of the gaze in relation to media conventions as well as contemporary conceptions of the child, I suggest an alternative to the screen theory explanation for the reception of Virginia's image. In contrast to the dominant figure of the "innocent," "nonsexual" child, the barred Virginia is constructed as both sexual (through the concealment of her genitals) and a victim (through the shrouding of her eyes). I argue that anxiety emerges from viewing this image from a point where one sees Virginia not only as sexual but also as victim. This coincidence of the viewer's gaze with the gaze of the pedophile creates both unrealistic anxiety and a sense of self-scrutiny.

My analysis also shows ways in which censorship practices, specifically the barring of Virginia's body, betray their own pretense. While overtly "protecting" the innocence and nonsexuality of the child, the barring of her body reveals an implicit "belief" in her eroticism. In Žižek's terms, such an act "creates what it purports to conceal, its 'repressed' point of reference"—in this case, the sexuality of the child (Žižek *PF* 7). In other words, according to Žižek, the "usual conservative attitude toward child sexuality" has the paradoxical structure of a "prohibition of something which is already in itself impossible... [Childhood sexuality] does not exist, children are innocent beings, that is why we must control them strictly and fight child sexuality" (Žižek *SOI* 164). In short, we face here a familiar paradox: if child sexuality does not exist, then why labor to conceal it?

Manifestations of "unrealistic anxiety," such as the barring of Virginia's image, not only result from material practices but also have material effects. Mann reported that after seeing the censored representation, a confused and annoyed Virginia wrote to the *WSJ* to tell them, "I don't like the way you crossed me out" (Steiner 49). And Mann notes, after this incident, Virginia began displaying signs of shame in her body, covering herself up and refusing to be photographed nude for a while. Shame, as argued by Neil Postman, is the root of the distinction between the categories of the (innocent) child and the (sexual) adult. Thus, paradoxically, the censorship of Virginia's image

may be thought of as sexualizing her. Wendy Steiner laments that "puritanical censorship led to this child's shame at her own body" (49).

Much concern with regulating images or representations of children stems from a desire to protect actual children. Higonnet goes further to argue that "this impulse to censor images of children in order to protect actual children depends entirely on a belief in photography's realism" (Higonnet *CBO* 2). I want to extend Higonnet's claim by suggesting that the cultural policing of images also goes beyond trying to protect actual children to protecting the division between child and adult. For example, consider the decision by the Meese Commission (the 1985-86 Senate committee devoted to investigating effects of pornography) to declare "images of obviously adult men and women dressed in exaggerated fashions of high school students" as "child pornography" (Vance 219). Such images have not involved actual children: their guilt lies instead in highlighting the ambiguity of adulthood and childhood, rather than upholding the rigid adult (sexual) and child (nonsexual) distinction.

In another example from Canada in 1993, Eli Langer's paintings of children in what appear to be sexual poses were confiscated for violating Canada's law that "no one under the age of 18 can be represented nude or in a sexual posture, whether in art or not" (Steiner 75). The paradox, as Steiner notes, is that this bill exists in a country where the legal age of consent for sex is 14: "here the representation of sex involving 14-year-olds is a crime when the act of sex involving them is not" (75). The bill also suggests that the key issue at stake here is not so much the protection of children from sex, as the troubling of the sexual division between adult and child.

By vividly revealing the disavowed space between adult and child, Mann's work makes untenable dominant cultural narratives of childhood, in which this division is embedded. But by contrast with Harvey's *Myra* , which was readily appropriated by conventional frameworks of meaning, Mann's work has a robustly disruptive effect, which makes difficulties for any attempts to reassert the clarity of the conventional distinction between adult and child. Instead Mann's work facilitates a strategy of masquerade, which rejects symbolic mastery and recognizes the multiplicity of places and ambiguities of form in which the figure of the child may appear. Here, then, we see the way in which a work of art may partake in a political project of subversion: not through parading subversive meanings or content but rather by facilitating a feminine spectatorial strategy to what it says/leaves unsaid.

Conclusion

Film Theory for Post-theory

Recently, film scholars David Bordwell and Noel Carroll have garnered much attention by claiming that film studies has entered the realm of "posttheory." They call for the end of "grand Theory," which they characterize in terms of the psychoanalytic and specifically Lacanian approaches that have dominated much film scholarship since the 1970s. Such work, they claim, suffers from a formulaic methodology in which films are used merely to confirm the workings of a predetermined theoretical position. In its place they propose cognitivist/historicist and empirical approaches, which, they argue, are better attuned to address questions raised by specific filmic events. Whereas grand Theory, in their formulation, performs from the top downward (in applying a theory to a text), posttheorists tout their approaches as "piece-meal," "middle-range," and "problem-driven" (Smith 2).

I share with these scholars the concern that film theory from the 1970s and 1980s was fraught with many problems. But I disagree with their reasons. Rather than criticize this work for its global theoretical approach per se I have taken issue with its selective and oversimplified interpretation of psychoanalytic theory. Thus I align myself with Žižek when he contends that posttheory invalidly extrapolates from the failings of a particular theory (psychoanalytic film theory) to the failure of theory in general (including the Lacanian successor of film theory):

So as a Lacanian, I seem to be caught in a...double-bind: I am, as it were, being deprived of what I never possessed, made responsible for something others generated as Lacanian film theory....My response to this is, of course: what if one should finally give Lacan himself a chance? (Žižek FRT 2)

This challenge, to "finally give Lacan a chance," has in large part motivated the preceding project. In particular, rather than reject theory in toto

111

(as post-theorists suggest), my work seeks, through a Lacanian "return to Freud," to contribute to the revitalization of theory, especially psychoanalytic theory, as it is deployed by film studies. In particular, drawing upon deep conceptual connections between Lacan and Barthes (which have been obscured by earlier film scholarship), I have proposed theoretical approaches that, rather than simply advocating a broad theory for theory's sake, are not only sensitive to but also motivated by particular historical, political, cultural, and textual questions. In particular, I have shown how a focus on the *punctum* (as the Lacanian signifier of lack in the Other) provides a way of highlighting the importance of the strongly contextual and profoundly local dimension necessary for film theoretical approaches that can meet the challenges posed by contemporary film studies.

In chapter 1, I proposed an interpretation of Barthes' *Camera Lucida* in which I take issue with critics for failing to acknowledge Barthes' engagement with the Lacanian Real. A similar oversight, I argued, pervades most film theory scholarship, most notably the influential and foundational work of Christian Metz and Jean Louis Comolli. In particular, in "engaging with" Lacan, these film theorists emphasize Lacan's notion of the Imaginary to the virtual exclusion of his concept of the Real. This exclusion manifests in a limited notion of the spectator. Specifically, a focus on the Imaginary restricts us to considering how images provide points with which spectators can identify. An emphasis on the Lacanian Real, by contrast, enables the supplementary understanding of these points as places where the image's meaning breaks down.

I extended this insight in the following chapter by demonstrating the possibilities that attend a shift in focus from the Imaginary to the Real through an analysis of André Kertész's photograph "New York City." From the perspective of the Imaginary, the *bust* invites viewers to identify with an image *of* Woman. But such an approach fails to address spectators' inevitable failure to achieve stable identity. From the perspective of the Real, by contrast, we focus upon the way in which the *vase* can mobilize the spectator to look *as* Woman—to confront "not just what we see but how we see—[to conceive of] visual space as more than the domain of simple recognition" (Rose 231). It is thus through the notion of the Real that we can begin to rethink connections between the image and sexual difference. A prick by the *punctum* launches the spectator toward the looming shadow of the Real, thus causing a dire uncertainty regarding not only where the spectator "stands in relation to the picture" but also regarding her/his sexual identity. As Rose suggests, such visual disturbances provide subjects with the sinking feeling that "our identities as male or female,

our confidence in language as true or false, and our security in the image we judge as perfect or flawed, are fantasies" (227).

I argued further that political potential resides in viewers responding to these moments of disruption through the position Lacan ascribes to Woman, rather than through the position he designates to Man. To be specific, when viewers "come up against a...point of the [visual] system...[that] fails to integrate itself," the scopic strategy of Man entails attempting to "refuse that moment...by trying to run away from it or by binding it back into the logic and perfection of the [visual] system itself" (219). Such efforts yield reactionary results through attempts to reinscribe antagonism back into the symbolic order. The viewing position of Woman, by contrast, carries radical potential in that it undermines the system's coherence, by inhabiting, rather than concealing, its points of lack and excess. In this sense Woman provides a structural model upon which a political practice may be based.

In chapter 3, I explicitly detailed some of the difficulties inherent in traditional film theory scholarship. In particular, I returned to the Freudian and Lacanian concepts upon which film theory has built its approach in order to suggest alternative interpretations. I suggested that in spite of arguing against essentialist notions of femininity and masculinity, most film theory unintentionally reinforces essentialism. This suggestion in turn provides the basis for my claim in the following chapter that a properly Lacanian view of sexuation avoids not only the trap of essentialism but also the opposing risk of taking sex/gender as merely conventional. This Lacanian approach, I also proposed, provides the seeds for a politically subversive spectatorship strategy.

After developing this theoretical framework, I applied it to a series of three case studies: Jamie Wagg's computer-generated painting, *History Painting: Shopping Mall*, based upon the security camera footage of James Bulger's abduction; Marcus Harvey's *Myra*, a larger-than-life-size painting of Myra Hindley's iconic mug shot; and Sally Mann's photographs dealing with the complexities of representing childhood. These studies, I now argue, refute Bordwell and Carroll's claim that psychoanalytic approaches are restricted to a top-down, mechanical application of predetermined theoretical framework.

In particular, I contend, my case studies challenge posttheory's claim that, because of its focus upon "exceptional" phenomena, psychoanalysis is only useful as a last resort, when all other explanations have been exhausted. As Bordwell makes the claim, psychoanalysis is "restricted to dealing with phenomena that cannot be explained by other means.... [W]here we have a

convincing cognitivist account, there is no point whatsoever in looking any further for a psychoanalytic account" (Bordwell "CFSVGT" in *Post Theory* 65).

If Bordwell's claim were correct, then the analysis in chapter 5 of the disparate receptions of the Bulger abduction image in the press and in the gallery would stop at the point where it identifies that the gallery image lacked the interpretative frame present in the newspaper context. But, by showing how framing contexts often provide viewers with the pleasure of "seeing through," the psychoanalytic approach that I am suggesting goes further.

In chapter 6, my analysis of Marcus Harvey's *Myra* also challenges Bordwell's claim that psychoanalytically minded theorists do no more than apply psychoanalysis as an overarching Grand Theory in order to "make sense of everything that interests" them (Bordwell "CFT" 2). In particular, I argue that psychoanalysis is unable to explain the responses evoked by *Myra* since the scandal ignited prior to (and partly as a substitute for) the public's viewing of the image. I make this point not in order to falsify psychoanalytic theory, however, but rather to show how psychoanalytic theory needs to draw upon other theoretical resources. Particular images raise particular sets of questions; such questions not only must motivate our choice of theoretical tools but also, I would argue, must enable us to interrogate the theories to which we turn.

Chapter 7 illustrates this two-way approach between theory and case study in exploring how the *Wall Street Journal's* barring of Virginia Mann's image points to a limitation in usual approaches to theories of the gaze. This particular example, I argued, suggests a need for a more relational account of the gaze as dependent upon the interplay among composition, cultural context, and viewer expectation.

Carroll implores contemporary film theorists to "become more conscious of [their] dialectical responsibilities... [in order to avoid] the ever-present danger that theoretical premises will be taken as given" (Carroll 57). But according to Žižek, Carroll's version of a dialectics falls short of achieving a "dialectics proper" in which "the subject's position of enunciation is included, inscribed, into the process" (Žižek *FRT* 15). Žižek claims that, in advocating an "apparently modest proposition" (of drawing theoretical conclusions from thorough empirical research), Carroll takes a "much more immoderate position of enunciation of the post-theorist himself/herself as the observer exempted from the object of his/her study" (16).

Žižek then goes on to suggest that in order to avoid assuming the "arrogant position of enunciation of the subject who assumes the capacity to com-

pare a theory with 'real life,'" the theorist must look at a system, not as a closed body of thought but as an entity whose apparent closure is guaranteed only through its exception. This concept of the exception figures prominently in Lacan's work as the *pas tout* (not all), the exclusion around which a system coheres. As Rose describes, a "system is constituted as system or whole only as a function of what it is attempting to evade" (Rose 219). But, as I discussed in chapter 4, Woman within Lacanian theory functions as the very *pas tout*,—the point of exception—of the symbolic system. In theory no less than in politics, it seems that scholars should proceed from Woman's strategy of the masquerade in implicating and inscribing ourselves as subjects within the very structures we weave, rather than following, as Bordwell and Carroll do, the logic of Man's imposture by attempting to master a system from the outside.

Notes

1. For a good account of this scholarship, see E. Ann Kaplan's edited collection, *Women in Film Noir* (London: BFI, 1980).

2. Carol J. Clover's *Men, Women, and Chain Saws: Gender in the Modern Horror Film* (New Jersey: Princeton University Press, 1992) remains a key text in the area of feminism and horror films.

3. See both "The Popular Film as Progressive Text: A Discussion of Coma," originally published in M/F, part 1 in M/F 3, 1979, and part 2 in M/F 4, 1980 and reprinted in *Feminism and Film Theory*, ed. Constance Penley (New York: Methuen 1989) and the chapter "Narrative Positions and the Placing of the Woman Protagonist in *Coma* in Cowie's *Representing the Woman: Cinema and Psychoanalysis* (London: MacMillan, 1997).

4. Although Clover "is deeply reluctant to make progressive claims for a body of cinema as spectacularly nasty towards women as the slasher film," her analysis reveals "the...fact that the slasher does, in its own perverse way...consistitute a visible adjustment in the terms of gender representation" (Clover 127).

5. Teresa De Lauretis' *Alice Doesn't: Feminism, Semiotics, and Cinema* has been touted as "one of the most important theoretical contributions to the analysis of female spectatorship" (Mayne 70).

6. See Jackie Stacey's *Star Gazing: Hollywood and Female Spectatorship* (London: Routledge, 1994).

7. In part, I suggest this confusion emerges through Barthes' refusal to sustain the nature/culture distinction that typically circumscribes accounts of the photograph. As I will explore in the next chapter, Barthes' depiction of the photograph's relationship to the Real recasts discussions of the photographic accident away from the epistemology/aesthetic distinction.

8. Susan Stewart in, *On Longing*, offers a provocative account of this traditional view of nostalgia as regressive and conservative, prompting her to

characterize nostalgia as a "social disease." Tagg's critique implies a similar conception of nostalgia.

9. As Celia Lurie notes, it may be worth considering Tagg's reading of Barthes within the context of Tagg's dedication of *The Burden of Representation* to his own mother ("'In memory of my mother, Ethel Tagg, born 1922, died 1980'").

10. For Žižek, nostalgia functions as a way of avoiding the violence of the gaze, of disguising the split between the eye and gaze. As Žižek explains, "the function of nostalgic fascination is thus to conceal, to appease the eruption of the gaze *qua* object" (*LA* 115). The referent, *qua* "lost object," is not what fascinates so much as the imagined gaze of the hypothetical spectator who lived coextensively with the referent (before it became a lost object).

11. In "The Rhetoric of the Image" (1964), Barthes identifies the photograph's "unprecedented...consciousness" in terms of its special relationship to loss rather than unity. A consciousness of unity, based upon the *"being-there* of the thing," can, Barthes argues, be provoked by any copy.

12. In these terms, it is its indexical rather than iconic power that informs the photograph's realism. For Barthes, the photograph's "evidential force...bears not on the object, but on time" (Barthes *CL* 89).

13. Following Žižek's view of Lacan, I argue that Barthes' later period is more properly "poststructuralist" if one takes the term literally to refer to analyses of representation beyond structure. I, therefore, situate Barthes alongside Lacan who, in Žižek's formulation, is the "only post structuralist," in the sense that he confronts the way eruptions of the Real into the symbolic disrupt conceptions of a structural totality. Thus, Žižek's explanation of Lacan can be extended to Barthes: "in this sense we could even say that deconstructionists are basically still 'structuralists' and that the only post structuralist is Lacan, who affirms enjoyment as the 'real Thing' the central impossibility around which every signifying network is structured" (Žižek *LA* 143).

14. Barthes was known to occasionally attend Lacan's seminars.

15. By comparing the Barthesian referent to the Lacanian object, an apparent difficulty emerges. If one follows Joan Copjec, for example, the referent must be contrasted from the object, since their confusion leads to "'realist imbecility'" (143). She maintains that by focussing on the referent (as "the enunciation") rather than the object (in the sense of the "particularity of the enunciator") one misses the way the object endures in spite of attacks on the veracity of the referent. Copjec refers to the failure of American news media to discredit Ronald Reagan in spite of their frequent exposure of his "bold-faced lies" (141) to exemplify that by attacking the referent (the president's statements), while leaving intact the object (the partic-

ularity of Reagan—what is in Reagan "more than himself"), America was able to continue to love Reagan, since this love was not based on what Reagan said, "but simply because he was Reagan" (143). I suggest, however, that the "stubborn" Barthesian referent (unlike the referent of the "realist illusion") persists similarly to the object. For Barthes, the "trace" of the photographic referent asseverates beyond its materiality (Tagg). Whereas for Copjec the referent is precisely the point vulnerable to dissolution, for Barthes, the referent is the point of endurance. In further contrast to Copjec, for Barthes the referent of photographs violated by the *punctum* falls more squarely on the side of the "particularity of the enuniciator," rather than on the side of the enunciation, since the referent's animation emerges from its status as object—as an "unnameable excess" (143).

16. Bruce Fink, in the *Lacanian Subject* alludes precisely to this phenomenon when he explains that "not everything is fungible, certain things are not interchangeable for the simple reason that they cannot be 'signifierized.' They cannot be found elsewhere, as they have a Thing-like quality, requiring the subject to come back to them over and over again" (Fink 92).

17. Kertész's photographic work spans about seventy years (1914–1980) and three major cities (Budapest, Paris, New York) and comes accompanied by a range of provocative remarks, which, we will see, sharpen questions regarding the photographic accident and its relationship to both nature and culture.

18. Unlike Lacan's notion of the gaze (a vague, indeterminate, enigmatic blur, disrupting the visual field), which instantiates the *objet petit a*, the *punctum*, like these concrete but meaningless details, derives its logic from the object that Lacan designates as the "signifier of lack in the other."

19. Since the "shock" rests on the penis's unexpected appearance, viewers equipped with appropriate artistic cultural capital would likely find this utterly predictable.

20. It is likely that Barthes had this photograph in mind when he describes the way in which Mapplethorpe's photographs function erotically, rather than pornographically. Barthes writes: "Mapplethorpe shifts his close-ups of genitalia from the pornographic to the erotic by photographing the fabric of underwear at very close range: the photograph is no longer unary, since I am interested in the texture of the material" (Barthes CL 41–42).

21. Among the distortions, it is perhaps significant for our purposes that one finds an image of a woman's nude body eclipsed by a distorted vase.

22. See, in particular, the influential work of Laura Mulvey, Raymond Bellour, Christian Metz, Mary Ann Doane, Stephen Heath, and Jean-Louis Baudry.

23. As Samuel Weber points out, the reason the boy attributes the penis to everyone and cannot accept that some do not have a penis is due to narcissism. The boy seeks validation in the image of the M(O)ther. The underlying male narcissism within Freud's tale has not been sufficiently remarked by film theorists who tend to base the political problems of female spectators of representations of women, in large part, on the facilitation of women's narcissism.

24. Much of the film theory scholarship that investigates sexual differences (particularly Mulvey and work that builds upon her insights) assumes an opposition, between the "passivity" of woman and the "activity" of man, that it attributes to Freud. Although Freud often invoked this as a widely held belief, it was one against which he explicitly and consistently cautioned. Three passages from different stages in Freud's work confirm this point:

> 1905: "Every individual...shows a combination of activity and passivity whether or not these character-traits tally with his biological ones" ("Three Essays on the Theory of Sexuality" 219–20)

> 1930: "[W]e far too readily identify activity with maleness and passivity with femaleness, a view which is by no means universally confirmed" (*Civilization and Its Discontents* 106)

> 1932: "You have decided in your own minds to make 'active' coincide with 'masculine' and 'passive' with 'feminine.' But I advise you against it." ("Femininity" 115).

25. Curiously, the problem of film theory scholarship to which Rose alludes here, namely, its propensity for deemphasizing the role of visual incomprehensibility in favor of focusing on determinate symbolic meaning, fails to arise at precisely the point where it might perhaps be most welcome. According to Rose, Christian Metz (upon whose work Doane most directly draws), along with most contemporaneous film theorists, unduly mystifies the child's visual apprehension of the female anatomy. Metz's account of the Freudian moment as "a revelation" for the boy child overlooks the culturally mediated symbolic significance of the penis and consequently naturalizes the penis as an inherently (rather than contingently) privileged organ. Fink explains that the role the phallus has come to play in our society is "'anthropological' or 'imaginary' in nature, not structural....There is no theoretical reason why it could not be something else, and there perhaps are (and have been) societies in which some other signifier plays (or played) the role of the signifier of desire" (Fink 102). The status of the penis, as Linker puts it, "is specific to patriarchy, to its particular attribution of values" (in Risatti 212). The significance this moment carries for the child occurs, not through a

"notion of immediate causality" (implicit in Metz's version), but rather through the Freudian structure of *Nachträglichkeit*, which retrospectively places the scene within a structure of differences and values already that will have been *already* held (i.e., the phallus' privileged status within our culture), "without which the moment of perception would strictly have no meaning" (Fink 202). The scene becomes infused with tremendous gravity only in the light of its imminent social significance.

26. In the Lacanian system, "mother" and "father" refer not to actual people, but rather to particular psychic functions that can be accomplished by a variety of people, objects, or institutions (i.e., law as the father function). As Rose cautions, "to make of him [the father] a referent is to fall into an ideological trap" (Rose 63).

27. Lacan plays with this connection at the level of the signifier since in French "tree" (*arbre*) functions as an anagram for "bar" (*barre*).

28. In his later elaborations on sexual identity (*Seminar XX*), Lacan makes the more refined point that it is not simply that sexual identity always falls short of its destination but rather more tragically that sexual identity is constituted *through* the very impossibility of reaching its destination. Whereas in the tale from *Ecrits*, the boy and the girl make the analogous mistake, in *Encore*, Lacan highlights the asymmetry between the mistake made by Woman and Man. As Lacan tells us, a subject has only two ways to respond to the failure of the symbolic: the male way or the female way. As will be made clear, for Lacan it is not merely that there exists an asymmetry in sexual position, but rather more radically, sexuation is constituted *through* asymmetrical responses to the same problem.

29. In British parlance, "being made redundant" refers to having lost one's job, thus intensifying the connection between economic insecurity and masculine insecurity. The men feel redundant, superfluous, as men after being made redundant as breadwinners.

30. According to Kaja Silverman, the on-screen image carries the task of screening the male lack, and thus itself takes on the role of a fetish.

31. The most notable figures in this area are John Fiske, Ien Ang, Angela McRobbie, Christine Gledhill, Janice Radway, Tania Modleski, and Colin Mercer.

32. The pleasure of *jouissance* differs from the pleasure derived from what Roland Barthes calls "*plaisir*" (the pleasure that "contents…that comes from culture and does not break with it" (Barthes *PT* 14) The pleasure that Mulvey and others wish to destroy is of this second kind.

33. If, as Žižek explains, it was possible "to symbolize sexual difference, we would have not two sexes but only one" (Žižek *ME* 160).

34. I use baldness here deliberately in order to evoke Adams' and Apters' (and others) observation that hair and baldness share a complex relationship to the phallus. Hair, conceived often as both fetish and phallus, serves both to satisfy an "exuberant exhibitionism" as well as the "function of covering over something in modesty" (Adams 137). As Adams suggests, baldness, in exposing the scalp, "corresponds to the moment which in respect of the phallus is equally revelation and castration.... [I]t evokes that 'moment of turning the light on' that which must always be shrouded" (137). The phallus, therefore, as Žižek tells us, should be understood as an "element in which excess and lack coincide.... [T]he impossible fullness at the level of meaning (signified) is sustained by the void (the castrating dimension)—(signifier)" (Žižek 60 *FRT*).

35. With this in mind, we may return to the culminating scene of *The Full Monty* in which the men perform their "one night only" show to the Joe Cocker tune "You Can Leave Your Hat On." The final moment of this scene, in which the men are left completely naked, with only their hats to cover their penises, is a freeze-frame shot of the men from behind as they toss their hats into the air. In terms of the metaphors of the "hat" and the "toupée" one may consider both the ways in which the characters' abandonment of their hats might be read as constituting a "masquerade" and the potential that the film's illustration of a strategy of masquerade might have for facilitating a spectatorial position, based on the logic of the masquerade.

36. In *Ecrits*, Lacan refers to the signifiers above the two doors as an "imperative...by which [our] public life is subjected to the laws of urinary segregation" (Lacan 151).

37. Quoted from Howard's introduction to Barthes' *The Pleasure of the Text* (vii).

38. Wagg reports that "when I was asked 'who buys these pictures; that's sick' [an often repeated quote taken from an interview with James Bulger's uncle], I was never given the chance to reply that we all do, every time we...buy a newspaper. We devour images like this and the editors of the tabloids know it" (Wagg 27).

39. Whereas *Myra* functioned as a site for the release of tensions internal to the art world (and to the Royal Academy itself, as witnessed by insults unleashed among the academicians toward one another—particularly the remark by Norman Rosenthal, the organizer of the *Sensation* exhibit, in a BBC documentary regarding fellow academician who resigned in protest over the *Sensation* show, seventy-nine-year-old figurative painter John Ward: "'Maybe...the world will suddenly declare John Ward...to be a great artist but at the moment I doubt it.'" Ward remained unmoved by Rosenthal's sub-

sequent apology announcing: "I want his balls. I shall go on campaigning to get him sacked"), Wagg's work prompted only conspicuous silence from the art communities (Reynolds October 8, 1997; October 6, 1997). For the first time in its history, the Whitechapel Gallery closed for a week while the controversy surrounding Wagg's paintings subsided, yet no major art publication made any mention of this unprecedented act.

40. Here I draw upon Stewart's *On Longing* in which, through a wide breadth of cultural and material artifacts and narratives, she traces the concept of the child to notions of the miniature, the interior, the private, and the protected. By contrast, she argues, the adult belongs to the representational category of the "gigantic" with its associations with "the grotesque, the body...the exterior and the public" (Stewart 97). She argues further that this is the realm of the "monster," a word frequently used to describe Hindley.

41. As Barthes puts it, "what I can name cannot really prick me. The incapacity to name is a good symptom of disturbance [associated with the *punctum*]" (Barthes *CL* 51). The nature of the scandal that broke out in New York surrounding Ofili's *The Holy Virgin Mary* is another instance where the fervor provoked by an image can be understood through purely symbolic and conventional relationships.

42. For detailed elaborations of the phenomenon of "moral panic," see Stanley Cohen, Stuart Hall, Jeffrey Weeks, and Simon Watney.

43. Indeed Hindley did die in November, 2002 before ever being released.

44. The trial judge and the Lord Chief Justice recommended no more than a ten-year minimum prison sentence for Bulger's murderers, Robert Thompson and Jon Venables. Howard, however, raised it to a fifteen-year minimum sentence. Three years later, however, Howard publicly declared that he acted unfairly. He explained that he lengthened the sentence, not because it was lawful, but rather because he enacted what he perceived to be the wishes of the "ordinary man in the street" (Shaw).

45. This state of affairs is influenced by the reign of pluralism in contemporary art addressed in the introduction. As Szanto explains, "in an era of aesthetic pluralism, it is harder and harder to agree about what new art is worthy of display in an art museum...just as contemporary art is struggling to regain a sense of purpose, so museums are feeling their way in a milieu where demands on them are expanding exponentially" (Szanto 190).

46. This division carries particular saliency in regard to the mythology of the mysterious, lurking, voyeuristic pedophile. This myth prevails in spite of continual evidence that most child abusers are figures known to the child— often family members who are part of the domestic space.

47. In the next chapter I elaborate on the relationship between the concept of the 'child' and the category of the adult.

48. Harvey has admitted that he found Hindley "sexually alluring" (Walker 213).

49. "Womenandchildren," to use Cynthia Enloe's phrase in "The Gendered Gulf," is a historical articulation which works to highlight and strengthen the subordinate status of women and children as "symbols, victims, or dependents" (Enloe 96). It continues to endure although it gets mobilized in specific ways at different times. As Shulamith Firestone in *The Dialectic of Sex* argues: "Women and children are always mentioned in the same breath ("Women and children to the forts!"). The special tie women have with children is recognized by everyone. I submit, however, that the nature of this bond is no more than shared oppression. And that moreover this oppression is intertwined and mutually reinforcing in such complex ways that we will be unable to speak of the liberation of women without also discussing the liberation of children and vice versa" (Firestone 81).

50. In struggling to understand how ten-year-old boys could murder James Bulger, blame similarly falls on the media. In particular, the film *Child's Play 3* is reported to have influenced the boys to commit the crime. In response to these speculations, Britain's Association of Video Retailers requested that rental shops remove the video from its shelves. Twentieth Century-Fox postponed its British release of *The Good Son* (which deals with an "evil child") in the light of the Bulger murder (Morrison).

51. Kipnis points out the absurdity of this view in connection with the members of the Meese Commission, which spent years viewing pornography. They maintain that watching pornography leads to violent behavior, yet no member reports having become more violent as a result.

52. Johnson argues that censorship would not be necessary if we lived in an "ideal society, fully mature, with free choice and rich leisure," which stand as (not so) coded words on behalf of bourgeois, middle and upper class society. Censorship, Johnson seems to say, is only necessary as long as there is a working class.

53. Aries' argument has been contested by subsequent scholarship. See, for example, Anthony Burton, "Looking Forward from Aries: Pictorial and Material Evidence for the History of Childhood and Family Life," in *Continuity and Change* 4 (1989): 203–30.

54. Child protection rhetoric is mobilized frequently in political campaigns, with the effect of distracting voters' attention away from the candidates' actions that belie a commitment to fostering children's well-being. For

instance, one of the main themes of Clinton's 1996 reelection campaign was his commitment to helping children. While this position rhetorically punctuated the campaign, very little mention was made of Clinton's cut to welfare programs on which actual children depend.

55. The effects of taboos regarding physical affection between children and adults were poignantly rendered in an *NY Times Magazine* article in which a new mother struggled with guilt regarding the tremendous pleasure she derived from bathing, caressing, and smelling the soft, fragrant skin of her infant. Her joys, she reported, were muted by panic about whether this sensuous delight was appropriate? Art historian Anne Higonnet recalls similar feelings of a "maternal passion for [her] son's body when confronted with Edward Weston's *Neil* photographs. Higonnet describes, "How many times have I stared adoringly at him, caressed him, kissed him, hugged him, inhaled his infant breath like the smell of life? I long for him physically when we are apart, to hold him close is bliss" (Higonnet 13).

56. This adult-constructed child bears little resemblance to actual children; the way adults perceive children has to do, instead, with the way adults desire children to be. This constitutes a crucial gap that, we will see, interferes with our ability to know and understand real children. The theoretical category of "the child" faces other limitations as well. Particularly, it tends to implicitly reference white, middle-class, (usually) girl children and does not account for differences such as class, race, gender, and so on, which have important effects on how actual children are treated.

57. But it is important to remember that the "Knowing child" is not necessarily more "real" than romantic child. Each belongs to and reveals investments of "particular historical moments" (Higonnet 209).

58. A psychiatrist administers a Rorschach test to a new patient. The patient's remarks about what he sees in each ink blot become increasingly vivid in their sexual explicitness. After the exam, the psychiatrist, wipes his brow and tells the patient, "I know this is unprofessional to say, but I'm a bit stunned by some of the things that you've said today." The patient, equally discommoded, replies, "*You're* stunned? Imagine how *I* feel going to a doctor who shows me such dirty pictures!"

59. These constructions have often been the source of complaints that Mann "cheats" her audience. One critic tells us that "upon discovering that she has stage-managed a scene, some people feel cheated, as if their emotions have been trifled with" (Woodward 36). It seems that when we find out how constructed and produced Mann's images are, our conventional understanding of photography as "evidence" is undermined.

60. For a detailed account of the disciplinary history of screen theory, which foregrounds its role within broader theoretical debates of the 1970s, see Judith Mayne's *Cinema and Spectatorship*.

Bibliography

Adams, Parveen. "Of Female Bondage." *Between Feminism and Psychoanalysis.* Ed. Theresa Brennen. London: Routledge, 1990.

———. *Emptiness of the Image: Psychoanalysis and Sexual Difference.* London: Routledge, 1995.

Apter, Emily. *Feminizing the Fetish: Psychoanalysis and Narrative Obsession in Turn-of-the-Century France.* Ithaca: Cornell University Press, 1991.

Aries, Philippe. *Centuries of Childhood: A Social History of Family Life.* Trans. Robert Baldick. New York: Vintage Books, 1962.

Barthes, Roland. *Mythologies.* Trans. Annette Lavers, New York: Hill and Wang, 1972.

———. *The Pleasure of the Text.* Trans. Richard Miller, New York: Hill and Wang, 1975.

———. *Camera Lucida.* Trans. Richard Howard, London: Vintage, 1980.

———. "Change the Object Itself." *Image-Music-Text.* Trans. Stephen Heath. New York: Noonday, 1988.

———. "The Death of the Author." *Image-Music-Text.* Trans. Stephen Heath. New York: Noonday, 1988.

———. "The Photographic Message." *Image-Music-Text.* Trans. Stephen Heath. New York: Noonday, 1988.

———. "The Reality Effect." *Image-Music-Text.* Trans. Stephen Heath. New York: Noonday, 1988.

———. "Rhetoric of the Image." *Image-Music-Text.* Trans. Stephen Heath. New York: Noonday, 1988.

Becker, Carol. "The Brooklyn Controversy: A View from the Bridge." *Unsettling 'Sensation:' Arts-Policy Lessons from the Brooklyn Museum of Art Controversy.* Ed. Lawrence Rothfield. New Jersey: Rutgers University Press, 2001.

Blaine, Diana York. "Necrophilia, Pedophilia, or Both? The Sexualized Rhetoric of the JonBenet Ramsey Murder Case." *Sexual Rhetoric: Media Perspectives on Sexuality, Gender, and Identity.* Ed. Meta Carstarphen and Susan Zavoina. Westport, CT: Greenwood, 1999.

Bordo, Susan. *Twilight Zones: The Hidden Life of Cultural Images from Plato to O. J.* Berkeley: University of California Press, 1997.

———. *The Male Body: A Look at Men in Public and in Private.* New York: Farrar, Straus and Giroux, 1999.

Bordwell, David. "Contemporary Film Studies and the Vicissitudes of Grand Theory." *Post Theory: Reconstructing Film Studies.* Ed. Bordwell and Carroll. Wisconsin: University of Wisconsin Press, 1996.

———. "Cognitive Film Theory." http://www.geocities.com/davidbordwell/cognitive.htm Bordwell, 2000.

Bradley, Ann. "Myra Hindley—A Bad Woman." *Living Marxism* 76, February 1995.

Brewer, John. "Shop Value." *Unsettling 'Sensation:' Arts-Policy Lessons from the Brooklyn Museum of Art Controversy.* Ed. Lawrence Rothfield. New Jersey: Rutgers University Press, 2001.

Bronski, Michael. "*The Full Monty:* Taking It Off for Thatcherism." *Z Magazine*, December 1997.

Campbell, Duncan. *The Guardian*, December 30, 1995.

Carlisle, Elizabeth. "Why the RA Should Hang Myra." *London Times*—undated Xerox.

Carroll, Noel. "Prospects for Film Theory: A Personal Assessment." *Post-Theory: Reconstructing Film Studies.* Ed. Bordwell and Carroll. Wisconsin: University of Wisconsin Press, 1996.

Copjec, Joan. *Read My Desire: Lacan against the Historicists.* Massachusetts: MIT Press, 1994.

Cousins, Mark. "Security as Danger." In *15:42:32 12/02/93.* London: History Painting Press, 1996.

Cowie, Elizabeth. *Representing the Woman: Cinema and Psychoanalysis.* London: Macmillan, 1997.

Creed, Barbara. "General Introduction." *The Sexual Subject: A Screen Reader in Sexuality*. London: Routledge, 1992.

Daston, Lorraine, and Galison, Peter. "The Image of Objectivity." *Representations*, 40 (1992).

de Grazia, Edward. "The Big Chill: Censorship and the Law." *The Body in Question. Aperture* 121 (Fall 1990).

Doane, Mary Ann. "Film and the Masquerade: Theorizing the Female Spectator." *Screen* 23 (3–4) (1982).

———. *Desire to Desire: The Woman's Film of the 1940s*. Bloomington: Indiana University Press, 1987.

Dubin, Steven C. *Arresting Images: Impolitic Art and Uncivil Actions*. New York: Routledge, 1992.

———. "How 'Sensation' Became a Scandal." *Art in America*, 2000.

Edelson, Gilbert S. "Some Sensational Reflections." *Unsettling 'Sensation:' Arts-Policy Lessons from the Brooklyn Museum of Art Controversy*. Ed. Lawrence Rothfield. New Jersey: Rutgers University Press, 2001.

Edelstien, Teri J. "Sensational or Status Quo: Museums and Public Perception." *Unsettling 'Sensation:' Arts-Policy Lessons from the Brooklyn Museum of Art Controversy*. Ed. Lawrence Rothfield. New Jersey: Rutgers University Press, 2001.

Elliott, Christopher. "Withdraw Portrait of Me, Urges Hindley," *Guardian*, July 31, 1997.

Evans, Dylan. *An Introductory Dictionary of Lacanian Psychoanalysis*. London: Routledge, 1996.

Fink, Bruce. *The Lacanian Subject: Between Language and Jouissance*. Princeton: Princeton University Press, 1995.

Fiske, John, *Television Culture*. London: Routledge, 1992.

Foster, Hal. *Return of the Real: The Avant-Garde at the End of the Century*. Massachusetts: MIT Press, 1996.

Freud, Sigmund. "Fragment of an Analysis of a Case of Hysteria" (Dora) SE 7, 1905.

———. *Three Essays on the Theory of Sexuality*. SE 7, 1905.

———. "Analysis of Phobia in a Five-Year-Old Boy." (Little Hans) SE 10, 1909.

————. "Notes upon Case of Obsessional Neurosis" (Rat Man) SE 3, 1909.

————. "Femininity." *New Introductory Lectures*. SE 22, 1933.

Friedlander, Jennifer. *Moving Pictures Where the Police, the Press and the Art Image Meet*. Sheffield: Sheffield Hallam University Press, 1998.

Furedi, Frank. *Culture of Fear: Risk-taking and the Morality of Low Expectation*. London: Cassell, 1997.

Geimer, Peter. "Noise or Nature? Photography of the Invisible." *Shifting Boundaries of the Real: Making the Invisible Visible*. Ed. Helga Nowotny and Martina Weiss. Zürich: VDU, 2000.

Goffman, Erving. "The Arts of Impression Management." *The Production of Reality: Essays and Readings on Social Interaction*. Ed. O'Brien and Kollock. California: Pine Forge, 1997.

Hall, Stuart, et al., "Social Production of News." *Policing the Crisis: Mugging, the State, and Law and Order*. Basingstoke: Macmillan Education, 1978.

————. "Reconstruction Work: Images of Post-War Black Settlement." In *Family Snaps*. Ed. Jo Spence et al. London: Virago, 1991.

Hardy, James. "Hindley Demands Access to Lover." *Telegraph*, December 15, 1996.

Higonnet, Anne. "Conclusions Based on Observation." *The Yale Journal of Criticism* 9, (1) (1996).

————. *Pictures of Innocence: The History and Crisis of Ideal Childhood*. London: Thames and Hudson, 1998.

Imperato, Alessandro. "Jamie Wagg Interview." In *Moving Pictures: Where the Police, the Press, and the Art Image Meet*. Jennifer Friedlander. Sheffield: Sheffield Hallam University Press, 1998.

Jardine, Lisa. "Looking over the Overlooked." Electronic *Telegraph*, November 22, 1997.

Jenkins, Philip. *Moral Panic: Changing Concepts of the Child Molester in Modern America*. Connecticut: Yale University Press, 1998.

Johnson, Pamela Hansford. *On Iniquity: Some Personal Reflections Arising out of the Moors Murder Trial*. New York: Scribner's Sons, 1967.

Jones, Amelia. "Postfeminist, Feminist Pleasures, and Embodied Theories of Art." *The Art of Art History: A Critical Anthology*. Ed. Donald Preziosi. Oxford: Oxford University Press, 1998.

Kemp, Sandra. "Myra, Myra on the Wall": The Fascination of Faces." *Critical Quarterly* 40 (1) (Spring 1998).

Kertesz, Andre. *Kertesz on Kertesz*. Addeville, 1985.

Kincaid, James R. *Child-Loving: The Erotic Child and Victorian Culture*. New York: Routledge, 1992.

Kipnis, Laura. *Bound and Gagged: Pornography and the Politics of Fantasy in America*. New York: Grove, 1996.

Krips, Henry. *Fetish: An Erotics of Culture*. New York: Cornell University Press, 1999.

Lacan, Jacques. *Book I: Freud's Papers on Technique 1953–1954*. Trans. John Forrester. New York: Norton, 1991.

———. *Ecrits: A Selection*. Trans. Alan Sheridan. New York: Tavistock, 1977.

———. *The Four Fundamental Concepts of Psycho-Analysis, Book XI*. Ed. Jacques-Alain Miller. Trans. Alan Sheridan. New York: Norton, 1981.

———. *The Seminar of Jacques Lacan, Book XX: Encore*. Ed. Jacques-Alain Miller. Trans. Bruce Fink, New York: Norton, 1998.

Laplanche, J., and Pontalis, J.-B. *The Language of Psychoanalysis*. Trans. Donald Nicholson-Smith. New York: Norton, 1973.

Lapsley, R., and Westlake, M. *Film Theory: An Introduction*. London: St. Martin's, 1990.

Lehman, Peter. *Running Scared: Masculinity and the Representation of the Male Body*. Philadelphia: Temple University Press, 1993.

Linker, Kate. "Eluding Definition." *Postmodern Perspectives: Issues in Contemporary Art*. Ed. Howard Risatti. New Jersey: Prentice Hall, 1997.

Lury, Celia. *Prosthetic Culture Photography, Memory and Identity*. London: Routledge, 1998.

Malcolm, Janet. "The Family of Mann." *The New York Review*, February 2, 1992.

Mann, Sally. *At Twelve*. New York: Aperture, 1988.

Mayne, Judith. *Cinema and Spectatorship*. New York: Routledge, 1993.

Miller, Jacques-Alain. "On Semblances in the Relations between the Sexes." *Sexuation*. Ed. Renata Salecl. Durham: Duke University Press, 2000.

Millward, David. "Free Me, Begs 'Sorrowful' Myra Hindley.' *Telegraph*, December 8, 1994.

Mitchell, W. J. T. "Offending Images." *Unsettling 'Sensation:' Arts-Policy Lessons from the Brooklyn Museum of Art Controversy*. Ed. Lawrence Rothfield. New Jersey: Rutgers University Press, 2001.

Modleski, Tania. *The Women Who Knew Too Much: Hitchcock and Feminist Theory*. New York: Routledge, 1988.

————. Feminism without Women: Culture and Criticism in a "Postfeminist" Age. New York: Routledge, 1991.

Morrison, Blake. *As If: A Crime, a Trial, a Question of Childhood*. New York: St. Martin's, 1997.

Mulvey, Laura. "Visual Pleasures and Narrative Cinema." *Screen* 16 (3) (1975).

Nye, David. "The Emergence of Photographic Discourse: Images and Consumption." *European Contributions to American Studies* [Netherlands] 1991 (21): 34–48.

Phillips, Sandra S., Travis, Davis, and Naef, Weston J. *Andre Kertesz: Of Paris and New York*. New York: Art Institute of Chicago and the New York Metropolitan Museum, 1985.

Pollock, Griselda. *Vision and Difference: Femininity, Feminism and the Histories of Art*. London: Routledge, 1988.

Postman, Neil. *The Disappearance of Childhood*. New York : Delacorte, 1982.

Quinet, Antonio. "The Gaze as an Object." *Reading Seminar XI: Lacan's Four Fundamental Concepts of Psychoanalysis*. Ed. Richard Feldstein, Bruce Fink, and Marie Jaanus. New York: State University of New York Press, 1995.

Ragland-Sullivan, Ellie. *Jacques Lacan and the Philosophy of Psychoanalysis*. Chicago: University of Illinois Press, 1986.

————. "The Sexual Masquerade: A Lacanian Theory of Sexual Difference." *Lacan and the Subject of Language*. Ed. Ellie Ragland-Sullivan and Mark Bracher. New York: Routledge, 1991.

Randall, Colin. "Myra Hindley Is Told She Will Never Be Released." *Telegraph*, February 5, 1997.

Reynolds, Nigel. "All Art Is Moral, Says Academy Chief in Hindley Row." *Telegraph*, September 17, 1997.

Reynolds, Nigel. "RA To Discipline Organizer of Modern Art Exhibition." *Telegraph*, October 6, 1997.

———. "Academy Rebuke For Sensation Organizer." *Telegraph*. October 8, 1997.

Risatti, Howard, ed. *Postmodern Perspectives: Issues in Contemporary Art*. Prentice Hall, 1997.

Riviere, Joan. "Womanliness as a Masquerade." *Female Sexuality: The Early Psychoanalytic Controversies*. Ed. Grigg, Hecq, and Smith. New York: Other, 1999.

Rodowick, D. N. *The Difficulty of Difference: Psychoanalysis, Sexual Difference, and Film Theory*. London: Routledge, 1991.

Rose, Jacqueline. *Sexuality in the Field of Vision*. London: Verso, 1986.

Ross, David A. "An All-Too-Predictable Sensation." *Unsettling 'Sensation:' Arts-Policy Lessons from the Brooklyn Museum of Art Controversy*. Ed. Lawrence Rothfield. New Jersey: Rutgers University Press, 2001.

Salecl, Renata. *The Spoils of Freedom: Psychoanalysis and Feminism After the Fall of Socialism*. London: Routledge, 1994.

———. *(per)Versions of Love and Hate*. London: Verso, 1998.

———. *Love and Sexual Difference: Doubled Partners in Men and Women Sexuation*. Ed. Renata Salecl. Durham: Duke University Press, 2000.

Sante, Luc. "The Nude and the Naked." *New Republic*, May 1, 1995.

Saussure, Ferdinand de. *Course in General Linguistics*. Ed. Charles Bally, et al. Trans. Wade Baskin. New York: McGraw Hill, 1966.

Shaw, Terence. "Howard Asks For Bulger Decision to Be Overturned." *Telegraph*, January 28, 1997.

Silverman, Kaja. *Male Subjectivity at the Margins*. New York: Routledge, 1992.

———. *Threshold of the Visible World*. York: Routledge, 1996.

Smith, Michael. "Royal Academy Attacked over Hindley Picture," *Telegraph*, July 26, 1997.

Sontag, Susan. *On Photography*. New York: Anchor Books, 1977.

Stacey, Jackie. "Desperately Seeking Difference." *The Sexual Subject: A Screen Reader in Sexuality*. London: Routledge, 1992.

Stavrakakis, Yannis. *Lacan and the Political*. London: Routledge, 1999.

Steiner, Wendy. *The Scandal of Pleasure: Art in an Age of Fundamentalism.* Chicago: University of Chicago Press, 1995.

Stewart, Susan. *On Longing: Narratives of the Miniature, the Gigantic, the Souvenir, the Collection.* North Carolina: Duke University Press, 1993.

Stoney, Elisabeth. "Alice Does: The Erotic Child of Photography." www.sfca. unimelb.edu.au/screenscape/alice.htm University of Melbourne, 1995.

Storey, John. *Cultural Studies and the Study of Popular Culture: Theories and Methods.* Athens: University of Georgia Press, 1996.

Szanto, Andras. "Don't Shoot the Messenger: Why the Art World and the Press Don't Get Along." *Unsettling 'Sensation:' Arts-Policy Lessons from the Brooklyn Museum of Art Controversy.* Ed. Lawrence Rothfield. New Jersey: Rutgers University Press, 2001.

Tagg, John. *The Burden of Representation.* London: Macmillan, 1987.

Tatar, Maria. *Lustmord: Sexual Murder in Weimar Germany.* New Jersey: Princeton University Press, 1997.

Vance, Carole S. "Photography, Pornography and Sexual Politics. The Body in Question." *Aperture* 121 (Fall 1990).

Verhaeghe, Paul. *Beyond Gender. From Subject to Drive.* New York: Other, 2001.

Walker, John A. *Art and Outrage: Provocation, Controversy and the Visual Arts.* London: Plato Press, 1999.

Walkerdine,Valerie. *Daddy's Girl: Young Girls and Popular Culture.* Massachusetts, Harvard University Press, 1997.

Watney, Simon. *Policing Desire: Pornography, AIDS, and the Media.* Minneapolis: University of Minnesota Press, 1989.

Weber, Samuel. *Return to Freud: Jacques Lacan's Dislocation of Psychoanalysis.* Cambridge: Cambridge University Press, 1991.

Woodward, Richard B. "The Disturbing Photography of Sally Mann." *The New York Times Magazine,* September 27, 1992.

Wright, Elizabeth. *Lacan and Postfeminism.* London: Icon Books, 2000.

Žižek, Slavoj. *The Sublime Object of Ideology.* London: Verso, 1989.
———. *Looking Awry: An Introduction to Jacques Lacan through Popular Culture.* Massachusetts: MIT Press, 1991.

————. (ed.). *Everything You Always Wanted to Know about Lacan...(but were afraid to ask Hitchcock.)* London: Verso, 1992.

————. *Tarrying with the Negative: Kant, Hegel, and the Critique of Ideology.* Durham, Duke University Press, 1993.

————. *The Metastases of Enjoyment: Six Essays on Woman and Causality.* London: Verso, 1994.

————. *Plague of Fantasies.* London: Verso, 1997.

————. "The Thing from Inner Space." *Sexuation.* Ed. Renata Salecl. Durham: DukeUniversity Press, 2000.

————. *The Fright of Real Tears: Krzystof Kieslowski between Theory and Post-Theory.* London: BFI, 2001.

Index